About the Author

Julie Adair King is the author of many books about digital photography and imaging, including the best-selling *Digital Photography For Dummies*. Her most recent titles include a series of *For Dummies* guides to Canon, Nikon, and Olympus digital cameras. When not writing, King teaches digital photography at such locations as the Palm Beach Photographic Centre. A graduate of Purdue University, she resides in West Palm Beach, Florida.

Author's Acknowledgments

I am extremely grateful to the team of talented professionals at John Wiley & Sons for all their efforts in putting together this book. Special thanks go to my awesome project editor, Kim Darosett, who is the type of editor that all authors hope for but rarely experience: supportive, skilled, and amazingly calm in the face of any storm, including my not infrequent freakouts.

I also owe much to the rest of the folks in both the editorial and art departments, especially Heidi Unger, Leah Michael, Rashell Smith, Nikki Gee, Steve Hayes, and Andy Cummings. Thanks, too, to technical editor Lyle Mannweiler for his eagle-eyed observations and thoughtful suggestions. This book simply would not have been possible without each and every one of you.

Finally, thanks to my family and friends for not only putting up with me, but doing it with humor and grace.

Publisher's Acknowledgments

We're proud of this book; please send us your comments at http://dummies.custhelp.com. For other comments, please contact our Customer Care Department within the U.S. at 877-762-2974, outside the U.S. at 317-572-3993, or fax 317-572-4002.

Some of the people who helped bring this book to market include the following:

Acquisitions and Editorial

Project Editor: Kim Darosett

Executive Editor: Steven Hayes

Copy Editor: Heidi Unger

Technical Editor: Lyle Mannweiler

Editorial Manager: Leah Michael

Editorial Assistant: Amanda Graham

Sr. Editorial Assistant: Cherie Case

Cover Photo: © iStockphoto.com / Carmen Martinez Banus

Cartoons: Rich Tennant (www.the5thwave.com)

Composition Services

Project Coordinator: Nikki Gee

Layout and Graphics: Claudia Bell, Carl Byers, Joyce Haughey

Proofreaders: Lauren Mandelbaum, Shannon Ramsey

Indexer: Estalita Slivoskey

Publishing and Editorial for Technology Dummies

 Richard Swadley, Vice President and Executive Group Publisher

 Andy Cummings, Vice President and Publisher

 Mary Bednarek, Executive Acquisitions Director

 Mary C. Corder, Editorial Director

Publishing for Consumer Dummies

 Kathleen Nebenhaus, Vice President and Executive Publisher

Composition Services

 Debbie Stailey, Director of Composition Services

Contents at a Glance

Table of Contents

Introduction

When I wrote the first edition of this book, way back in 1997, digital cameras were just coming onto the scene. They were much more expensive than film cameras and, worse, they weren't capable of producing images that could generate decent prints. You could impress your tech-savvy friends with your cool new toy — one of the few benefits of being an early adopter — but as far as serious photography, well, let's just say that digital cameras weren't ready for prime time.

Now, of course, all that's changed. Film is all but dead, and everyone from preteens to great-grandmothers uses digital cameras. And the features and quality packed into today's digital cameras are nothing short of astounding. Tiny, fit-in-your pocket cameras are now capable of producing images that, in some cases, surpass those of professional models from five or six years ago — and at prices that were unheard of in years past. Digital SLR and compact system models, which accept interchangeable lenses, are now remarkably inexpensive, too, making the step up to semipro features much more accessible to enthusiastic shutterbugs.

One thing that hasn't changed over the years, though, is that figuring out how to use all the features offered by today's cameras is an intimidating proposition. First you have to deal with all the traditional photography lingo — *f-stop, shutter speed, depth of field* — and on top of that, you then have to decode a slew of digital buzzwords. Just what *is* a megapixel, anyway? If your professional photographer friend keeps talking about "shooting Raw," does that mean that you should do the same — whatever it is?

Digital Photography For Dummies answers all these questions and countless more. As did the first six editions of this book, this edition takes you by the hand and helps you get up to speed with all the latest digital photography tools, tricks, and techniques. In easy-to-understand language, with a dash of humor thrown in to make things more enjoyable, this book spells out everything you need to know to make the most of your digital camera. Whether you're taking pictures for fun, for work, or a little bit of both, you'll find answers, ideas, and solutions in the pages to come.

What's in This Book?

Digital Photography For Dummies covers all aspects of digital photography. It helps you assess your current digital photography needs, determine the best gear and products to suit your style, and learn how to combine the newest

digital innovations with tried-and-true photography techniques. In addition, this book explains what happens after you get the shot, detailing the steps you need to take to download your picture files, produce great prints to hang on the living room wall, and share your favorite images online.

Here's just a little preview of what you can find in each part of the book.

Part I: Gearing Up

This part helps you stock your camera bag with the right equipment for the type of photography that interests you.

- ✓ Chapter 1 provides an overview of the latest and greatest camera features, explaining how they affect your pictures and your photography options.
- ✓ Chapter 2 introduces you to some cool (and useful) camera accessories, picture-storage products, and digital-imaging software for your computer.

Part II: Easy Does It: Taking the Fast Track to Great Pics

Just because you're new to digital photography doesn't mean you can't start taking better pictures right away. This part is designed to make it easier for you to be successful from the get-go, even if you don't know an f-stop from a shortstop.

- ✓ Chapter 3 guides you through initial camera setup and explains some important picture settings, including resolution and file type. (Don't worry; it's not as intimidating as it sounds.)
- ✓ Chapter 4 guides you through your first picture-taking steps, starting with tips for composing a memorable shot and then showing you how to get the best results when you use your camera's fully automatic exposure modes.

Part III: Moving Beyond Full Auto

When you're ready to take the next step in your photography journey, this part helps you take more control over your pictures by taking advantage of your camera's more advanced options.

✔ Chapter 5 covers exposure, explaining fundamentals such as f-stops, shutter speeds, and ISO, and offering tips on related subjects such as using flash to light your subject.

✔ Chapter 6 introduces focus techniques that can help you add drama to your pictures and also looks at options that enable you to manipulate color.

✔ Chapter 7 wraps up all the previous chapters with a summary of the best settings and techniques to use for specific types of pictures, from portraits to landscapes to action shots.

Part IV: From Camera to Computer and Beyond

After you fill up your camera with photos, you need to get them off the camera and out into the world. Chapters in this part of the book show you how.

✔ Chapter 8 introduces you to some common picture-playback options and then explains the process of transferring pictures to your computer.

✔ Chapter 9 provides a thorough review of your printing options, including information about different types of photo printers, and provides advice to help you get the best prints from your digital originals.

✔ Chapter 10 looks at ways to display and distribute images electronically — placing them on web pages and attaching them to e-mail messages, for example.

Part V: The Part of Tens

In the time-honored *For Dummies* tradition, information in this part is presented in easily digestible, bite-sized nuggets.

✔ Chapter 11 lists ten great websites where you can find equipment reviews, chat with other digital photographers, and more.

✔ Chapter 12 describes ten critical steps you should take to protect and maintain your gear — and also offers advice about what to do if disaster strikes.

Appendix

As you probably have already discovered, the digital photography world is very fond of jargon. Terms and acronyms you need to know are explained throughout the book, but if you need a quick reminder of what a certain word means, head for the Appendix, where you'll find a glossary that translates geek-speak to everyday language.

Icons and Other Conventions Used in This Book

Like other books in the *For Dummies* series, this book uses icons to flag especially important information. Here's a quick guide to the icons used in *Digital Photography For Dummies:*

This icon represents information that you should commit to memory. Doing so can make your life easier and less stressful.

Text marked with this icon breaks technical gobbledygook down into plain English. In many cases, you really don't need to know this stuff, but boy, will you sound impressive if you repeat it at a party.

The Tip icon points you to shortcuts that help you avoid doing more work than necessary. This icon also highlights ideas for creating better pictures and working around common digital photography problems.

When you see this icon, pay attention — danger is on the horizon. Read the text next to a Warning icon to keep yourself out of trouble and to find out how to fix things if you leaped before you looked.

In addition to icons, *Digital Photography For Dummies* follows a few other conventions. When I'm discussing tasks you do on the computer, I indicate commands that you need to choose from program menus by listing the menu name followed by an arrow and then the command name. For example, if you need to choose the Print command from the File menu, you see this instruction: Choose File➪Print.

Sometimes, you can choose a command more quickly by pressing keys on your keyboard than by clicking through menus. These keyboard shortcuts are presented like so: Press Ctrl+A. This simply means press the Ctrl key and the A key at the same time, and then let up on both keys. When shortcuts differ depending on whether you're a Windows or Mac user, the PC shortcut appears first, followed by the Mac shortcut.

What Do I Read First?

The answer depends on you. You can start with Chapter 1 and read straight through to the index, if you like. Or you can flip to whatever section of the book interests you most and start there.

Digital Photography For Dummies is designed so that you can grasp the content in any chapter without having to read the chapters that came before it. So if you need information on a particular topic, you can get in and out as quickly as possible.

The one thing this book isn't designed to do, however, is insert its contents magically into your head. You can't just put the book on your desk or under your pillow and expect to acquire the information by osmosis — you have to put eyes to page and do some actual reading.

With our hectic lives, finding the time and energy to read is always easier said than done, but if you spend just a few minutes a day with this book, you can increase your digital photography skills tenfold. Heck, maybe even elevenfold or twelvefold. Suffice it to say that you'll soon be able to capture any subject, from a newborn baby to an urban landscape, like a pro — and have a lot of fun along the way.

Occasionally, we have updates to our technology books. If this book does have technical updates, they will be posted at www.dummies.com/go/digitalphotographyfd7updates.

Part I
Gearing Up

The past few years have seen an explosion of new digital photography tools — new cameras, new software, tons of gadgets and accessories, and gaggles of features, all coming at you like a tidal wave of technology. And that can be pretty darned intimidating, even for professional photographers. What's a regular person to do? Read this part of the book; that's what.

Chapter 1 helps you determine what camera features you need for the type of photography you'd like to pursue, and Chapter 2 introduces you to some accessories that can make your photography easier, more fun, or both. As you no doubt already know, there's a considerable amount to ponder before you head to the checkout lane, but these two chapters should help you sort everything out.

Choosing Your First (Or Next) Digital Camera

*P*erhaps you picked up this book because you're finally ready to part with your film camera and join the digital photography ranks. Or, if you're like a lot of people, you might be considering selling your first (or even second or third) digital camera on Craigslist and treating yourself to a new model. Either way, the news is all good: Today's digital cameras offer an amazing array of features and top-notch picture quality at prices below what you would have paid even a year ago.

Because there are so many great cameras out there, however, it can be tough figuring out which one is best suited to your needs. To help you make the right decision, this chapter reviews your options, starting with a look at the basic types of digital cameras and then offering my take on which features make a real impact on your pictures and which ones are less important. Toward the end of the chapter, you'll find some questions that will help you decide if it's time to move on to your next camera and, if so, pointers on how to get the most for your money.

Choosing a Basic Camera Type

Your first step in finding the perfect camera is to choose from two basic types of cameras:

✔ **Interchangeable lens cameras:** Cameras in this category comprise two separate components: the camera body, which contains the guts of the picture-taking system, and a lens that you mount on the body. The beauty of these cameras is that you can swap out lenses at any time depending on how you want to capture your subject. For example, you can put on a wide-angle lens to capture a large mountain vista and then switch to a macro lens to get a close-up shot of a wildflower.

Most interchangeable lens cameras fall into one of two camps: dSLR *(digital single-lens reflex)* cameras like the Nikon model shown on the left in Figure 1-1, and *mirrorless compact system* cameras like the Panasonic Lumix model shown on the right. You can also buy a third type of interchangeable lens camera, a *rangefinder,* but at present, there are few digital rangefinders available — and only at a high price.

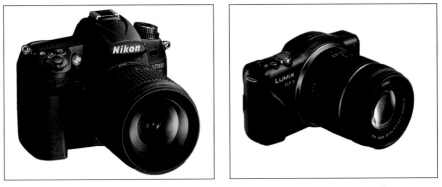

Nikon USA *Panasonic*

Figure 1-1: Most interchangeable lens cameras fall into these categories: dSLR (left) and compact system cameras (right).

✔ **Fixed lens cameras:** By *fixed lens,* I mean a lens that's permanently paired with the camera body. Cameras in this category include point-and-shoot compacts and "gadget cams" — the tiny cameras built into cellphones and multimedia devices such as Apple's iPod touch.

Just because you can't change lenses doesn't necessarily limit you to one angle of view: Many point-and-shoot cameras have zoom lenses that reach from wide-angle to telephoto views, so you still enjoy lots of picture-taking flexibility. Some gadget cams also enable you to zoom in and out on your subject.

Technically, there is one other option for going digital: If you own a medium- or large-format film camera, you can attach a *digital back,* a device that enables you to output digital images rather than film negatives. (*Medium-* and *large-format* cameras use film that's larger and differently proportioned than the 35mm film used in most film cameras.) Because digital backs are hugely expensive — we're talking $8,000 and up — and aimed at a small segment of the advanced photographer market, I assume that most readers of this book aren't interested in them, so this is the last I mention them.

For help deciding which of the other types of cameras will work best for you, check out the next few sections, which detail the pros and cons of each.

dSLRs: Not just for pros anymore

First things first: What the heck does *dSLR* mean, anyway? Well, the *d* stands for *digital,* distinguishing this type of camera from a film SLR. And *SLR* stands for *single-lens reflex,* referring to the viewfinder system used in these cameras: Light comes through the lens and is *reflected* to the viewfinder via a series of mirrors. The section "Considering viewfinder options," later in this chapter, provides an illustration and more details, if you're interested.

Once upon a time, dSLRs were strictly a pro's game. They were expensive, complicated, and bulky. But now manufacturers offer "starter" dSLRs that are smaller, lighter, and less costly than pro-oriented models. In addition to their smaller form factor, entry-level dSLRs also include features to help the novice use the camera, such as automated exposure modes.

Although most pros use dSLR cameras, that doesn't mean the technology is right for you, even if you're a serious photography enthusiast. So consider the pros and cons before you buy:

 ✔ **Pros:** On the upside, a dSLR brings you these benefits:

 • *Lens flexibility:* Your choice of lenses is virtually unlimited — you just need to make sure to buy a lens compatible with the lens mount on your camera. For example, for a Canon camera, you need a lens that fits a Canon lens mount.

 The major dSLR camera manufacturers offer lenses designed specifically to work with their dSLRs; Figure 1-2 shows a smorgasbord of lenses from Canon, for example. But you can also find great third-party lenses, although in some cases you may need to buy an adapter to mount them to your camera.

 Do note that some lenses may not be compatible with all features on every dSLR. For example, some Nikon dSLRs don't have an auto-focus motor built into the camera, so to autofocus, you must buy a lens that has an autofocusing (AF) system. You can still take pictures with a non-AF lens — you just have to focus manually.

Check the camera manual for a list of which lenses can take advantage of all the camera's features.

- *Superb image quality:* You can expect top-notch image quality from a dSLR, especially when compared with inexpensive point-and-shoot models and gadget cams. One reason is that dSLRs use larger image sensors —that's the part of the camera on which the image is formed. And as a general rule, the larger the sensor, the better the image quality. See the section "Assessing sensor size," later in this chapter, for an explanation. Lenses for dSLRs also tend to be of high quality, which also impacts picture quality.

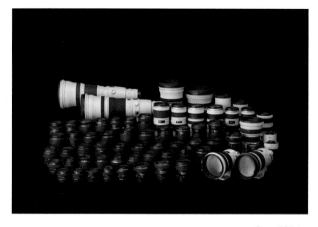

Canon U.S.A. Inc.

Figure 1-2: You can pair a dSLR with a vast array of lenses.

- *Advanced controls:* dSLRs offer features that give you precise control over exposure, focus, color, and other aspects of your picture. As just one example, Figure 1-3 offers an illustration of the 39-point autofocusing system found on some Nikon models. You can enable all the points, a cluster of points, or a single point, giving you ultimate control over how the camera finds its focusing target.

- *Convenience features:* As shown in Figure 1-4, dSLRs are covered with external knobs, buttons, and dials so that you can adjust picture settings quickly, without having to dig through menus. And you typically have access to lots of other time- and work-saving features, too. For example, some cameras let you store your favorite picture-taking settings as custom exposure modes so that you can easily switch from settings you prefer for, say, portraits to those you like for shooting sports.

✔ **Cons:** Like most things in life, dSLRs also have some downsides:

- *Cost:* dSLRs are expensive; expect to pay $400 and up for the body plus additional dollars for lenses. (The section "Looking at lenses," a little later in this chapter, offers some pointers on choosing lenses.)

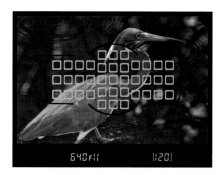

- *Size and weight:* Even the smallest models can be cumbersome to carry around, making it more likely that you'll leave your camera home instead of carting it

Figure 1-3: dSLRs typically feature advanced autofocusing controls, such as this 39-point, customizable focusing system found on some Nikon models.

to that birthday party or baseball game. If you have back, neck, or shoulder problems, consider whether you really want to hang several pounds of camera and lens around your neck — the joy of photography dissipates pretty quickly when you're hurting.

- *Learning curve:* Finally, dSLRs can be intimidating to novice photographers. Figuring out which button to press to activate each feature takes some time, and even deciphering the information shown on the camera settings screen isn't easy, as illustrated by the one shown on the left in Figure 1-4.

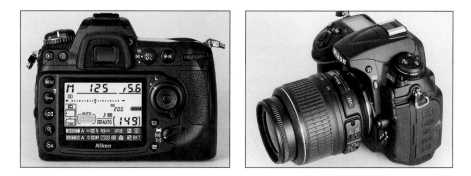

Figure 1-4: An array of external controls enables you to adjust picture settings more quickly than by using menus.

If you're new to SLR photography, your best bet is to check out entry-level or intermediate models, which offer automated shooting and other ease-of-use features not found on high-end models. A good book doesn't hurt either — and hey, what do you know, I happen to have written *For Dummies* guidebooks to Nikon and Canon dSLRs. (End of shameless plug.)

If you decide that a dSLR is for you, the upcoming section "Getting Specific: What Features Do You Need?" offers a review of critical camera options to help you pick just the right model.

Mirrorless compact system cameras

If the idea of being able to shoot with different lenses appeals to you but you're put off by the size and weight of a dSLR, a *mirrorless compact system camera* may be the perfect solution.

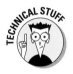

About the terminology: *Mirrorless* refers to the fact that this type of camera lacks the mirror-based viewfinder system used in a dSLR. Without the mirror assembly, the camera body can be significantly smaller and lighter than a dSLR — thus, *compact*. And yet like a dSLR, these models enable you to use a variety of lenses, building a camera and lens *system,* if you will. You also may hear this type of camera referred to as a mirrorless interchangeable lens, or IL, camera.

Whatever you call them, the most common cameras in this category at present follow the Micro Four Thirds design. Figure 1-5 offers an example in the Olympus PEN lineup of Micro Four Thirds models along with a look at an assortment of lenses designed for this type of camera.

Olympus America

Figure 1-5: Micro Four Thirds models are so named because of their size and the fact that they capture images with a 4:3 aspect ratio.

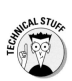

Four Thirds is the name given to a camera design that was developed jointly by several manufacturers who wanted to create a dSLR built from the ground up to be a digital creature rather than modeled after a traditional film SLR. Four Thirds cameras create images with an aspect ratio of 4:3 (hence, the name), the same as most computer monitors in the days before wide-screen displays became popular. Standard dSLRs, on the other hand, produce 3:2 images, the same as 35mm film. When mirrorless Four Thirds cameras were introduced, they got the *Micro* tag because of their smaller body size.

Not all mirrorless interchangeable lens cameras follow the Micro Four Thirds design standard, however. Sony's NEX series of cameras and Nikon 1 system cameras capture 3:2 format images, the same as 35mm film.

Which is best — 4:3 or 3:2? Well, there's no magic to either aspect ratio. But 3:2 originals translate perfectly to a 4 x 6 print, while a 4:3 image must be cropped to fit. Mind you, you also need to crop 3:2 originals to print them at other frame sizes — 5 x 7, 8 x 10, and so on. And many cameras enable you to choose from several aspect ratios for your pictures or to crop them to a certain proportion using in-camera editing tools. Just understand that if you want to take advantage of the entire image sensor and all the pixels on it — to achieve the maximum image resolution, in other words — you have to shoot in the camera's native (normal) aspect ratio. For more on this topic, see the sections "Understanding resolution" and "Assessing sensor size," later in this chapter.

Regardless of picture aspect ratio, the pros and cons of compact system cameras are the same:

- ✔ **Pros:** First, the upside:

 - *Size:* The compact size gets a definite thumbs-up from photographers (including me) who find that a few hours with a dSLR hanging from the neck is, well, a pain in the neck. And although not small enough to fit in a shirt pocket, mirrorless models tuck pretty easily into a large handbag or briefcase, which is a claim that even the smallest dSLR can't make.

 - *Lens flexibility:* You can use a variety of lenses, just as with a dSLR. Even better, some lenses built specifically for mirrorless models retract in when not in use, making the camera even more compact. Figure 1-6 shows an Olympus lens in its extended and retracted position.

 - *Both beginner and advanced features:* Because these cameras are aimed at the enthusiast photographer, they offer the same advanced options as on a dSLR, including both automatic and manual control over exposure, focus, and color. But the novice isn't left completely adrift, as most models also provide the same type of automated-shooting features and onscreen guidance found in entry-level dSLRs and most point-and-shoot cameras.

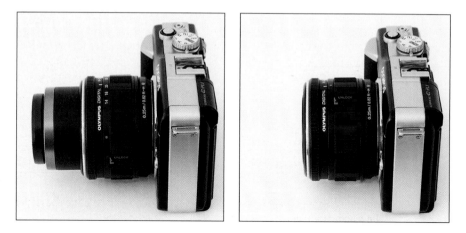

Figure 1-6: Some compact system camera lenses retract when not in use for greater portability.

✔ **Cons:** Even with all these advantages, there are a few downsides to consider:

• *Cost:* As with a dSLR, you have to factor in the cost of both the body and lenses into your purchasing plan. As I write this, prices for the camera body start at about $300; a body and basic lens begin at about $400.

• *You may need to buy a viewfinder:* Most compact system cameras have no built-in viewfinders — remember, it's the lack of the SLR viewfinder mirror assembly that enables compact system cameras to be so small.

With no onboard viewfinder, you're left with two choices for framing your shots. You can use the monitor to compose images, as illustrated on the left in Figure 1-7, but that option presents some challenges. Even the best monitors can be difficult to see in bright sunlight, and you have to hold the camera out in front of you to take a picture, increasing the chance of *camera shake* — small camera movements during the exposure that can blur the image.

Fortunately, most models let you attach an *electronic viewfinder,* or EVF, as shown on the right in Figure 1-7. And a few models have a built-in EVF. Either way, the electronic viewfinder displays everything that normally would appear on the monitor: the live view of the scene in front of the lens, menus, and, in playback mode, the pictures you've already taken. In some cases, you can rotate the EVF to suit the viewing angle you need, as shown here.

A few models include the electronic viewfinder in the camera price, but in most cases, you'll pay extra — as much as $200 extra, in fact. Still, if you go mirrorless, I recommend this accessory for full enjoyment of your camera.

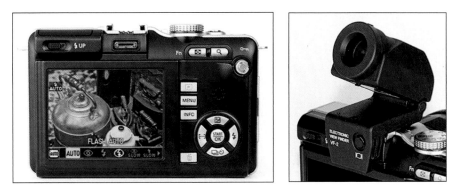

Figure 1-7: Some compact system cameras give you the option of composing images using the monitor (left) or attaching an electronic viewfinder (right).

- *Feature accessibility:* Because of their diminutive size, these cameras tend to provide most picture-taking features via menus rather than by external knobs or dials — there simply isn't a lot of landscape on which to put external controls. Digging through menus can be a time-consuming way to change picture settings, so if you're someone who really likes to play with settings between shots, experiment with a model you're considering to make sure that the menu-driven operation won't bug you too much.

- *Autofocusing and continuous capture speed:* One major complaint about the first generation of compact system cameras is that they were slow in the autofocusing department. The whys and wherefores aren't important; the critical point is that with the latest models, autofocusing speed is greatly improved.

 Where many compact system cameras still lag behind dSLRs is in the area of continuous capture, or *burst mode* photography. This feature enables you to record a continuous series of frames as long as you hold down the shutter button, which is extremely beneficial for shooting action. At least with current mirrorless models, the frames-per-second rate typically isn't quite as fast as what you can enjoy on a top-flight dSLR. The capture rate varies from model to model, and some of the newest models offer burst capture rates to rival dSLRs, so check this specification when you shop.

For more help deciding which model is your best buy, dive into the section "Getting Specific: What Features Do You Need?" later in this chapter. Or for a look at yet another interchangeable lens option, rangefinder cameras, move on to the next section.

Rangefinders

Figure 1-8 gives you a look at this type of camera. At first glance, rangefinders look a lot like compact system cameras — they're both small and lightweight, and both can accept a variety of lenses. But the two types of cameras work very differently.

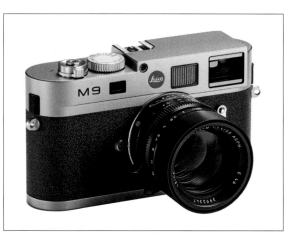

Leica Camera

Figure 1-8: Leica is currently the only manufacturer of digital rangefinder cameras.

The term *rangefinder* refers to the focusing system used on this type of camera: In the viewfinder, you see two slightly separate views of your subject. You determine the focusing distance, or *range,* by turning the focus ring on the lens until those two images are in perfect alignment.

Although rangefinders were common in the early days of film photography, they're a rare breed in the digital world. In fact, as I write this, only a couple rangefinders are on the market, all offered by Leica.

Where are the EVIL cameras, please?

As of yet, the camera industry hasn't settled on a specific label for mirrorless interchangeable lens cameras like the Olympus PEN and Panasonic Lumix models. The acronyms CSC *(compact system camera),* MIL *(mirrorless interchangeable lens),* IL *(interchangeable lens),* and EVIL *(electronic viewfinder interchangeable lens)* are all used to refer to this technology.

In this book, I go with *compact system camera.* To me, MIL and IL are too nebulous because a rangefinder also has no mirror and accepts multiple lenses, and EVIL is inaccurate because not all mirrorless models come with or can accept an electronic viewfinder — a fact that manufacturers like to stress in their very understandable campaign to rule out this term. All that said, I admit that I am amused by the prospect of customers walking into the local Buy Stuff store and asking to see the EVIL cameras.

Why so rare? Well, rangefinder technology has some complications that cause most consumers to rule it out. First off, there's that focusing system: Rangefinders have no autofocusing — you can only focus manually, using the technique just discussed. Nor will you find many of the features that draw consumers to other types of digital cameras, including movie recording, scene modes, or even fully automatic exposure modes.

In addition, rangefinders don't have through-the-lens viewfinders; instead, the viewfinder is set above and to the side of the lens. That means that what the viewfinder shows you is slightly different from what the lens is seeing. With practice, you can learn to compensate for this *parallax error* when framing your images, however. (The same issue arises for most point-and-shoot cameras, by the way.)

To sum up, a rangefinder isn't geared to the typical consumer; these cameras are built for experienced, serious photographers. And if the rangefinder design isn't enough to convince you, the price tag may: Prices for the body only start at about $7,000. But if you know what you're doing behind the lens and money isn't an issue, you may fall in love with a rangefinder, not just for its cool looks but also because the rangefinder bodies and lenses currently on the market are engineered to provide superb image quality.

Fixed-lens, point-and-shoot cameras

Point-and-shoot cameras like the Canon models shown in Figure 1-9 comprise the largest category of digital cameras: compact models that have a single, fixed lens. They come in a range of sizes and also vary in their feature sets.

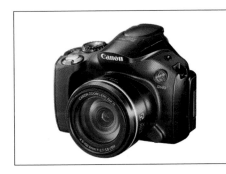 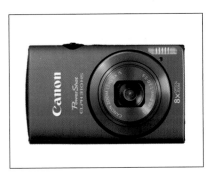

Canon Canon

Figure 1-9: Point-and-shoot cameras come in many sizes, styles, and price ranges.

The name *point-and-shoot* stems from the fact that these cameras are aimed at beginners and so offer automatic settings that enable the novice to, well, point and shoot. Yet I almost hesitate to use the term because many models in this category also offer advanced features that photography enthusiasts enjoy.

Fixed lens also may need some tweaking — because although you can't swap out lenses on these cameras, you're not necessarily limited to a single, fixed focal length. (*Focal length* refers to the angle of view that a lens can capture; see "Looking at lenses," later in this chapter, for details.) Many point-and-shoot models sport zoom lenses that cover a wide range of focal lengths, so you can take everything from close-ups to telephoto shots with a single lens.

Of course, like just about everything in life, point-and-shoot cameras have positive and negative features:

- **Pros:** In the plus column, point-and-shoots offer the following:

 - *Small size and weight:* Even the largest point-and-shoot weighs very little and can be carried easily in a handbag or briefcase. Some are even small enough to tuck into a shirt pocket, and that small size translates to a camera that you're more likely to carry with you to casual events than a dSLR or even a compact system or range-finder model.

 - *Simplicity:* Again, because these models are aimed at the novice, you find lots of automated settings, such as scene modes that make it easy to capture better portraits, sports shots, and other specific types of images. Some models even offer onscreen guidance to walk you through the process of taking a certain type of shot.

 - *Price:* You can buy a bare-bones point-and-shoot model for under $100 (although more advanced models can sell for hundreds of dollars more).

 - *Advanced features (some models):* With higher-end point-and-shoots, you get many of the same advanced controls over exposure, focus, and color as you find on the other types of cameras already discussed. So point-and-shoot doesn't necessarily mean that your photography options are limited.

- **Cons:** And now for the Debbie Downer commentary:

 - *Varying image quality and performance:* Read reviews carefully before you buy, because the quality of the images produced by point-and-shoot models ranges from excellent to, er, not so much. Focusing speed also depends on the specific model, as does the shot-to-shot lag time — how long you must wait after taking one shot before you can take another.

 - *Viewfinder issues:* Many point-and-shoots don't offer a viewfinder, meaning that you must compose shots using the monitor. As

already stated, that increases the risk of camera shake because you have to hold the camera out in front of you to take the shot. (Use a tripod to eliminate the problem.) Additionally, most monitors wash out in bright sunlight, making composing outdoor shots difficult. Be sure to take a camera you're considering outside for a test shot to see how well the monitor performs in bright light.

Cameras that do offer viewfinders use the same second-lens technology as rangefinders: The viewfinder is actually a small lens set above and to the side of the lens, so you don't get a completely accurate preview of your image. (See "Considering viewfinder options" for more insights about viewfinder technology.)

- *Fixed lenses:* Remember that you can't swap out the lens on a point-and-shoot camera, so be sure that the model you pick has the right focal length for the type of pictures you want to shoot. If you like to photograph at the zoo, for example, you want a camera that has a long focal length or a zoom lens that reaches to the telephoto range. See "Looking at lenses" for more tips on this issue.

A few models do enable you to attach optional lens modifiers. You may be able to add a modifier that enables the lens to produce a wide-angle or fisheye view, for example. But these attachments tend to be pricey, so you may be better off sticking with a compact system camera or a dSLR if you like to use different types of lenses.

- *Cumbersome controls:* Most picture-taking settings are accessed via menus rather than external controls, both because there isn't a lot of real estate on the smaller point-and-shoot camera body and because manufacturers don't want to confuse beginners with lots of buttons and switches. So although a top-end point-and-shoot may offer the same feature set as an entry-level dSLR or mirrorless model, using those features often involves navigating a maze of menu options.

Especially difficult is focusing manually on cameras that offer that option: Instead of simply twisting a focusing ring on the lens, you have to pull up a menu option and then specify the exact distance between the camera and the subject.

Check out the later section "Getting Specific: What Features Do You Need?" for my take on other features that will help you narrow your choices if you opt for a point-and-shoot camera.

Gadget cams

If you carry a cellphone or MP3 player, it probably has a built-in digital camera. Ditto for portable tablet computers such as the Apple iPad and for most laptop computers. The question is, do you really need a standalone digital camera, or will the one on your portable device serve you just as well?

Let's strike tablet and laptop cameras off the list right off the bat — even with a small tablet, using the built-in camera for anything other than web chats is cumbersome, to say the least. That leaves cellphone cameras and cameras built into multimedia players such as the Apple iPod touch.

Although these gadget cams beat out even the smallest dedicated camera in terms of size and portability, they don't provide an adequate substitute for a "real" camera, even if all you want to do is just take great snapshots of your vacations, family events, and other daily activities. First, consider picture quality. Although some gadget cams offer lots of *megapixels* — that's the specification that determines how large you can print a picture — those pixels are clustered on a very tiny sensor, which translates to lesser image quality. And picture quality is hampered even more by the fact that the lenses are small and tend to be of low quality. Additionally, gadget cams either lack a flash or have a very tiny, harsh flash that produces ugly lighting and red-eye.

As for the ability to precisely control exposure, color, and focus, forget it. You may find a few options that allow you to play with those characteristics, but nowhere near the number of features available on dedicated cameras. And most gadget cam monitors fade out drastically in the sunlight, making it next to impossible to see what you're shooting.

All of this is not to say that gadget cams don't have their place. They're great for shooting quick pics whose purpose is to simply transmit information. For example, you can snap an image of your bedroom to take with you to the furniture store so that you can show the designer what pieces you need to work around.

You can also create some pretty cool images by transforming your gadget-cam originals with photo-effects applications — *apps,* in cool-kid lingo. For example, you can find apps that give your photo a watercolor look, apply psychedelic color effects, create the look of an antique photo, and countless others. A whole app industry has evolved around creating photo apps for the iPhone, in fact.

All of this is not to discourage you from using your gadget cam. But because I think that most people who buy this book are primarily interested in using dedicated digital cameras, I aim the discussion in this book toward those models, although the general concepts of photography apply no matter what type of camera you use. If you want to delve more into the phone and gadget-cam imagery, you may want to pick up a book that specifically covers the subject. If you have an Apple iPhone, one to try is *iPhone Photography & Video For Dummies,* by Angelo Micheletti.

Getting Specific: What Features Do You Need?

After deciding which type of camera suits you, start comparing features to narrow the field to a specific model. The next several sections explain the most important features.

Understanding resolution

Resolution refers to a camera's pixel count. *Pixels* are the tiny points on your camera's image sensor that absorb light and turn it into a digital photo. Today, the pixel count of new cameras is so high that resolution is stated in *megapixels (MP),* with 1 megapixel equal to 1 million pixels. You may also see pixel count stated as the number of horizontal pixels by vertical pixels, as in 3000 x 2000. You get the total megapixel count by multiplying those two values and dividing the result by 1 million. For example, 3000 x 2000 pixels equals 6 million pixels, for 6 megapixels.

Chapter 4 explains resolution thoroughly, but for the purpose of camera shopping, all you need to know is that the higher the pixel count, the larger you can print your pictures without lowering image quality. The following list offers general guidelines on how many megapixels you need to produce prints at standard sizes:

- **4 x 6 inches:** 1 MP
- **5 x 7 inches:** 1.5 MP
- **8 x 10 inches:** 3 MP
- **11 x 14 inches:** 6 MP

With the exception of gadget cams, all new digital cameras offer at least 6 megapixels. So given that 6 megapixels translate to an 11 x 14-inch print — a size that most of us don't produce on a regular basis — should you pay more for a camera that offers an even higher resolution — 10, 12, even 24 megapixels?

It depends. Having a monster megapixel count makes sense for photographers who regularly crop their photos and then make large prints of the cropped image. As an example, see Figure 1-10. When I photographed this scene, the subject was far enough away that even with my telephoto lens, the closest framing I could accomplish was the shot you see on the left. It contains way too much extraneous background, distracting the eye from the subject. So after downloading the picture, I cropped it to the much better composition shown on the right. Had this photo been taken with a low-resolution camera, the cropped area wouldn't have contained enough pixels to generate a good print at anything but a very small size. But because the

image originally contained about 10 megapixels, the cropped area retains the necessary pixels for a good print — in fact, it could be printed even larger than space permits here.

Figure 1-10: A high-resolution camera enables you to crop and enlarge your photos without picture quality loss.

If you usually stick with snapshot-size prints or don't crop your photos much, though, having oodles of pixels is just a waste of money. It also makes storing your digital files harder than it needs to be because more pixels means larger digital files, meaning that you run out of space on your camera memory card and computer hard drive faster.

The same advice applies if you don't print your photos but instead just share them online. For reasons you can explore in Chapter 10, you need very few pixels to display an image at a large size onscreen. For example, the image in Figure 1-11 measures just 480 x 320 pixels; and as you can see, it consumes a large portion of the display area.

Long story short: Don't let an overeager salesperson convince you that more is better when it comes to pixels — just get enough pixels to cover your print needs. If you plan on both printing your photos and sharing them online, concentrate on how many pixels are appropriate for print use, knowing that if you have enough for that purpose, your online needs are more than covered. (See Chapter 10 to find out how to trim the pixel count of your original images to make them suitable for online use.)

Figure 1-11: Low-resolution images are fine for online sharing; the large photo on this web page has just 480 x 320 pixels.

Assessing sensor size

Just as important as the pixels in a digital camera are the size and shape of the *image sensor,* which is the part of the camera that houses all those pixels. Figure 1-12 offers a look at a sensor used in some Nikon dSLR models.

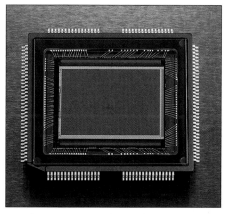

Nikon USA

Figure 1-12: The image sensor is the heart of the digital camera's electronics.

All other things being equal, a smaller sensor produces lower image quality than a large sensor. That's because when you cram tons of pixels into a small area, you increase the chances of electronic noise that can degrade the picture. Now you know one reason why the pictures from a 6-megapixel phone camera can't compare with

images from a dSLR with the same pixel count. Of course, larger sensors cost more to manufacture, which affects the price of the camera.

You can find out the size of a camera's sensor by looking at the manufacturer's spec sheet. Also be aware of the following terms that are sometimes used to indicate sensor size:

- **Full frame:** The sensor is the same size as a 35mm film negative.

- **APS-C** *(advanced photo system-type C)***:** This is a smaller-than-full frame sensor but with the same 3:2 proportions as a 35mm negative.

- **Four Thirds:** This is also smaller than full frame and with a 4:3 aspect ratio.

Looking at lenses

Also important to your long-term satisfaction with a camera are the type and quality of its lens and its related bits and pieces. When comparing cameras or shopping for lenses for an interchangeable lens camera, consider these factors:

- **Optical quality:** Without getting into technical details, the quality of the image that a lens can capture depends on both its material and manufacture. To get an idea of the difference that optical quality can make, just imagine the view that you get when looking through sunglasses that have cheap, plastic lenses versus pristine, real-glass lenses.

 Optical quality has improved significantly over the past several years, especially among point-and-shoot cameras. Many models now sport lenses that are made from professional-quality materials and offer powerful optical zoom capabilities. Unfortunately, it's tough to evaluate a camera's optical quality; it's not something you can judge just by playing around with a few models in the store. So again, your best bet is to study reviews in camera magazines and at online photography sites, where optics are tested according to rigorous technical standards.

- **Focal length:** The focal length of a lens, stated in millimeters, determines the angle of view that the camera can capture and the spatial relationship of objects in the frame. Focal length also affects *depth of field,* or the distance over which focus remains sharp.

 You can loosely categorize lenses according to the following groups:

 - *Wide-angle:* Lenses with short focal lengths — generally, anything under 35mm — are known as *wide-angle lenses.* A wide-angle lens has the visual effect of pushing the subject away from you and making it appear smaller. As a result, you can fit more of the scene

into the frame without moving back. Additionally, a wide-angle lens has a large depth of field so that the zone of sharp focus extends a greater distance. All these characteristics make wide-angle lenses ideal for landscape photography.

- *Telephoto:* Lenses with focal lengths longer than about 70mm are called *telephoto* lenses. These lenses seem to bring the subject closer to you, increase the subject's size in the frame, and produce a short depth of field, so that the subject is sharply focused but distant objects are blurry. Telephoto lenses are great for capturing wildlife and other subjects that don't permit up-close shooting.

- *Normal:* A focal length in the neighborhood of 35mm to 70mm is considered "normal" — that is, somewhere between a wide-angle and telephoto. This focal length produces the angle of view and depth of field that are appropriate for the kinds of snapshots that most people take.

Figure 1-13 offers an illustration of the difference that focal length makes, showing the same scene captured at 42mm and 138mm. Of course, the illustration shows you just two of countless possibilities, and the question of which focal length best captures a scene depends on your creative goals. So you may want to visit a camera store, where you usually can find brochures that illustrate the types of shots you can capture at specific focal lengths. Some lens manufacturers offer similar illustrations on their web sites. Then just think about the subjects you usually shoot and match the lens focal length to your needs.

Also, check out Chapter 6 for a further explanation of how you can manipulate depth of field to achieve different creative results.

42mm 138mm

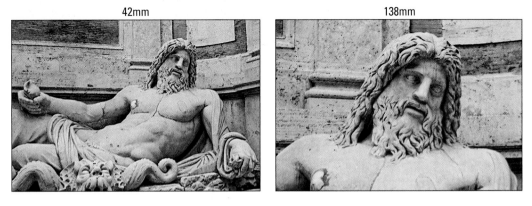

Figure 1-13: A short focal length captures a wide angle of view (left); a long focal length brings the subject closer (right).

✓ **Crop factor:** When you shop for a digital camera lens, you need to know that focal lengths are stated in terms of the results you would get if you put that lens on a camera body that uses 35mm film (that's the size you've probably been using in your film camera for years). But very few digital cameras have a so-called *full-frame sensor,* which is the same size as that 35mm film negative. Most sensors are smaller (because they're cheaper to manufacture), and because of that reduced size, the angle of view that any given focal length can capture is reduced when you put the lens on a digital body. The resulting picture is similar to what you would get if you took a picture with a 35mm film camera and then cropped the picture.

How much frame area you lose varies from camera to camera and is called the *crop factor.* Most dSLR image sensors have a crop factor ranging from 1.5 to 1.6, for example, and Four Thirds interchangeable lens models typically have a crop factor of 2. Figure 1-14 illustrates the image area at these crop factors when compared to the full-frame view.

1.5 crop factor

Full frame 2.0 crop factor 1.6 crop factor

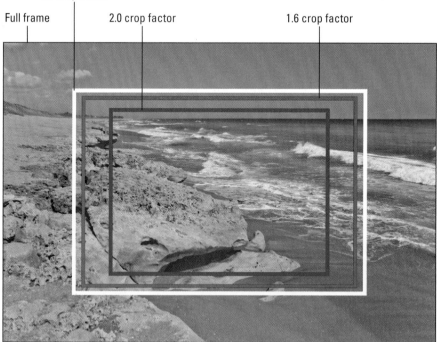

Figure 1-14: On a digital camera, the angle of view that can be recorded at any focal length depends on the camera's crop factor.

To figure out how a lens you're considering will perform, multiply the camera's crop factor by the lens focal length. For example, if the camera has a crop factor of 1.5, a 50mm lens gives you the same angle of view as a 75mm lens on a 35mm film camera.

If you opt for a point-and-shoot camera, you typically see a specification that gives both the actual focal length of the lens and the 35mm equivalent, as in "5mm lens, equivalent to 35mm lens on 35mm-format camera." In this case, "equivalent" refers to the angle of view of the lens.

✔ **Aperture range:** The *aperture* is an adjustable diaphragm in a lens. By adjusting the aperture size, the photographer can control the amount of light that enters through the lens and strikes the image sensor. The aperture setting also affects depth of field: A wide-open aperture produces a short depth of field; a narrow aperture, long depth of field.

Chapters 5 and 6 cover these issues in detail. For the purposes of lens shopping, you need to know just a few things.

- *Every lens has a specific range of aperture settings.* Obviously, the larger that range, the more control you have as a photographer. Note that some point-and-shoot camera lenses have just a couple of f-stop settings, which will frustrate serious photographers.

- *The larger the maximum aperture, the "faster" the lens.* Aperture settings are stated in *f-stops,* with a lower number meaning a larger aperture. For example, a setting of f/2 results in a more open aperture than f/4. And if you have one lens with a maximum aperture of f/2 and another with a maximum aperture of f/4, the f/2 lens is said to be *faster* because you can open the aperture wider, thereby allowing more light into the camera and permitting the image to be captured in less time. This not only benefits you in low-light situations but also when photographing action, which requires a fast shutter speed (short exposure time).

- *Depth of field at any aperture varies depending on the size of the image sensor and lens.* For technical reasons that I won't get into here, cameras with small sensors and lenses produce a much greater depth of field at any f-stop than cameras with larger sensors and lenses. The result is that it can be difficult to achieve much background blurring even if you open the aperture all the way. That's an important consideration if you're interested in the type of photography that benefits from a short depth of field, such as portraiture. On the other hand, if you're a landscape photographer, you may love the extended depth of field those smaller cameras produce.

- ✔ **Zoom power:** With a zoom lens, you get a range of focal lengths in one unit. For example, a lens might zoom from 18mm to 55mm. Do note that with a lens that offers a really large focal range — say, 18 to 200 — you tend to see some quality drop-off at certain points in the range because a lens can be engineered to optimal performance at only a single focal length. That said, one of my favorite lenses has a monster focal length range — 18 to 270mm — so here again, it pays to read reviews and shop carefully.

 When testing a point-and-shoot camera, make sure that the button or knob you use to manipulate the zoom is conveniently positioned and easy to use. On interchangeable lens cameras, you zoom by twisting the lens barrel, so this isn't an issue. However, you do want to watch out for so-called *lens creep:* Some zooms have a tendency to slide from one focal length to another, without any input from you, when you tilt the camera.

- ✔ **Optical versus digital zoom:** For zoom lenses on point-and-shoot cameras, another important factor to note is whether the lens offers an *optical* or *digital* zoom.

 - *Optical zoom:* This is a true zoom lens and produces the best picture quality.

 - *Digital zoom:* This is a software feature that simply crops and enlarges your image, just as you might do in a photo-editing program. Because you're then left with fewer original image pixels, the result is typically a reduction in image quality.

 You don't have to disregard cameras that have digital zoom; just don't think that it's a benefit to your photography, and if the camera offers both an optical and digital zoom, find out whether you can disable the digital part. Some cameras automatically shift into digital zoom mode when you reach the end of the optical zoom range and don't alert you to that change.

Considering viewfinder options

Some cameras lack a traditional viewfinder and instead force you to frame your shots using the LCD monitor. Manufacturers omit the viewfinder either to lower the cost of the camera or to allow a nontraditional camera design. But it can be difficult to go without a viewfinder because you have to hold the camera a few inches away to see the monitor. If your hands aren't that steady, taking a picture without moving the camera can be tricky. When looking through the viewfinder, however, you can brace the camera against your face. Additionally, monitors tend to wash out in bright light, making it hard to see what you're shooting.

Most, but not all, cameras aimed at photo enthusiasts do sport a viewfinder, fortunately. But not all viewfinders work the same way, and because this component plays a critical role in your camera use, it's worth understanding the differences. Here's a look at your options:

- **Mirror-and-pentaprism (dSLR) viewfinders:** In a dSLR, a tiny mirror sits in front of the *shutter,* the barrier that keeps light from hitting the image sensor until you press the shutter button. The mirror reflects the light coming through the lens onto a *pentaprism,* which is a multi-angled mirror that flips the reflected image to its proper orientation and then bounces it to the viewfinder, as illustrated in Figure 1-15. When you press the shutter button, the mirror flips up, the shutter opens, and the light passes through the lens to the film or sensor.

 This type of viewfinder is categorized as a *through-the-lens,* or TTL, viewfinder because the viewfinder shows you exactly what the lens is seeing.

- **Non-TTL (through-the-lens) viewfinders:** The problem with the mirror-and-pentaprism approach used by dSLR cameras is that the assembly that makes it possible adds to the size and weight of the camera. So rangefinders and most point-and-shoot cameras instead use a different setup: The viewfinder is set above and to the side of the lens, as illustrated in Figure 1-16.

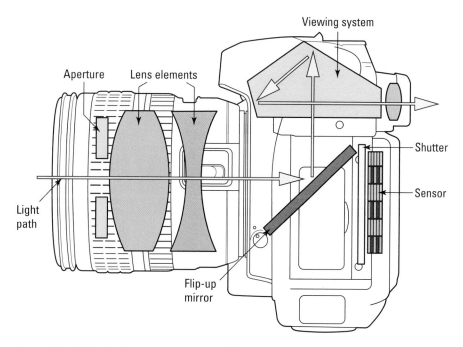

Figure 1-15: dSLR viewfinders use a system of mirrors to reflect the image onto the viewfinder.

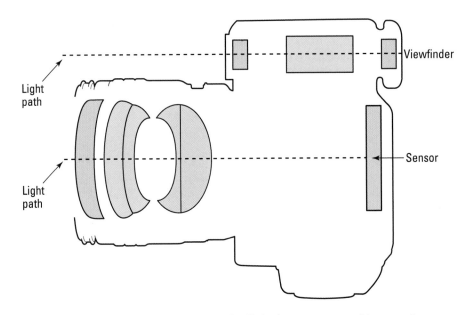

Figure 1-16: On most compact cameras, the viewfinder is a separate small lens set above and to the side of the main lens.

The disadvantage to this viewfinder setup is that it results in parallax error. Again, that simply means that because the viewfinder and lens have slightly different angles on the world, the viewfinder doesn't show you exactly what the lens will capture, making it difficult to precisely frame a photo. To help solve the problem, most cameras include framing marks in the viewfinder to guide you when composing images; when camera shopping, be sure the framing marks are easily visible. And note that not all viewfinders of this type are created equal — the amount of parallax error varies from camera to camera, so do your research.

✔ **Electronic viewfinder (EVF):** In the past few years, manufacturers found another way around the parallax problem with the development of *electronic viewfinders,* which is the type available for mirrorless interchangeable lens cameras and some point-and-shoot models. With an electronic viewfinder (EVF), the camera simply sends the live feed that's normally displayed on the camera monitor to the viewfinder, and because the monitor shows the same area as the lens, this viewfinder option offers the same improvement in accuracy that you get with the dSLR system. However, EVF displays vary in quality, so this is one component you should test in person. Some are amazingly crisp, looking like a high-def TV display, while others are grainy and blurry, making it difficult to compose your pictures precisely. Also, keep in mind that you usually can't see anything through the viewfinder until you turn the camera on, which means that you can't set up your shots without using up battery life.

While we're on the subject of viewfinders, make sure that you can easily make out the data displayed in the viewfinder. Especially for people who wear glasses, the readouts in some viewfinder displays are too small and dim to be easily read. You also want a viewfinder that can be adjusted to your eyesight; the control in question is called a *diopter adjustment*. See Chapter 3 for help using it, and see Chapter 2 for a look at a special pair of eyeglasses designed just for photographers who have viewfinder issues.

Finding a low-light performer

Through a digital-camera feature called ISO Sensitivity control, you can adjust the light sensitivity of the image sensor. These light-sensitivity settings are stated in *ISO numbers,* such as ISO 100, ISO 200, and so on. (ISO refers to the International Organization for Standardization, the group that developed the system.) The higher the ISO number, the more sensitive the camera is to light. That means that you can capture an image in dim lighting without flash, use a faster shutter speed, or use a smaller aperture. (Chapter 5 explains these last two controls and provides more details on the ISO setting.)

However, raising the ISO can also produce *noise,* a defect that gives your image a speckled look. Figure 1-17 offers an example. Noise also can be caused by long exposure times, which are sometimes necessary in low-light conditions whether you raise the ISO or not. Finally, low-quality image sensors sometimes create a little bit of noise because of the heat and electrical processes that occur when the camera is used.

Figure 1-17: Many a low-light shot suffers from noise, the speckly defect that mars this image.

Today's cameras are much less noisy than in years past, but noise can still be a problem with high ISO settings and very long exposures. Only a few, high-end cameras can be set to ISOs above 1600 without producing noise, for example. Some cameras start to exhibit noise at ISO 400, in fact.

Because noise levels vary from camera to camera, this is an important characteristic to study during your camera search. Camera reviews online and in photography magazines regularly include noise tests; see Chapter 11 for some of my favorite online resources.

Exploring make-it-easy features

You say you're not interested in becoming the next Annie Leibovitz or Ansel Adams? Relax. You can take great pictures without having to know a thing

about aperture, shutter speed, and all the other terms you hear your photographer friends toss about.

New digital cameras offer a variety of features designed to make getting great shots easier than ever; just look for the options explored in the next several sections when you shop.

Automatic scene modes

Scene modes are settings that automatically set your camera to shoot a specific type of picture. Most cameras now offer a standard handful of basic scene modes, offering settings designed to shoot action shots, portraits, close-ups, landscapes, and nighttime scenes. Typically, the major scene modes are represented by little icons, as shown on the left in Figure 1-18. But some cameras add many more scene modes, offering settings designed to cope with any number of settings, subjects, and lighting conditions, from shooting underwater to capturing children playing in snow. You usually access these modes via menu options, as shown on the right in the figure.

Figure 1-18: Scene modes automatically choose the right settings for portraits, landscapes, and other types of photos.

When evaluating cameras, pay attention not just to the number of scene modes, but also to how easily you can access them. Some cameras make you dig through layers of menus to access scene modes, and the more hassle that's required to get to a feature, the less likely you are to use it.

See Chapter 4 for more about scene modes, including why they don't always perform as well as you might hope.

Image stabilization

One common cause of blurry pictures is *camera shake.* That is, the camera moves during the period when the camera's shutter is open and light is

hitting the image sensor. The longer the exposure time, the longer you have to hold the camera still to avoid this type of blur. Camera shake is also more of a problem if you shoot with a telephoto lens, especially if it's one of the long, heavy types you can buy for a dSLR.

You can always avoid camera shake by mounting the camera on a tripod. But a feature called *image stabilization* can enable you to get sharper shots when you need to handhold the camera. The feature may go by different names depending on the manufacturer: *vibration reduction, anti-shake, vibration compensation,* and the like. Whatever the name, the feature is implemented in one of two ways:

- **Hardware-based stabilization:** With this method, sometimes called *optical image stabilization,* the anti-shake benefit is produced by a mechanism built into the camera or, in the case of some digital SLRs, the lens. This type of image stabilization is considered the best.

- **Software-based stabilization:** This type of stabilization, sometimes known as *electronic image stabilization,* or EIS, is applied by the camera's internal operating software rather than a hardware mechanism. It works differently depending on the camera. In some cases, the camera applies some complex correction filters to the image when motion is detected. Other cameras address camera shake by automatically increasing the ISO setting, which makes the camera more sensitive to light. At a higher ISO, you can use a faster shutter speed, which means that the length of time you need to hold the camera still is reduced. Unfortunately, a higher ISO often brings the unwanted side effect of image noise, as discussed earlier, in the section "Finding a low-light performer."

The payoff you get from image stabilization is another one of those features that is difficult to evaluate from merely playing with a camera for a few minutes in a store. In general, optical stabilization is better than software-based stabilization, but for specifics on how well the cameras you're considering perform in this arena, search out in-depth reviews.

Even the best possible stabilization system can't work miracles; you still need a tripod for very long exposures. But in most cases, you can expect to get a steady shot at shutter speeds one or two notches below what you can enjoy without stabilization.

In-camera Help systems

Many cameras now offer internal Help systems. If you can't remember what a particular button does, for example, you can press a button to see a screen that reminds you. Some cameras also offer hints to help you solve exposure problems or just capture a more compelling image, as illustrated by the screens shown in Figure 1-19, taken from an Olympus camera.

Taking the Help screen to a higher level, some cameras offer *guided* shooting modes. You choose a picture type from a menu, and then follow onscreen prompts that tell you what settings to choose to get the best results.

If you're a beginner, these built-in photography teachers can help get you up to speed more quickly. But even for experienced photographers, having these built-in guides can be handy when you don't have your camera manual close by and come across an unfamiliar feature.

Figure 1-19: Some cameras offer built-in photography guidance.

Smile/face/blink detection

Camera companies are always looking for new snazzy features to impress you — and just maybe make your photos even better. One of the newest is *face recognition*. This feature automatically detects and focuses on a subject's face as long as you're at a typical portrait-taking distance. This feature is great for taking photos of kids who squirm a lot when getting their picture taken. All you do is aim the camera at your portrait subjects, and focusing frames automatically appear around their faces, as shown in Figure 1-20.

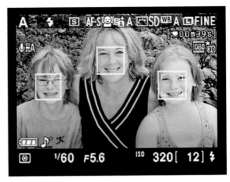

Figure 1-20: Face-recognition autofocusing systems make shooting portraits easier — as long as your subject is facing forward.

Taking face recognition one step further, a few companies have announced cameras capable of *smile* and *blink* detection. In this mode, the camera tracks a subject's face and then snaps the photo automatically when the person's eyes are open and smile is widest.

Of course, these features aren't foolproof; most face-recognition systems don't work unless your subject is facing forward, for example. And as for smile and blink technology, they do the trick only if everyone in the portrait displays wide smiles and bright eyes at the exact same moment. So the best way to ensure that you get a great portrait is to snap many different images of your subject. When you review your photos on the monitor, most cameras enable you to magnify the view so that you can double-check for open eyes and great smiles.

Stepping up to advanced features

Most digital cameras offer fully automatic everything, so you really can just "point and shoot." But if you're a photography enthusiast or ready to move out of automatic mode, look for the features outlined in the following sections.

Raw image capture

Most cameras capture images in the JPEG *(jay-pegg)* file format. *(File format* refers to the type of data file that's used to record the pictures you take.) But advanced cameras offer a second format called Camera Raw, or just Raw for short. Chapter 3 explains both formats completely, but the short story on Raw is that it offers benefits that appeal to pro photographers and serious photo enthusiasts. Suffice it to say, if you're in that category, look for a camera that can capture Raw files as well as JPEG files.

Advanced exposure controls

In order to get creative with exposure, you need a camera that gives you at least some control — and, hopefully, full control — over two critical settings: aperture (f-stop) and shutter speed. You can get a full briefing on how these two settings work in Chapter 5, but for now, just give points to cameras that offer the following options:

✔ **Aperture-priority autoexposure:** In this semi-automatic exposure mode, you select the aperture, or f-stop, and the camera then selects the shutter speed needed to produce a good exposure. Having control over aperture is important because the setting you use affects *depth of field,* or the distance over which objects in the scene appear in sharp focus. So if you're shooting a landscape, for example, you can choose to keep both near and far objects sharp, as shown on the left in Figure 1-21, or throw the background out of focus to bring more attention to the main subject, as shown on the right.

Timothy B. Holmes

Figure 1-21: With control over aperture, you can choose whether background objects appear sharp (left) or blurry (right).

- **Shutter-priority autoexposure:** In this mode, you select the shutter speed, and the camera selects the aperture setting needed to expose the picture properly. Because shutter speed determines whether moving objects appear blurry or "frozen" in place, gaining control over this exposure setting is especially important if you shoot lots of action pictures.

- **Exposure compensation:** Sometimes known as EV *(exposure value)* compensation, this setting enables you to tell the camera that you want a slightly darker or lighter picture than the autoexposure system thinks is appropriate.

- **Manual exposure:** In this mode, you can specify both aperture and shutter speed to precisely control exposure. Doing so isn't as hard as you may think by the way, because most cameras still guide you by displaying a meter that lets you know whether your picture will be properly exposed.

- **Metering mode options:** The *metering mode* tells the camera which part of the frame to consider when calculating exposure. The best cameras in this regard offer whole-frame metering, often called *pattern, matrix,* or *evaluative* metering; spot metering, which bases exposure on a small, selected area of the frame; and center-weighted metering, which considers the whole frame but puts more emphasis on the center. Really

advanced cameras even let you customize the size of the spot or center-weighted metering area.

✔ **Automatic exposure bracketing:** This feature automates the process of capturing the same scene at multiple exposure settings, which increases the odds that you'll get at least one exposure that you love.

✔ **Histogram displays:** A *histogram* is a chart that offers a graphical representation of the brightness values in an image. Many advanced cameras can display a histogram along with an image during picture playback. Experienced photographers use this tool to evaluate exposure rather than relying solely on the monitor, which may give an inaccurate impression depending on the light in which it's viewed. For a look at a histogram and a full explanation, see Chapter 8.

These controls are the most critical for photographers who want to manipulate exposure, but they're just the start of the multitude of exposure-related features found on today's high-end cameras. You can read about additional features and get the complete story on exposure in Chapter 5.

Advanced white-balance controls

Digital cameras use a process called *white balancing* to ensure accurate colors in any light source. In most cases, automatic white balancing works fine, but problems can occur when a scene is lit by multiple light sources — a classroom illuminated by a mix of window light and fluorescent light, for example. So having the ability to adjust color manually is helpful. Just a few feature names to look for:

✔ **Manual white balance modes:** Enable you to choose a white-balance setting designed for a specific light source, which can solve some color problems.

✔ **White-balance bracketing:** Records the shot three times, using a slightly different white-balance adjustment for each image.

✔ **White-balance shift (or correction):** Makes minor tweaks to the color adjustment that the camera applies for different light sources.

✔ **Custom white-balance presets:** Enable you to create and store your own white-balance setting. So if you have special photography lights that you use for studio shooting, for example, you can fine-tune the white-balance adjustment to those exact lights.

Chapter 6 fully explores white balance and other color issues.

Advanced flash features

If you do a lot of flash photography, look for a camera that offers the following features:

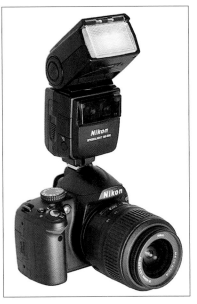

Figure 1-22: Cameras that have a hot shoe enable you to mount an external flash head.

✓ **Hot shoe or cable connection for external flash:** The built-in flash on most cameras produces harsh, direct lighting that often overpowers a subject. For best results, look for a camera that has a *hot shoe,* which is a connection on top of a camera for attaching an external flash head, as shown in Figure 1-22. As an alternative, some models can connect to a flash head via a cable — known as a *sync cord.* You can then attach the flash head to a bracket that positions the flash to the side of the camera or just hold the flash up by hand, depending on how you want to angle the light. (You often see wedding photographers using this type of setup.)

✓ **Control over when the flash fires:** On some point-and-shoot models, you can use flash only when the camera thinks additional light is needed. So look for a model that offers at least some exposure modes that let you dictate when the flash fires.

✓ **Flash exposure compensation:** This feature enables you to adjust the power of the flash. Usually, it allows you to tweak the output of both an onboard flash and an external flash head.

✓ **Flash recycle time and power usage:** If the flash on your current camera seems sluggish, you can probably enjoy a significant performance upgrade by investing in a new camera. Flashes on newer cameras also tend to have a faster recycle time — that is, they can recharge and be ready to shoot again more quickly — and use less battery power than in years past.

✓ **Commander mode:** Some flash units can be set to *commander mode,* which lets you use them to wirelessly trigger off-camera flashes. If your camera's flash can't perform this function, however, you can buy a separate commander unit that you attach to the camera's hot shoe.

See Chapter 5 for more about flash photography.

Getting the speed you need

Among both amateur and pro photographers, one of the most common complaints about digital cameras in years past was that they were slow: slow to come to life when you turned them on, slow to respond when you pressed the

shutter button, and slow to finish recording one image so that you could capture another. This sluggish behavior made capturing action shots extremely difficult.

Well, camera manufacturers heard the complaints and responded with a variety of technical changes that greatly reduced the problem. So if you've been frustrated with this aspect of your current camera, a new model will likely ease the pain. Most cameras now can keep up with the most demanding rapid-fire shooter, although again, you should read reviews carefully because cameras vary in this regard.

Along with faster start-up and image-recording times, many new cameras also offer some, if not all, of the following features to make speed shooting even easier:

✔ **Burst mode:** In this mode, sometimes called *continuous capture,* you can record multiple photos with one press of the shutter button, reducing the time needed to record a series of pictures. With higher-end cameras, you can capture several frames per second — the exact number varies from camera to camera. In Figure 1-23, for example, a burst speed of three frames per second captured five stages of the golfer's swing.

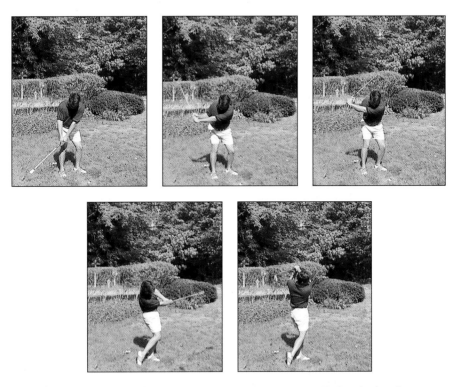

Figure 1-23: A capture setting of three frames per second broke a golfer's swing into five stages.

✔ **Shutter-priority autoexposure or manual exposure:** In both exposure modes, you can control the shutter speed, which is critical to determining whether a moving subject appears blurry. If you shoot a lot of action shots, this kind of shutter control is highly recommended. (See Chapter 5 for an explanation of shutter speed.)

✔ **Sports mode:** This mode enables even photography novices to capture action without having to learn all the ins and outs of shutter speed, ISO, and other exposure intricacies. Just dial in the Sports setting, and the camera automatically adjusts all the necessary controls to best capture a moving target. However, be aware that in dim lighting, even Sports mode won't do the trick in most cases. See Chapter 4 to find out more.

✔ **Dynamic or continuous autofocus:** This autofocus mode, which may go by different names depending on the model, adjusts focus as needed right up to the time you take the shot to keep moving subjects in focus.

✔ **Compatibility with high-speed memory cards:** Camera *memory cards* — the little removable cards that store your pictures — are rated in terms of how fast they can read and write data. With a faster card, the camera needs less time to store the image data after you shoot the picture. Although older cameras often can't take advantage of the speed increases, newer models are designed to work with the fastest cards.

Evaluating video capabilities

Most new digital cameras sold today can record video as well as still pictures. But are they really an alternative to a full-fledge video camera?

In my opinion, no. Yes, with many new cameras you can record stunning HD video. And, if you use an interchangeable lens camera, you get lens flexibility that you don't get with a regular video camera. I'd be the first one to say that it's an awesome choice to be able to record a wildlife video on high def with a long telephoto lens, but digital still cameras still lag behind digital video cameras in lots of important ways:

✔ **Audio recording:** Still cameras that can record audio have tiny microphones built into the camera body. These small mikes tend to be of low quality and record only *monaural* (that is, not stereo) audio. And with the microphone closer to the videographer than the subject — well, let's just say that you need to remember to stop talking and even breathe quietly if you want to hear your subject's voice clearly. For better audio, some cameras allow you to attach an external, stereo microphone that you can place away from the camera and close to your subject. But typically, the only cameras that offer a microphone jack are of the high-end variety. You also can record your soundtrack using a completely separate audio recording device and then combine the video and soundtrack later in a video-editing program.

✏ **Continuous autofocusing:** Most cameras can't automatically track focus during recording like video cameras do. Instead, you set focus before you hit the record button, and the camera sticks with that focusing distance throughout the whole recording. If your subject moves beyond that focusing distance, you can either move in tandem, yell "cut" and start a new recording, or live with that dreamy soft-focus effect.

A few digital still cameras can track autofocus continually, but some of those pose another problem: If you use the camera's internal microphone to record sound, you can usually hear the sound of the autofocus motor doing its thing when you play the movie.

Some of the very latest cameras are better in this regard. And again, you can always attach an external microphone (if your camera accepts one) and position it far enough from the camera to avoid picking up the focusing sounds. On interchangeable lens cameras, you also can forego autofocus and focus manually during the recording, but unless you put the camera on a tripod, it's tricky to adjust focusing as needed while keeping the camera steady enough to avoid camera shake.

✏ **Framing your shots:** For technical reasons I won't bore you by explaining, only cameras that offer an electronic viewfinder allow you to use the viewfinder for movie recording. On cameras that use a different type of viewfinder — or offer no viewfinder at all — you have to compose shots using the monitor, as shown in Figure 1-24.

Try shooting a movie outdoors on a sunny day, and you'll quickly see why this is problematic. Even the best monitor washes out in the sunlight, making it difficult to know for certain that your subject is still in the frame, and having to hold the camera out in front of you to compose the scene typically leads to lots of camera shake, giving your movies that jittery look that's all the rage in hip crime movies but gets old fast when you're watching a movie of your kids playing baseball or your dog running around the yard.

✏ **Movie length:** Whereas standalone video cameras record on media that can hold long movies, digital still cameras must stow your videos on memory cards, limiting the length of video clip you can record. A 16MB memory card, for example, can hold roughly 40 minutes of video if you shoot using the highest movie-quality settings. And even if there's room on the card for more data, some cameras limit you to recording only a few minutes of HD video at a time.

With the exception of the movie length limitation, you can buy accessories to get around the drawbacks just listed: video-oriented tripods that have *panning* heads that enable you to move the camera up, down, and around smoothly as needed to follow the action; monitor shades to make the screen easy to view in bright light; and external microphones or audio recorders. You also can buy special video lights to illuminate the scene in dim lighting (your flash won't do the trick because it doesn't provide a continuous light source).

If you're okay with that kind of expense or complication, don't let my negative take on the subject stop you from your creative urges. But I opted not to cover the subject in this book for two reasons. If you're just into recording casual videos, there's not much to tell — on most cameras, you just press a record button once to start recording and again to stop. If you *are* into all the gadgetry that's involved in serious videography with a still camera, then you either know everything there is to know already or, if you're just getting started, really need a resource completely dedicated to that subject. You can find lots of good tutorials online; one site to get you started is `www.dslr videoshooter.com`.

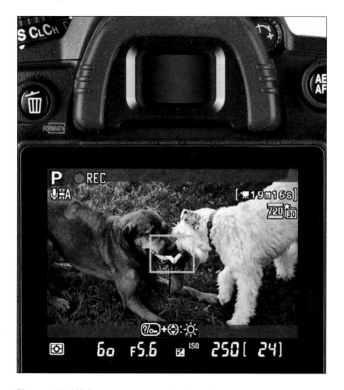

Figure 1-24: With most cameras, the viewfinder is disabled during video recording so you must use the monitor to compose your shots.

Reviewing a few other fun (and practical) features

Describing all the features found on the latest digital cameras is nigh on impossible; it seems that every day, some new camera option is announced.

But the following list introduces you to some of the most common additional features that may be of interest to you. These options fall into the category of not necessary but nice to have:

- **Articulating (adjustable) monitors:** Most newer cameras feature larger LCD screens than the somewhat smallish versions offered in first-generation models. In fact, some monitors are nearly as large as the back of the camera. But some cameras, such as the Canon model shown in Figure 1-25, take the monitor design a step further, featuring fold-out screens that can be rotated to a variety of angles. This adjustable type of monitor enables you to shoot at nearly any angle while still being able to see the monitor.

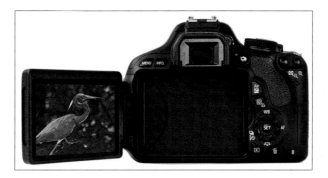

Figure 1-25: Some monitors can be adjusted to different viewing angles.

- **In-camera editing tools:** Many cameras offer built-in retouching filters that can fix minor picture flaws, such as red-eye or exposure problems. Some cameras that can capture pictures in the Camera Raw format even offer an in-camera converter that translates your Raw file into the standard JPEG format. (You have to convert Raw files to JPEG in order to share them online.) These tools are especially helpful for times when you need to print or share a photo before you can get to your computer to fix the image in your photo software.

- **Wireless image transfer:** If you buy a camera that offers Wi-Fi (wireless networking) connectivity, you can enjoy the cable-free life when it's time to download pictures or share them online. Some cameras offer an alternative wireless transfer option, Bluetooth. Of course, you must be within range of a wireless network or Bluetooth device in order to use these features.

✔ **Touchscreen operation:** Some cameras, including the Fujifilm model shown in Figure 1-26, let you access certain camera options just by touching a finger to the monitor. Cool. Just be sure to wipe your fingers clean before you go poking at the screen.

Fujifilm North America Corporation

Figure 1-26: Touchscreen operation is one function borrowed from the world of smartphones.

✔ **Print and e-mail functions:** Many cameras enable you to create an e-mail-sized copy of a high-resolution image. (See Chapter 10 to find out why you don't want to simply send that high-res image through cyber-space.) And some cameras offer a feature called PictBridge, which enables you to connect your camera directly to your printer, so you can print your photos without ever down-loading to your computer. (The printer also must offer PictBridge capabilities.) This feature is great for printing pictures at birthday parties, conventions, and the like.

✔ **Video-out capabilities:** If the camera has a video-out port, you can con-nect the camera to a television and view your pictures on a TV screen. Some cameras offer both standard-definition and high-definition (HDTV) output; you may need to buy the necessary cables, however.

✔ **Waterproof/shockproof casing:** Most cameras won't survive being dropped on concrete or left out in the rain. But some models sport casings that are designed to survive the most rugged (or clumsy) photographer.

Note that *water resistant* is not the same thing as *waterproof*. A water resistant camera can take a few raindrops but isn't meant for prolonged exposure to the elements.

✔ **GPS tagging:** Have a hard time remembering — or proving — where you've been? Some cameras offer built-in GPS (global positioning satel-lite) technology that can tag your pictures with the location where you shot them.

✏ **Automatic copyright tagging:** Many cameras aimed at enthusiasts and pros enable you to add a hidden copyright notice to your photos, a feature designed to help stop unapproved use of your images. The notice doesn't appear on the image itself, but is added to the image *metadata* — extra picture information that can be viewed in many photo browsing programs. It's not a foolproof prevention against image theft, but at least if you decide to sue someone for using your photos without permission, you can prove that the image did carry a copyright notice. You also can add such tags in many photo programs, but having the camera do it for you saves time.

So . . . Is It Time for a New Camera?

Summing up all the details in the preceding sections, the answer to the question posed by the headline is, well, maybe. Assuming that your camera is a couple of years old, you should definitely look at a new model if any of the following statements apply:

✏ You're not happy with the quality of your photos, especially when you print them larger than snapshot size.

✏ You have trouble capturing action shots because your camera is a slow performer.

✏ Your pictures appear noisy (speckly) when you shoot in dim lighting.

✏ You're a serious photographer (or want to be) and your camera doesn't offer manual exposure control, Raw image capture, a flash hot shoe, or other advanced features.

✏ You have trouble viewing your pictures on the camera monitor because it's too small and difficult to see in bright light.

✏ Your pictures are often ruined by camera shake (which causes blurry pictures), and you could benefit from image stabilization.

Of course, some cameras address these issues better than others, so again, be sure that you read reviews on any new model you consider. Also consult with the salespeople at your local camera store, who can point you toward cameras that best solve the picture-taking problems you're experiencing.

Getting More Shopping Guidance

If you read this chapter, you should have a solid understanding of the features you do and don't want in your digital camera as well as in the other

components of your digital darkroom. But you need to do some more in-depth research so that you can find out the details on specific makes and models.

First, look in digital photography magazines as well as in traditional photography magazines (such as *Shutterbug*) for reviews on individual digital cameras and peripherals. Some of the reviews may be too high-tech for your taste or complete understanding, but if you first digest the information in this chapter, you can get the gist of things.

You can also find good information at several websites dedicated to digital photography. See Chapter 11 for suggestions on a few sites worth visiting.

One final bit of buying advice: As you would with any major investment, find out about the camera's warranty and the return policy of the store where you plan to buy. Many retailers charge a *restocking fee,* which means that unless the camera is defective, you're charged a fee for the privilege of returning or exchanging the camera. Some sellers charge restocking fees of 10 to 20 percent of the camera's price. You might also ask whether it's possible to rent the camera you're considering for a day or two so that you can be sure it's the right choice; some camera stores offer this service.

2

Extra Goodies for Extra Fun

Do you remember your first Barbie doll or — if you're a guy who refuses to admit playing with a girl's toy — your first G.I. Joe? In and of themselves, the dolls were entertaining enough, especially if the adult who ruled your household didn't get too upset when you shaved Barbie's head and took G.I. Joe for a spin in the garbage disposal. But Barbie and Joe were even more fun if you could talk someone into buying some of the accessories. With a few changes of clothing, a plastic convertible or tank, and loyal doll friends like Midge and Ken, Dollworld was a much more interesting place.

Similarly, you can enhance your digital photography experience by adding a few hardware and software accessories. They may not bring quite the same rush as a Barbie penthouse or a G.I. Joe surface-to-air missile, but they greatly expand your creative options and make some aspects of digital photography easier.

This chapter introduces you to some of the best and most necessary digital photography accessories, from memory cards to tripods to digital imaging software. As you read, keep in mind that the prices quoted in this chapter and elsewhere are what you can expect to pay in retail or online stores. Because prices for many digital imaging products seem to drop daily, you may be able to get even more for your money by the time you're finished reading this book.

Buying and Using Memory Cards

Instead of recording images on film, digital cameras use removable *memory cards.* Several types of cards exist, but the decision about which type you should buy is pretty much made for you because most cameras, with the exception of a few high-end models, can use only one kind.

The majority of cameras use either SD (Secure Digital) or CompactFlash memory cards, both shown in Figure 2-1. SD cards are the most widely used today because of their small size, reliability, and high capacity. CompactFlash cards once led the pack but have been overshadowed by SD card technology and now are used mainly in pro and high-end cameras.

Figure 2-1: The most widely used types of memory cards are CompactFlash (left) and Secure Digital (right).

SD and CompactFlash cards aren't the only game in town, however. Certain Sony models use a proprietary type of memory called a Sony Memory Stick, for example. And some older Olympus and Fujifilm models use xD cards, which are about the size of a postage stamp. Bottom line, check your camera manual to find out the type of card your camera can accept.

Shopping for memory cards

When you shop for memory cards, keep these tips in mind:

- ✔ **Card capacity:** Your camera manual should spell out how many pictures or minutes of video, if your camera offers movie recording, you can fit in a certain amount of card storage space. That number varies depending on the picture or movie resolution and quality settings you use; higher quality means bigger files and thus fewer pictures per memory card. For example, one of my cameras enables me to capture images at a resolution of 12 MP (megapixels), 7 MP, or 3 MP. If I set the camera to capture 12 MP images in the Camera Raw image format at the highest quality capture setting, I can fit only about 300 images on an 8GB (gigabyte) memory card. But if I switch to the JPEG format and the highest quality settings, I can fit about 2,000 photos. (Chapter 3 explains Raw, JPEG, and resolution, if those terms are new to you.)

 Today, memory cards come in capacities as high as 128GB, and plans are in the works for cards that go as high as 2 terabytes (1 terabyte equals 1,000 gigabytes). That begs the question: How much is enough? And should you buy one really big card or carry several smaller capacity cards?

Personally, I take the latter approach and carry several 8GB cards rather than one gargantuan card. Two reasons: Memory cards can fail or be damaged, and I've been known to lose cards altogether. With smaller cards, I risk losing fewer pictures if a card does turn up bad or doesn't turn up at all. However, I don't shoot much video, and because video eats up more file space than still photos, you may want to notch up to 16GB, 32GB, or even higher if you're a video enthusiast.

Before you rush out to buy the biggest card you can find, though, check your camera manual to find out the maximum capacity card it accepts. Some cameras are limited in this regard.

✔ **SD, SDHC, or SDXC:** When you shop for SD cards, they'll carry one of these three labels, which are used to indicate the capacity range of the card:

- *SD:* Come in capacities up to 2GB (gigabytes).

- *SDHC (Secure Digital High Capacity):* Come in capacities ranging from 4GB to 32GB.

- *SDXC (Secure Digital Extended Capacity):* Come in capacities starting at 32GB.

Although you can use SD cards in most devices that support SDHC or SDXC cards, the reverse isn't always true. Note, too, that if you want to download images to your computer using a memory-card reader, the reader also must be compatible with SDHC or SDXC, not just SD. (Chapter 8 talks about image downloads.)

✔ **Card speed:** Memory cards are rated in terms of speed as well as capacity. Card speed is an indication of how fast image data can be written on the card and downloaded to the computer. Speed is noted in a couple different ways: with a number and an "x" sign: 66x, 90x, 133x, and so on; or speed class, such as Class 6 or Class 10. Either way, a higher number means a faster card. Very recently, a new speed rating was introduced: UHS (for Ultra High Speed), which refers to the fact that these cards can use a faster *bus* (data communication interface) than other SD cards. They also carry a number designating speed, but at present, they're available in just one speed rating, UHS 1. Your camera must support the UHS standard to take advantage of this new type of card.

As you might expect, faster cards cost more. Is the difference worth the price? It depends. Card speed is especially important for cameras that can shoot lots of photos in quick succession; faster cards mean that you can keep shooting without any pauses. Additionally, faster cards make for smoother movie recording and playback.

Don't shell out the extra cash, though, until you find out whether your camera is engineered to take advantage of the higher-speed cards. Again, your camera manual has the info you need. Also, understand that you probably won't notice a huge difference unless you're shooting at high resolutions — say, 5 megapixels or more — or recording video.

Finally, note that when it comes to how fast you can download images, the speed of the card isn't the only factor; the capabilities of the card reader and your computer come into play as well.

✔ **Wireless transfer cards:** Some digital cameras can transfer pictures wirelessly to a computer. If yours doesn't and you want to go sans wires, Eye-Fi makes SD cards that have the wireless technology built in. You can find out more at www.eye.fi.

The cards are naturally more expensive than regular cards, but you may find the convenience of being able to transfer without having to connect your camera to the computer or use a memory-card reader worth the price, especially when traveling — who needs one more bit of digital equipment to haul in the carry-on bag? In addition, the wireless cards come with software that makes it easy to upload pictures automatically to the web. And if you use an iPhone, iPad, or Android tablet, you can also transfer pictures to those devices over the air

Care and feeding of memory cards

Chapter 3 offers some specifics about using memory cards. But in the meantime, follow these general tips to keep your memory cards in good working condition:

✔ **Avoid touching the contact areas of the card.** On an SD card, for example, the little gold strips are the no-touch zone, as shown in Figure 2-2. On a CompactFlash card, make sure that the little holes on the edge of the card aren't obstructed with dirt or anything else. Most cards ship with a little flyer that alerts you to the sensitive spots on a card.

✔ **Keep them clean.** If your card gets dirty, wipe it clean with a soft, dry cloth. Dirt and grime can affect the performance of memory cards.

✔ **Don't push your luck.** Try not to expose memory cards to excessive heat or cold, humidity, static electricity, and strong electrical noise. You don't need to be overly paranoid, but use some common sense.

Paws off!

Figure 2-2: Avoid touching the contact areas of the memory card.

You can, however, ignore rumors about airport security scanners destroying data on memory cards. Although scanners can damage film, they do no harm to digital media, whether the cards travel in checked or carry-on bags.

✔ **Keep them in a safe place.** When not using your cards, keep them stored in their original cases. Or consider buying a memory card wallet like the one shown in Figure 2-3, from Think Tank Photo. This wallet can store multiple cards and can be clipped to the strap of your camera bag or around a belt loop for easy access.

Think Tank Photo

Figure 2-3: A memory card wallet helps protect your cards from damage.

Protecting Your Camera

Perhaps the most important camera accessory you can buy is a camera bag, case, or other product that will keep your investment dry, cushioned, and easy to transport. Remember, a digital camera is at heart a computer with a lens, and electronics don't get along well with rain, dust, and dirt.

I'd like to be able to tell you exactly which bag is best for you, but the truth is that buying a camera bag is a personal decision based on how much gear you want to carry around. The best way to find a good bag is to head for a large camera store with your camera in hand and then try out different types of bags. That way, you can make sure that the bag fits the camera well and doesn't wear too heavily on your shoulder or waist. Of course, it's also important to make sure that the bag is well-constructed and provides lots of padding to cushion the camera if you drop the bag.

Rather than getting into details about all the different types of bags — really, we could be here for days — here's just a quick list of some of the more interesting solutions as well as a look at some products designed for special photography needs:

- **Computer-camera combo bags:** Because many photographers don't leave home without a netbook or tablet computer, manufacturers now offer bags that can handle both camera and computer. Figure 2-4 offers a look at a Tenba model.

- **Tripod toters:** If you do a lot of tripod shooting, a bag that has straps that you can use to attach the tripod, as shown in Figure 2-5, makes carrying your equipment a little easier. This Tamrac model (CyberPack Rolling Backpack, Model 5267) also sports wheels — an especially great feature for the traveling photographer who has to haul gear through big airports. (Just make sure that the bag meets the airline's requirements for carry-on bag sizes, because you don't want to check your camera gear.)

- **Heavy-duty travel options:** If you need to transport camera equipment and can't actually carry it with you, you can choose from a number of very solid, watertight cases that cushion your gear in customizable foam and seal it from any potential outside hazard. Pelican Products (www.pelican.com) produces an extensive line; many professional photographers rely on this type of product when flying to ship expensive gear as checked baggage.

- **Weather protectors:** For photography in rugged conditions, several companies sell products that protect your camera from

Tenba

Figure 2-4: This Tenba bag has room for both computer and camera.

Tamrac

Figure 2-5: A bag with wheels and a tripod harness, like this one from Tamrac, makes traveling with your gear easier.

the elements. Camera Armor (www.cameraarmor.com) offers a line of heavy duty protectors that wrap your camera in a shock-absorbing casing, while Kata (www.kata-bags.com) includes weather covers for shooting outdoors.

Steadying Your Camera

For nighttime shots and other photos that require long exposure times, keeping your camera steady is essential. Otherwise, you run the risk of camera shake during the exposure, which causes blurry photos.

Here's a look at some of the devices you can use any time you want to be sure that your camera remains absolutely still:

- ✔ **Traditional tripods:** You can spend a little or a lot on a tripod, with models available for anywhere from $20 to several hundred dollars. At the higher end of the price range, you get a sturdier product, designed to safely hold heavier cameras, such as dSLR models. You also get convenience features, such as a quick-release plate for easily attaching and removing the camera from the tripod head. Typically, you buy the tripod base separately from the head, which gives you a little more flexibility in buying the components you like best.

Take your camera when you shop to see how well the tripod works with it. Set the tripod at its maximum height, push down on the top camera platform, and try turning the tripod head as though it were a doorknob. If the tripod twists easily, or the legs begin to collapse, look for a different model.

- ✔ **Small solutions:** A great option for times when you don't want to carry around a full-size tripod is a product like the Joby GorillaPod (www.joby.com). Made of stiff but flexible gripping legs, it can stand as a short tripod or wrap around something and hold on — such as a tree, as shown in Figure 2-6. The GorillaPod comes in a variety of sizes, shapes, and colors for all types of cameras.

Joby, Inc.

Figure 2-6: The Joby GorillaPod lets you mount a camera nearly anywhere.

Another small solution with a similar name, The Pod (www.thepod.ca), is a beanbag-like platform that you can use to steady the camera on uneven surfaces and at various angles, as shown in Figure 2-7.

THE pod INDUSTRIES

Figure 2-7: The Pod offers another tiny but practical means of stabilizing the camera.

- ✔ **Monopods:** Another way to be portable but stable is to use a *monopod,* a collapsible stick that lets you hold your camera steady but doesn't stand on its own. You frequently see sports photographers at football games traipsing around the sidelines with a big camera, big lens, and a monopod. If you get tired of holding your camera, whatever its size, these are useful and easy to tote around. However, for nighttime photography or other instances where you want to use a slow shutter speed, monopods don't offer quite the protection against camera shake as a regular tripod — it's up to you to keep the monopod and the camera still during that long exposure.

- ✔ **Hybrids:** Some innovative tripod/monopod hybrids exist; they look like monopods, but you can pop out three mini-legs to let them stand on their own.

A hybrid isn't as stable as a full tripod, so don't stand too far from your camera with a strong wind blowing.

Adding a Few Filters

Lens filters screw onto your camera lens (or can be attached via an adapter). Some filters create special effects and so aren't everyday tools, but the following filters can come in handy on a more regular basis:

- ✔ **Ultraviolet (UV) filter:** A UV filter is a clear filter designed to block UV light rays, which can cause a blue tint to photos. With digital cameras, automatic white balancing usually takes care of that problem, so the main reason to attach a UV filter to your digital model is to protect the lens from breaking if you happen to knock it into something.

 However, a cheap UV filter can lower image quality, and it makes little sense to spend a lot of money on a good lens and then slap a poorly made piece of glass on top of it. If you do put on a UV filter, make sure

that it's of high quality — you'll pay about $80 or more. One of the most highly respected names in the filter biz is B+W, but your local camera store can guide you to other quality filters.

✏ **Polarizing filter:** A polarizing filter cuts glare from light rays that bounce off reflective objects, such as water and glass. It's sort of like putting a pair of polarized sunglasses on your lens. With landscape shots, polarizers can also produce bluer skies. You can see an example of a picture taken with and without a polarizer in Figure 2-8.

Without polarizing filter With polarizing filter

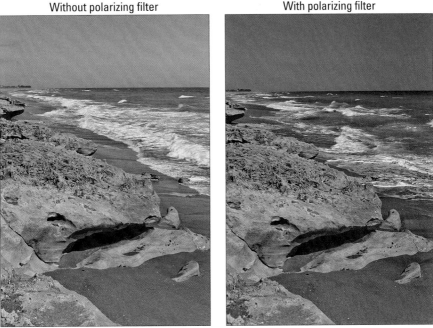

Figure 2-8: A polarizing filter cuts glare from light rays bouncing off water and other reflective surfaces.

It's important to understand, though, that in order to achieve the polarizing effect, you must have the sun at one shoulder, and your subject must be at a 90-degree angle to the lens. At other angles, you won't see any difference except a slight reduction in the amount of light coming through the lens. You also shouldn't use a polarizer if you like the look of specular highlights dancing on water — the polarizer will eliminate them. Keep in mind, too, that the filter cuts the amount of light coming through the lens, so you have to use a slower shutter speed, larger aperture, or higher ISO to expose the photo. (Chapter 5 explains these exposure terms.)

🖊 **Neutral density (ND) filter:** This filter is designed to cut light coming in through the lens without affecting picture colors — essentially, it's a gray (neutral) piece of glass. An ND filter is great for shooting outside on a very bright day because it enables you to use a slow shutter speed (to blur a moving object, such as a waterfall) or wide open aperture (for a blurry background) without overexposing the picture.

🖊 **Graduated ND filter:** A graduated ND filter is one that is clear on one side. The idea is to enable you to cut the light from a portion of the scene, but catch all the light from the rest, as when you're taking a picture of a bright sunset at the beach. Without the filter, you have to expose for the sunset, leaving the beach dark, or expose for the beach, blowing out the sunset.

For any filter that cuts light, the manufacturer provides information about how many *stops* of exposure shift you need to make to compensate for that reduced light. A stop refers to a change in exposure settings that results in twice as much light hitting the image sensor. (You can also speak of stops in terms of cutting the light in half, but in the case of filters, you need to go the other direction because the filter is eliminating some light.) Again, see Chapter 5 for more about exposure issues.

Equipping Your Digital Darkroom

In addition to your camera and photography equipment, you need some sort of computer system for downloading, storing, organizing, viewing, sharing, and printing your pictures.

Chapter 9 discusses printers; the next few sections here talk about the other hardware components of the digital darkroom.

Tablet computers

Without a doubt the sleekest and most portable digital darkroom, tablet devices like Apple's iPad provide the basics you need to view and share your pictures. With *apps* (programs) such as Adobe Photoshop Express or Apple's own iPhoto, you can even do some basic photo editing.

Tablet computers, however, don't sport enough onboard file-storage space to serve as a permanent solution for housing all your photo files. Some photographers get around that limitation by downloading their pictures to the tablet and then uploading them via an Internet connection to online photo storage sites.

Some tablets have USB ports that let you connect a camera or memory-card reader for picture download, and a few have SD card slots. But some do not, which means you need to find another way to get your pictures to the tablet. With an iPad, for example, you can purchase a camera connection kit that lets you cable your camera to the tablet. Wireless transfer is another option, if your camera offers that capability or you use the Wi-Fi–enabled Eye-Fi memory cards.

My take? I think a tablet works great as a temporary, portable solution for traveling and for sharing your latest pics with the gang when you all meet for dinner, and it's perfect for what it's really designed to do best, which is hitting your favorite photo sites on the web. But if you're someone who takes lots of pictures or wants to do a lot of photo editing, I recommend stepping up to a "regular" computer, as explained next.

Desktop or laptop computers

For your primary digital darkroom, I recommend a desktop or laptop computer rather than a tablet device. You'll gain a couple of benefits:

- **More storage:** Bigger hard drives mean more permanent picture storage space than a tablet.

- **Speed:** Faster processors, more RAM (system memory), and faster graphics cards mean you can upload, organize, and edit your photos faster.

- **Display:** A larger screen is optimal for viewing your pictures, especially if you connect one of the new wide-screen monitors.

What about netbooks — those mini-laptops? Again, I love them for travel and even for carrying along on a shoot, but they also have limited onboard storage and computing power, making them too slow for serious photo editing.

As for exactly how much storage space, processing power, and other system muscle you need, the answer to that question depends on what you want to do with your photos. Heavy-duty photo-editing programs require heavy-duty systems, but even a low-end system is perfectly fine for basic photo programs, Internet sharing, and the like.

Frankly, even if I could come up with a perfect spec sheet for different types of users, it would be outdated before the words even left my keyboard. So instead, I offer the following basic introduction to the components that make the most difference and then urge you to read the most current computer magazines for detailed guidance when you're ready to shop for a new system.

✓ **Processor:** This is the "brain" of the computer. *Ergo ipso facto,* the more powerful, the better. But that said, most experts suggest that the sweet spot is to buy a processor one grade under the latest and greatest. It never pays to be an early adopter, as the old computer adage goes.

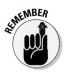

Most computer magazines and sites that review new computer components run performance tests comparing how the processors run Adobe Photoshop, the leading professional imaging software. Suffice it to say, if the processor does well on the Photoshop bench test, it'll serve your digital photography needs.

✓ **Hard drive:** The hard drive is the part of the computer that stores your programs, documents, and picture files. If you get a desktop system, you may want to get one that can house two hard drives; that way, you can store your files on one and put programs on the other, which boosts performance.

How much hard drive space you need depends on how many pictures you take and how many other files you keep on your computer. Keep in mind that a computer needs some empty hard drive space to use as temporary data storage space when you're running programs such as a photo editor. So if your current hard drive is packed, start doing some house cleaning or consider adding another drive.

If your computer doesn't have room for an additional internal drive, you also have the option of adding an external hard drive, but understand that an external drive runs a little slower than an internal drive because of the time the data needs to run through the cabling that connects the drive to the computer.

When looking at hard drives, note the drive speed as well as its capacity. Drive speed determines how quickly the system can read and write data to and from the drive. Again, check performance reviews in computer magazines for the latest speed data.

✓ **RAM (random access memory):** When you ask your computer to perform any task, it uses RAM to perform the calculations needed to get the job done, so more RAM equals faster performance.

For minor photo editing, web sharing, and general daily tasks such as e-mailing and word processing, 4GB (gigabytes) of RAM is probably enough. For more intense photo editing or video editing, double that number (at least). However, note that most programs can utilize only so much RAM, so going full tilt on RAM isn't always necessary. To find out the RAM requirements of the programs you like to run, check the software manufacturer's spec sheets.

If you're in the market for a new computer, find out how much RAM you can add — every system has a specific limit in the amount of RAM it can hold, so make sure that you don't buy a system that will leave you hamstrung in the future if your RAM needs increase.

✔ **Video (graphics) card:** Also called a *display adapter,* this is the component responsible for making text and images appear on the monitor. Buying video cards involves enough arcane terminology that I don't even dream of covering it here, so here's my best advice: Ask your local teenage video-game enthusiast to help you pick a card. If a card performs well for video gaming, which is the most demanding operation the video card must perform, it's sufficient for photo and imaging work. Of course, computer magazines and gaming magazines also cover these components (just don't say I didn't warn you that you'll encounter enough jargon to make your head spin).

✔ **DVD burner:** Hard drives can fail at any time, being mechanical devices with moving parts, so it's critical to back up your picture files to DVD — at present, the best option for long-term photo storage. This component is standard on desktop computers, but smaller laptop computers sometimes omit them — and netbooks don't have them at all. As a solution, you can always buy an external burner, however.

✔ **Operating system (Windows or Mac?):** The operating system — OS, in geek terminology — also can make a difference. You can run many photography programs on older versions of the Windows or Mac OS, but the newer versions are optimized to work better with images. For example, Mac Snow Leopard's Quick Look feature and Windows 7's Windows Live Photo Gallery both provide much-improved ways to search for and review images than previous editions of either operating system.

As for the whole Windows versus Mac debate: I say, pffffffft. I've used both for years, and both have brought me the same amount of pleasure and the same amount of pain. You do typically get more computing power for less money if you buy a Windows-based PC, and certainly there are more programs available for Windows than Mac, but other than that, it's personal preference, in my opinion. After all, when you open most programs, they look and work the same way regardless of whether you're working on a Windows or Mac machine.

Note that there are some other operating systems, including Linux, but that's an arena for computer "enthusiasts" only. I assume that if you're interested in Linux, you're enough of a computer scholar that you don't need me to tell you about its pros and cons.

✔ **Monitor:** A monitor is another important component of your digital darkroom. It used to be that those big, bulky TV-like monitors (CRT, or *cathode-ray tube,* monitors, to be specific) produced the best-quality

computer displays and that LCD monitors were considered amateurish and gimmicky. Not so today: LCD displays have overtaken the market as the standard, and the images they produce are nothing less than stunning. You can get ultra-high resolution monitors (that even support HDTV, for heaven's sake) at a remarkably affordable price that will make your photos look like they're alive in your studio.

I offer this one tip, however: Especially if you're doing color-critical imaging work, be sure to shop carefully to make sure that the LCD performs well for this type of use — some are better than others, as with any product. Also, if you still have a CRT monitor, and it's working well for you, there's no need to run out and replace it with an LCD. You may discover that it provides a better display than many new, low-priced LCDs, in fact. Of course, it doesn't look nearly as cool on your desk, but . . .

✐ **Extra points features:** To make life more convenient, look for a computer that has the following bonus points:

- *USB 3.0 ports:* USB (universal serial bus) connections are the type most commonly used to connect cameras and other external devices, such as memory-card readers and printers. So be sure your system has plenty of them; although you can add USB hubs that provide additional ports, sometimes devices get picky about working with those add-on ports.

 For the fastest performance, look for USB 3.0, the fastest form of USB data transfer. Most USB 3.0 devices can still run on USB 2.0, though, so don't sweat this upgrade if you're not keen on doing surgery on your computer and can't find a friendly computer tech to do it for you. If you're still running USB 1.0, however, you'll definitely notice a speed increase if you upgrade.

- *FireWire ports:* An alternative to USB, FireWire is just another type of port that enables you to connect external devices such as printers and hard drives. (As of now, digital still cameras don't offer FireWire connectivity.) For fastest data transfer, look for FireWire 800, which offers faster data transfer rates than FireWire 400.

- *Memory-card readers:* Although most cameras ship with a cable that you can use to connect your camera to the computer for picture download, a memory-card reader is a better solution. You take the card out of the camera, put it in the reader, and away you go, transferring files just as you would transfer any file from a CD, DVD, or external hard drive. You save battery power because the

camera doesn't have to be powered up during the transfer, and if you have a USB 3.0 card reader, you get faster downloads than with most camera cables, most of which are still of the USB 2.0 variety.

You can also buy inexpensive card readers that attach via a USB port, so this one isn't a biggie, but having the reader built in means you have one more USB port free for attaching other devices.

Mind you, this isn't to suggest that you must go out and buy a brand-new computer and all the trimmings. If you use a medium-resolution camera that doesn't produce huge picture files, and you stick with consumer-level photo software, such as Adobe Photoshop Elements or iPhoto, you may be just fine with a computer that's a few years old or a middle-of-the-line new system. If you do high-end work with programs like Adobe Photoshop or enjoy video editing, you may find it beneficial to treat yourself to some new hardware if your system is more than about three years old.

Sorting through Software Solutions

The software you load onto your computer is every bit as critical to your fun (and lack of frustration) in the digital darkroom as the hardware, and the good news is that if your needs are basic — you just want to view and organize your photos and maybe crop an image or two — you may not need to pay a dime for a good program. The next several sections introduce you to some leading programs of the free variety as well as a few to consider if you need more features than a free program can provide.

Free entry-level, photo-viewing and editing programs

If you don't plan on doing a lot of retouching or other manipulation of your photos but simply want a tool for downloading and organizing your pictures, one of the following free programs may be a good solution:

- **Your camera's own software:** Your camera probably shipped with a CD or DVD that contained free software designed by the camera manufacturer. In some cases, these free programs provide just basic photo viewing and organizing, but some are really quite capable. Nikon, for example, offers Nikon ViewNX 2, shown in Figure 2-9, which offers tools for removing red-eye, cropping pictures, and adjusting color and exposure.

Figure 2-9: Most manufacturers offer a free image browser and basic photo editor; here's a look at Nikon's ViewNX 2 program.

✔ **Apple iPhoto:** Most Mac users are very familiar with this photo browser, built into the Mac operating system and shown in Figure 2-10. Apple provides some great tutorials on using iPhoto at its website (`www.apple.com`) to help you get started if you're new to the program.

✔ **Windows Photo Gallery:** Some versions of Microsoft Windows also offer a free photo downloader and browser, Windows Live Photo Gallery (the name varies slightly depending on your version of the Windows operating system). Figure 2-11 offers a look at the version that ships with Windows 7.

Advanced photo-editing and browsing programs

Programs mentioned in the preceding section can handle simple photo downloading and organizing tasks, but if you're interested in serious photo retouching or digital-imaging artistry, you need to step up to a full-fledged, photo-editing program.

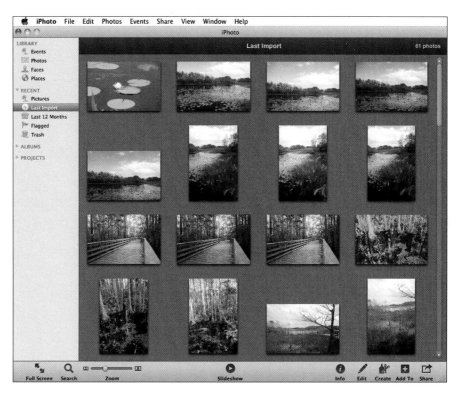

Figure 2-10: Apple iPhoto is a good basic tool for Mac users.

As with software in the free category, you have many choices; the following list describes just the most popular and widely acclaimed programs.

✔ **Adobe Photoshop Elements:** Elements has been the best-selling, consumer-level, photo-editing program for some time, and for good reason. With a full complement of retouching tools, onscreen guidance for beginners, and an assortment of templates for creating photo projects such as scrapbooks, Elements offers all the features that most consumers need. Figure 2-12 shows the Elements editing window with some of the photo-creativity tools displayed to the right of the photo. But don't think this is a lightweight player — you actually get many high-end editing features as well. The program also includes a photo organizer along with built-in tools to help you print your photos and upload them to photo-sharing sites. (You can find out more at www.adobe.com. The program sells for about $100.)

Figure 2-11: Windows Live Photo Gallery is free to Windows users.

✔ **Apple Aperture:** Aperture is geared more to shooters who need to organize and process lots of images but typically do only light retouching work — wedding photographers and school-portrait photographers, for example. (Find out more at www.apple.com. You can get this one for about $80 if you buy through the Mac store.)

✔ **Adobe Photoshop Lightroom:** Lightroom is the Adobe counterpart to Aperture, although in its latest version, it offers some fairly powerful retouching tools as well. Many pro photographers rely on this program or Aperture for all their work, in fact. You can get a glimpse of Lightroom in Figure 2-13. (Go to www.adobe.com for more information. This software sells for about $300.)

✔ **Adobe Photoshop:** The granddaddy of photo editors, Photoshop offers the industry's most powerful, sophisticated, retouching tools, including tools for producing HDR (high dynamic range) and 3D images. In fact, you probably won't use even a quarter of the tools in the Photoshop shed unless you're a digital-imaging professional who uses the program on a daily basis — even then, some tools may never see the light of day. (Get details on its features at www.adobe.com. Photoshop costs about $700.)

Figure 2-12: Adobe Photoshop Elements offers good retouching tools plus templates for creating scrapbooks, greeting cards, and other photo gifts.

Not sure which tool you need, if any? Good news: You can download 30-day free trials of all these programs from the manufacturers' websites.

Grabbing a Few Handy Extras

To round out your shopping spree, here are a few more accessories that just don't seem to fit neatly anywhere else:

- **Graphics tablet:** A tablet enables you to edit photos using a *stylus* (like a pen without ink) instead of a mouse. If you do a good deal of intricate touch-up work on your pictures or you enjoy digital painting or drawing, you'll wonder what you ever did without a tablet. Wacom, the industry leader in the tablet arena, offers a basic tablet called the Bamboo Pen and Touch, shown in Figure 2-14, which sells for about $100. It comes with a stylus, but you can also simply use your finger on the tablet as you do with a touchpad on a laptop computer. For details, visit www. wacom.com.

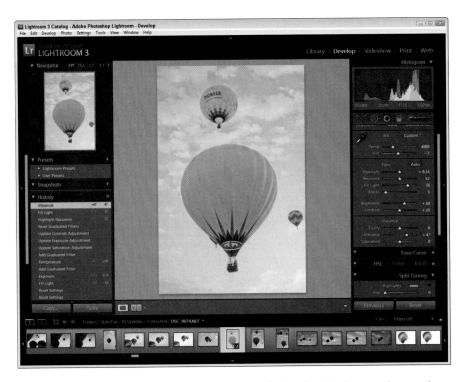

Figure 2-13: Adobe Photoshop Lightroom is a leading choice of studio photographers, and others who need to process lots of images.

✓ **Camera strap replacement:**
Here's a very simple but really useful and innovative alternative to the conventional camera strap. The R-Strap series of products from BlackRapid (www.blackrapid.com) is designed primarily for dSLR cameras (although they could be used, in theory, for most point-and-shoot models as well). The R-Strap attaches to the screw mount where you attach the camera to a tripod. The strap lets you hang the camera by your side — instead

Wacom Technology

Figure 2-14: Intricate photo-editing tasks become easier when you set aside the mouse in favor of a drawing tablet and stylus like this Wacom model.

of dangling from your neck — and with it, you can immediately swing your camera to shooting position. Prices vary, depending on the exact model, but start at about $50.

✔ **LCD shade/magnifier:** Ever tried to look at your camera's LCD to check your photo, but couldn't see it because of the bright sunlight? One practical solution is the Hoodman USA HoodLoupe (www.hoodmanusa. com), which is basically a small magnifying glass in a black case that hangs around your neck. When you take a photo and want to view it, you put the rectangular end up against your LCD screen and look through the viewfinder on the HoodLoupe. It enables you to see your images in even the harshest sunlight, it doesn't require mounting anything on your camera, and it works with any LCD screen. You can pick one up for about $80.

✔ **PhotoFrame eyeglasses:** For most people who wear glasses, making out the digital displays in camera viewfinders can be challenging. Hoodman USA comes to the rescue again, offering special photo frames that let you flip up one lens, as shown in Figure 2-15, so you can look through the viewfinder sans glasses, while leaving the other in place so you can still see out the other eye. You buy the frames (the price is about $150) and then take them to your optometrist to have them fitted with your prescription lenses. For the eye not looking through the frames, you can adjust the camera's viewfinder itself to your eyesight — Chapter 3 shows you how.

Hoodman USA

Figure 2-15: These clever eyeglass frames let you flip up one lens to get a better look through the camera viewfinder.

Preserving your pictures

When asked what belongings they'd be likely to grab first in the event they needed to escape a fire or flood in their home, many people say that their family photos are among their most precious treasures. But what most people don't realize is that ordinary, everyday life — and their practices in the digital darkroom — can be just as dangerous to the safety of their photos.

To ensure that your digital files live on, follow these guidelines:

- **Don't rely on a computer hard drive for long-term, archival storage.** Hard drives occasionally fail, wiping out all files in the process. This warning applies to both internal and external hard drives. At the very least, having a dual-drive backup is in order — you might keep one copy of your photos on your computer's internal drive and another on an external drive. If one breaks, you've still got all your goodies on the other one.

- **Avoid using portable devices for long-term storage.** Camera memory cards, flash memory keys, and other portable storage devices, such as one of those wallet-sized media players, are similarly risky. All are easily damaged if dropped or otherwise mishandled, and being of diminutive stature, these portable storage options also are easily lost.

- **Store treasured photos on high-quality DVDs.** The best way to store important files is to copy them to nonrewritable DVDs. Look for quality, brand-name DVDs that have an archival gold coating, which offer a higher level of security than other coatings and boast a longer life than your garden-variety DVDs.

Be aware, though, that the DVDs you create on one computer may not be playable on another because multiple recording formats and disc types exist: DVD minus, DVD plus, dual-layer DVD, and so on. Keep your eye on the technology horizon and, when you upgrade your computer, be sure it can read your DVDs before you give away your old computer or DVD drive. If not, make copies in a format the new drive can read.

- **Consider online storage services.** For a double backup, you may want to check into online storage services, such as Mozy (www.mozy.com) and IDrive (www.idrive.com). You pay a monthly subscription fee to back up your important files to the site's servers.

Note, though, the critical phrase here: *double backup.* Online storage sites have a troubling history of closing down suddenly, taking all their customers' data with them. (One extremely alarming case was the closure of a photography-oriented storage site called Digital Railroad, which gave clients a mere 24-hours' notice before destroying their files.) So anything you store online should be also stored on DVD or CD and kept in your home or office. Also note that photo-sharing sites such as Shutterfly, Kodak Gallery, and the like *aren't* designed to be long-term storage tanks for your images. Usually, you get access to only a small amount of file-storage space, and the site may require you to purchase prints or other photo products periodically to maintain your account.

✏ **On-the-go storage and viewing:** Even if you carry several large-capacity memory cards, you can fill them up quickly if you're using a high-resolution camera or shooting Raw files. Simply buying more cards as you go may sound logical, but whenever possible, you really should download as soon as you fill a card. Memory cards have been known to fail and are easy to lose, and your camera could be lost or stolen, with all your photos in it. You might get a new camera, but you won't have those photographs anymore.

For times when you don't want to travel with a computer or even a tablet computer like the iPad, you can pack smaller, more portable storage options in your camera bag. Figure 2-16 shows just two solutions, both from Digital Foci. The Photo Safe II, shown on the left, offers 250GB of storage for about $129; the Picture Porter Elite, shown on the right, adds a screen for viewing your photos and costs about $299 for a 250GB model.

Digital Foci, Inc.

Figure 2-16: Digital Foci offers two portable storage options that let you pack lots of photos into a small space.

As you might expect, prices for all these devices vary greatly, depending on the storage capacity, the size of the screen, and other features. But keep in mind that when you get home from your travels, you usually can attach these on-the-go devices to a computer via a USB cable and use them as another desktop or laptop storage drive.

Do be sure that whatever device you buy either offers a card slot for the type of memory card your camera uses (or that you can buy an adapter to make your card fit the slot) or can be connected directly to your computer via USB cable for image transfer. Also, note that some viewers can't display images captured in the Camera Raw format, so if you prefer that format, read the fine print. Chapter 3 explains Camera Raw.

Part II
Easy Does It: Taking the Fast Track to Great Pics

*Y*our camera battery is juiced up, you've got an empty memory card, and you're ready to start shooting. What you *don't* have is time to get a degree in photography — or even to digest the fundamentals presented in the next part of this book.

Relax. This part of the book is designed to help you take good pictures *now* — even if you're an absolute beginner. Chapter 3 walks you through some basic setup steps, explaining a few camera options that make your life easier and help guarantee good results. Chapter 4 guides you through the process of taking your first pictures, starting with a review of simple composition tips and then explaining how to get the best results when you use your camera's automatic photography modes.

Getting Your Camera Ready to Go

Digital camera manufacturers work hard to create a good "out of box" experience — that is, to make your first encounter with your camera fun, easy, and rewarding. To that end, cameras leave the factory in automatic picture-taking mode, using default settings that are likely to produce a good picture the first time you press the shutter button.

Before you snap that first shot, however, scan the information in this chapter, which offers advice on setting up your camera and choosing basic customization options. In addition, this chapter covers two setup options that play a critical role in overall picture quality: image resolution and file type.

Juicing Up: Checking the Batteries

Okay, so I know this is a book *For Dummies*. But I'm not going to insult your intelligence by explaining how to install the battery, or batteries, into your camera, and I'm pretty sure you don't need my help getting the battery charged, if your camera uses a rechargeable power source. But I do want to offer a couple pointers that may be new to you:

✏ **Monitoring battery status:** Upon startup, most cameras temporarily display a symbol that represents the battery status. Where the icon appears depends on the camera. In some cases, it's displayed on the monitor along with icons representing other picture-taking settings, as shown on the left in Figure 3-1. Or it may appear in the viewfinder or, if you have a high-end dSLR, on a top LCD control panel. Either way, a full battery like the one on the left side of the figure says you're good to go. When the battery icon looks half empty, you're running on borrowed time. Some cameras flash a low-battery warning in the viewfinder, as shown on the right in the figure, in addition to displaying the symbol when you first turn on the camera.

Full battery icon

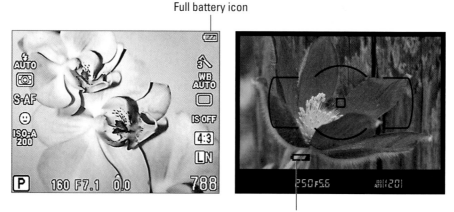

Low battery icon

Figure 3-1: When the battery is charged, the icon appears as on the left; a half-empty battery symbol means that you're running out of power.

✏ **Buying batteries:** If your camera ships with a proprietary battery and charger, you may want to buy a second battery so that you can always have a spare on hand, especially if you're going to be shooting for a long time and won't have the option of recharging — say, on a weekend camping trip.

If your camera runs on standard AA or AAA batteries, find out whether it can use rechargeable ones. You'll pay a little more up front and have to buy the charger itself, but you'll save money in the long run (and also help save the environment just a little, too). Look for NiMH recharge-ables; they typically last a little longer than an older type, NiCad (nickel cadmium). Remember that any rechargeable can lose power while it's sitting on the shelf, however, so be sure to charge up the night before you plan to shoot.

See Chapter 12 for some additional battery-related tips.

Working with Memory Cards

Remember the days of film? When accidentally opening the camera meant that you ruined all the pictures you shot? When you had to check the expiration date on the box to make sure the film was still good? When just getting the film wound on the take-up spool in the camera could be tricky?

Thankfully, digital photography and the era of camera memory cards put an end to those worries (buh-bye, film, don't let the door hit you and your stinky processing chemicals on the way out). Memory cards are far more durable and less finicky than film — and cheaper, too, since they can be reused shoot after shoot. In fact, I've even heard stories of memory cards that went into the washing machine, undetected in a shirt pocket, and came out unscathed. (I do not recommend that you test that claim.)

That said, you do need to take a few precautions when installing and using your cards to keep them in good working order and ensure the safety of the pictures they hold:

✔ **Formatting cards:** When you insert a card into your camera for the first time, you may need to *format* the card so that it's prepared to accept your digital images. Look in your camera manual for information on how to do this formatting. Usually, the camera's Setup menu contains the command that initiates card formatting, as shown in Figure 3-2. It's also a good idea to format cards on a regular basis after you download or erase the pictures they hold — the formatting process keeps all the data storage bits and bytes in proper working order.

Be careful *not* to format a card that already contains pictures or any other data that you want to retain, however. Formatting erases all the data on a card, even if you used your camera's picture protection feature to prevent accidental erasure. (See the playback information in Chapter 8 for more about protecting photos.) Also, use your camera to do this task. Although some computer programs can format memory cards, too, your camera is best equipped to prepare the card for shooting.

✔ **Inserting CompactFlash cards:** Be careful to position the card in the card slot at the proper angle, and don't try to force the card in if it doesn't want to slip in politely with a gentle push. If the card is slightly misaligned, it's easy to bend the little connection pins in the card slot — and getting them fixed is an expensive repair.

✔ **Waiting for the "done" signal:** Never remove a memory card while the camera is still recording or accessing the data on the card. Most cameras display a little light or indicator to let you know when the card is in use. When the light goes out, you can safely remove the card. Be sure to turn the camera off first.

Figure 3-2: Formatting prepares the card for use in the camera — but be careful because the process erases *all* data on the card.

Don't shut off the camera while it's accessing the card, either, or you can damage the card and lose pictures.

- **Locking and unlocking SD cards:** Some types of cards, such as SD cards, have a locking feature. By sliding a little switch on the card, you can prevent access to the card, which means that no files can be erased or added. Figure 3-3 gives you a look at the lock on an SD card. If the camera refuses to take any pictures while the card is inserted, check to make sure that the card isn't locked.

Lock switch

Figure 3-3: SD cards have a lock switch; when the card is locked, no files can be added or erased.

Adjusting the Viewfinder to Your Eyesight

If your camera has a viewfinder, it likely also has a *diopter adjustment control,* which is a little switch, knob, or wheel that enables you to adjust the viewfinder magnification to your eyesight. It's the exact same sort of mechanism you use to adjust binoculars to your peepers.

Making this adjustment is critical. Otherwise, objects that are really in focus may appear blurry in the viewfinder, and vice versa, so follow these steps to get the job done:

1. **Locate the diopter adjustment control.**

 It's typically set above and to the side of the viewfinder, as shown in Figure 3-4.

2. **Remove the lens cap and aim the lens at a blank wall or empty piece of paper.**

3. **Look through the viewfinder and concentrate on the focus point markings or framing markings in the display.**

 I'm talking about the little black lines and dots that typically indicate autofocusing points and framing guidelines in the viewfinder. The marks vary from camera to camera, but Figure 3-5 gives you an idea of what I'm talking about.

Diopter adjustment control

Figure 3-4: Most viewfinders sport a diopter adjustment control that lets you adjust the viewfinder to your eyesight.

If you don't see any framing marks but can see the viewfinder readout at the bottom of the display, as shown in the figures, concentrate on the numbers and data there instead. You may need to press the shutter button halfway and release it to wake up the camera's exposure metering and viewfinder display to see the data readout.

4. **Move the diopter adjustment control and notice that the viewfinder markings and data readout get blurrier or sharper as you make the change, as shown in Figure 3-5.**

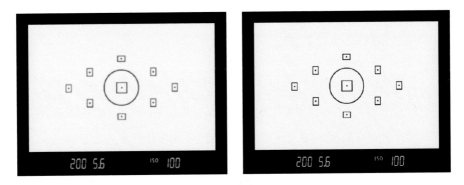

Figure 3-5: As you move the control, concentrate on whether the markings appear blurry (left) or sharp (right).

REMEMBER

Hey! Why can't I change this setting?

Because camera makers want to make your first interaction with the camera a frustration-free experience, they typically set the shooting mode, or *exposure mode,* to Auto. That's great for picture taking: Everything is done for you but framing the scene and pressing the shutter button.

The problem is that in most cases, you can't access critical picture-taking settings, such as whether the flash fires or how colors are rendered, when using the Full Auto exposure mode. Even *scene modes* — automatic modes geared to specific types of shots, such as portraits and landscapes — usually limit your options for controlling the camera.

If you scroll through your camera menus and notice that some settings are dimmed and inaccessible — or that whole menus that are mentioned in the manual don't show up — the cause is likely your exposure mode. On most cameras, you select the mode via a dial such as the one shown here. Try setting the mode to programmed autoexposure, usually represented

by a P. In that mode, the camera still handles exposure decisions for you but usually lets you access all other camera settings.

For more about taking pictures in Auto and scene modes, check out Chapter 4. Part III covers P mode and the other advanced exposure modes, including aperture-priority autoexposure, shutter-priority autoexposure, and manual exposure.

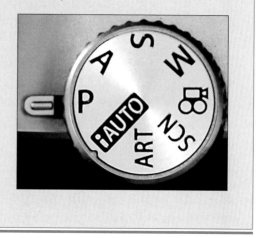

5. **Move the control until the markings or data readout appear sharp to you.**

 Remember, you're not actually focusing the camera on the scene in front of the lens — just the viewfinder display. But when you focus *after* adjusting the viewfinder, the scene should appear sharp in the viewfinder.

TIP

If you can't get the viewfinder in sync with your vision even when you push the diopter adjustment to its limit, you may be able to buy an add-on diopter that extends the range of change that's possible. Check your camera manual for details on this accessory.

Looking at a Few Setup Options

Somewhere on the back of your camera, you should find a Menu button that displays the camera menus on the monitor. And on one or more of those menus, you should find a few options for customizing the camera's basic operation. Again, your manual contains specifics, but here are a few bits of advice regarding the most common options:

✔ **Date and time:** Your camera records the current date and time in the image file, along with details about what other camera settings were in force when you shot the picture. In many photo editors and image browsers, you can view this information, known as *metadata*. (*Meta,* for *extra,* data.)

Having the correct date and time in the image file enables you to have a permanent record of when each picture was taken. More importantly, in many photo programs, you can search for all the pictures taken on a particular date. For example, in the Windows 7 photo browser, Windows Live Photo Gallery, you can display a calendar view, as shown in Figure 3-6, and click a date to view thumbnails of all the pictures you shot on that date.

Figure 3-6: Because the date is recorded with the picture file, you can easily track down pictures taken during a certain period.

Some cameras also have a time-stamp menu option that slaps a text label with the picture date and time on the image itself. Because this information is always stored in the image file, there's no need to permanently mar your image with the text label. You can always add a text label in a photo editor later if you want, but you can't get rid of it if it's created as part of the original image file.

✔ **Auto shut-off:** To conserve battery power, many cameras turn off automatically after a few minutes of inactivity. The drawback is that you can miss fleeting photographic opportunities — by the time you restart the camera, your subject may be gone. If you're not happy with the way this option works, see whether you can adjust the length of time that the camera must be idle before auto shutdown occurs; some cameras also give you the option of turning the feature off entirely.

✔ **Shoot without memory card:** When this feature is enabled, you can take a photo without a memory card installed in the camera. The image is stored in a tiny bit of internal camera memory but usually isn't retained for more than a few minutes. The point of the function is to enable camera salespeople to demonstrate cameras without having to keep memory cards in all of them. To avoid any possibility that you'll shoot all day without a memory card, turn off this function. It may go by another name, such as Slot Empty Release, so check your manual for information.

✔ **Instant review:** After you take a picture, your camera may display it automatically for a few seconds. On some cameras, you can't take another picture until the review period is passed, and if that's the case with your model, you may want to turn off instant review when you're trying to capture fast-paced subjects. And because monitors consume power, also turn off instant review if you're worried about running out of battery juice. You may also be able to adjust the length of the instant-review period.

✔ **File numbering:** Cameras assign filenames to photos, often beginning with a few letters and a symbol (for example, IMG_0023.JPG, DSCN0038. JPG, or something similar). You can often set up your camera to number files beginning with certain numbers, and some cameras actually let you put in a few of your own letters with the file numbers (although it's usually very limited).

Some cameras have an option that automatically restarts the file-numbering sequence when you swap out a memory card. For example, if the current memory card contains a file named IMG_0001.JPG and you put in a new memory card, the camera assigns that same filename to the first picture you take. Obviously, this option can lead to trouble after you download pictures to your computer because you can wind up with multiple pictures that share the same name. So check your manual to find out whether this option exists on your camera, and if so, avoid it.

✔ **Sound effects:** Digital cameras are big on sounds: Some play a little ditty when the camera is turned on. Some beep to let you know that the camera's autofocus or autoexposure mechanism has done its thing, and others emit a little "shutter" sound as you take the picture. There have even been cameras that said "Goodbye" in this odd little digitized voice when you turned the camera off. Before heading to a wedding or any other event where your camera's bells and whistles won't be appreciated, check your camera menu to see whether you can silence them or at least turn down the volume.

Some cameras offer a Museum mode. When you choose this setting, the camera automatically stifles its vocal chords and also disables the flash because flash photography isn't permitted in most museums.

✔ **Shooting information display:** Most cameras display some information about the current picture settings on the monitor, as shown on the left in Figure 3-7. If you find that data distracting, you may be able to hide it, as shown on the right. Usually, you alter the display type by pressing a button labeled Info or DISP (for display), but check your manual for details.

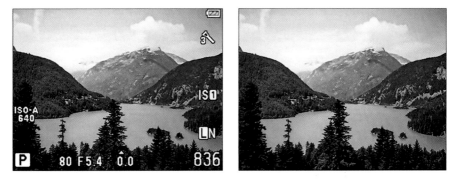

Figure 3-7: If the shooting data displayed on the monitor becomes distracting (left), you may be able to hide it (right).

✔ **Viewfinder and monitor alignment guides:** On some cameras, you can display a grid in the viewfinder or monitor, as shown on the left in Figure 3-8. The grid comes in especially handy when you're shooting landscapes or other scenes where it's important to frame the shot so that the horizon is level. Depending on the camera, you may even be able to display a little digital level, as shown on the right in the figure, to let you know when the camera is level with the horizon.

Figure 3-8: You may be able to display alignment aids in the monitor or viewfinder.

✏ **Monitor brightness:** Adjusting the monitor brightness can make pictures easier to view in bright light. But be careful: The monitor may then give you a false impression of your image exposure. Before you put your camera away, double-check your pictures in a setting where you can use the default brightness level. As another alternative, you may be able to display an exposure guide called a *histogram;* see Chapter 5 for details.

✏ **Button customization:** If you own a higher end camera, you may also have the option of changing the function of certain camera buttons. For example, some cameras have a Function (FN) button, which you can assign to perform any number of tasks, from turning on self-timer shooting to setting the image picture quality. These options are best left alone until you have a good grasp of all the camera's operations — if you start changing the button functions, instructions in the camera manual or any other camera guide won't work.

✏ **Picture resolution and file type:** These two critical settings determine the size and quality of your pictures as well as how much post-capture work you need to perform before you can use those pictures. They're a bit complex, so I cover them separately in the next part of this chapter. If you're not up to poring through that discussion, just use the manufacturer's default settings. Depending on the camera, you may set resolution and file type separately or together; look for options that have names such as Picture Quality, Image Size (resolution), Quality, and so on.

✏ **Return to default settings:** Speaking of default settings, if you ever want to restore all the original camera settings, look through the camera menus for an option that restores the defaults automatically. In some cases, you even can restore just the options on a specific menu.

One note to owners of cameras that automatically reset file numbering whenever you put in a new memory card: Don't forget that if you reset the camera to its defaults, this setting may also go back to that dangerous auto reset option. So after resetting the defaults, change the file numbering setting back to one that doesn't reset you at file 1 every time you swap memory cards.

That concludes my list of basic setup options to check; be sure to flip through your camera manual (or click through, if the manual is provided in electronic format) to find out other options. Then keep moving forward here to learn more about the aforementioned resolution and file type options.

Setting the Resolution and File Type

Almost every digital camera today can create big, beautiful pictures. But in order to get maximum results, you need to understand the two remaining setup options covered in this chapter:

- ✔ **Resolution:** This setting determines how large you can print the photo before quality becomes visibly degraded. It also affects the size of the picture file and how large it displays on a computer monitor or other device.

- ✔ **File type:** This setting controls the format of the picture file — usually, your options are JPEG *(jay-peg)* or Camera Raw. Your choice affects picture quality, file size, and a few other aspects related to capturing and using your pictures.

You may be surprised to learn that most manufacturers don't choose the resolution and file type settings that produce the highest quality results as the defaults (the original camera settings). Why? Because as with everything in life, there are some disadvantages to those higher quality settings, so most cameras ship with settings selected to produce good picture quality without the downside of the maximum settings.

If you're itching to know more, the rest of this chapter gives you the complete scoop. Not itchy yet? Then, again, just stick with the manufacturer defaults for now — your picture quality will be fine, and you won't have to deal with those max-quality disadvantages I mentioned.

Resolution: How many pixels are enough?

Have you ever seen the painting *A Sunday Afternoon on the Island of La Grande Jatte,* by the French artist Georges Seurat? Seurat was a master of a technique known as *pointillism,* in which scenes are composed of thousands

of tiny dots of paint, created by dabbing the canvas with the tip of a paint-brush. When you stand across the room from a pointillist painting, the dots blend together, forming a seamless image. Only when you get up close to the canvas can you distinguish the individual dots.

Digital images work something like pointillist paintings. Rather than being made up of dots of paint, however, digital images are composed of tiny squares of color known as *pixels. Pixel* is short for *picture element.* If you display an image in a photo-editing program and then use the program's Zoom tool to magnify the view, you can see the individual pixels, as shown in the inset in Figure 3-9. Zoom out on the image, and the pixels seem to blend together, just as when you step back from a pointillist painting.

Figure 3-9: Zooming in on a digital photo enables you to see the individual pixels.

The number of pixels in an image is referred to as *resolution.* You can define resolution either in terms of the *pixel dimensions* — the number of horizontal pixels and vertical pixels — or total resolution, which you get by multiplying those two values. This number is usually stated in *megapixels,* or MP for short, with 1 megapixel equal to 1 million pixels.

Every digital photograph is born with a set number of pixels, which you control by using the capture settings on your digital camera. Check your camera manual to find out how to access the setting; it may be called Image Size, Resolution, Quality, or something similar. Note, too, that in some cases, you set the resolution separately from the file type, but on other models, the two are adjusted together.

Your choice of resolution setting is important because it affects three aspects of a digital photo:

- The maximum size at which you can produce good prints
- The display size of the picture when viewed on a computer monitor or television screen
- The size of the image file, which in turn affects how much storage space is needed to hold the file

To help you determine the right pixel population for your photos, the following three sections explore each of these issues.

Pixels and print quality

Generating a good print from a digital photo requires that you feed the printer a certain number of pixels per inch, or *ppi.* So the pixel count of a photo determines how large you can print the image without noticing a loss of picture quality.

Compare, for example, the images in Figures 3-10 through 3-12. The first image has resolution of 300 ppi; the second, 150 ppi; and the third, 75 ppi.

For print purposes, resolution is measured in terms of pixels per *linear* inch, not square inch. So 75 ppi, for example, means 75 pixels wide by 75 pixels high, for a total of 5625 pixels in a square inch.

Why does the 75-ppi image look so much worse than its higher-resolution counterparts? Because at 75 ppi, the pixels are bigger, and the bigger the pixel, the more easily your eye can figure out that it's really just looking at a bunch of squares. Areas that contain diagonal and curved lines, such as the edges of the coins and the handwritten lettering in the figure, take on a stair-stepped appearance.

Figure 3-10: A photo with an output resolution of 300 ppi looks terrific.

Figure 3-11: At 150 ppi, the picture loses some sharpness and detail.

If you look closely at the black borders that surround Figures 3-10 through 3-12, you can get a clearer idea of how resolution affects pixel size. Each image sports a 2-pixel border. But the border in Figure 3-12 is twice as thick as the one in Figure 3-11 because a pixel at 75 ppi is twice as large as a pixel at 150 ppi. Similarly, the border around the 150-ppi image is twice as wide as the border around the 300-ppi image.

Figure 3-12: Reducing the resolution to 75 ppi causes significant image degradation.

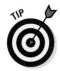

So the burning question is this: Exactly how many pixels are enough to guarantee great prints? Well, it depends in part on how close people will be when viewing the pictures. Consider a photo on a billboard, for example. If you could climb up for a close inspection, you would see that the picture doesn't look very good because billboard photos are typically very low-resolution images, with few pixels per inch. But when you view them from far away, as most of us do, they look okay because our eyes blend all those big pixels together. Unless you're doing billboard photography, however, people will be viewing your images at a much closer range, so a higher resolution is required if you want the pictures to appear crisp and sharp.

The exact resolution you need to produce the best prints also varies depending on the printer. But a good range to shoot for is 200–300 ppi. For quick reference, Table 3-1 shows you the approximate pixel count you need to produce traditional print sizes at the low end of that scale. The first set of pixel values represents the pixel dimensions (horizontal pixels by vertical pixels); the value in parentheses represents the total pixel count, in megapixels (MP).

Table 3-1	How Many Pixels for Good Prints?
Print Size (in inches)	*Pixels for 200 ppi*
4 x 6	800 x 1200 (1 MP)
5 x 7	1000 x 1400 (1.5 MP)
8 x 10	1600 x 2000 (3 MP)
11 x 14	2200 x 2800 (6 MP)

It's critical that you set your camera to the resolution setting that matches your final print needs *before* you shoot. Although some photo programs enable you to add pixels to an existing image — a process called *upsampling* — doing so isn't a good idea. The problem is that when you add pixels, the photo-editing software simply makes its best guess as to what color and brightness to make the new pixels. And even high-end photo-editing programs don't do a very good job of pulling pixels out of thin air, as illustrated by Figure 3-13.

Figure 3-13: Here you see the result of upsampling the 75-ppi image in Figure 3-12 to 300 ppi.

To create this figure, I started with the 75-ppi image shown in Figure 3-12 and resampled the image to 300 ppi in Adobe Photoshop, one of the best photo-editing programs available. Compare this new image with the 300-ppi version in Figure 3-10, and you can see just how poorly the computer adds pixels.

With some images, you can get away with minimal upsampling — say, 10 to 15 percent — but with other images, you notice a quality loss with even slight pixel infusions. Images with large, flat areas of color tend to survive upsampling better than pictures with lots of intricate details.

Chapter 9 provides an in-depth look at printing, talking more about the whole pixel-count issue and exploring other factors that affect print quality. In the meantime, keep these pixel pointers in mind:

✔ The numbers in Table 3-1 assume that you're printing the *entire* photo. If you crop the photo before printing, you need more original pixels to generate a given print size because you're getting rid of a portion of the image.

✔ If you're having your photo professionally printed, you may be required to submit a photo at a specific resolution. For example, the publisher of this book requires photos to be sent at a resolution of 300 ppi. You can establish the resolution for print output in many photo editors.

✔ A resolution of 300 ppi also is typically the right resolution if you're having your photos printed at a local lab such as those at Costco or Wal-Mart, although you don't need to be right on that mark. If you're uploading picture files to the lab's online printing service, the ordering screen usually displays some guidance as to the maximum recommended print size for each picture's resolution.

✔ For do-it-yourself printing on a home printer, 200 to 300 ppi should work just fine. A few printers, however, such as some from Epson, do request that you feed them a slightly higher ppi, so check your printer manual for guidelines.

✔ Although you don't want to drop much below the 200-ppi threshold, neither do you need to shoot for the moon when it comes to pixel count. Once you get past 300 ppi, you usually don't gain anything in terms of print quality; in fact, many printers, when fed an excess of 300 ppi, simply dump the overage. And images with ginormous pixel counts aren't suitable for online sharing and also produce large file sizes, two drawbacks you can read about in the next two sections.

In other words, if you're shooting with a really high-resolution camera, you may not always want to set it to capture the maximum number of pixels. Instead, try to find a sweet spot that delivers the print size you want without bloating the pixel count unnecessarily. Keep in mind that 6MP gives you enough data to print an 11 x 14 print. On the other hand, if you're interested in making huge prints, don't go *too* low — remember, you can always get rid of extra pixels but you can't make them up after the fact.

Pixels and screen images

Although resolution has a dramatic effect on the quality of printed photos, it's irrelevant to the quality of pictures viewed on a monitor, television, or other screen device. The number of pixels controls only the *size* at which the picture appears on the screen. No matter what the pixel count, the quality of the display remains the same.

Here's why: Like digital cameras, computer monitors (and other display devices) create everything you see onscreen out of pixels. With a monitor, you typically can choose from various display settings — through the Windows Control Panel or the Mac System Preferences dialog — each of which results in a different number of screen pixels. Standard settings range from 800 x 600 pixels for a small laptop screen to much more for large, widescreen monitors, which may offer resolutions of 1920 x 1200 pixels or more. Some HDTV sets even double as giant computer monitors, and they have extremely high pixel dimensions.

At any rate, when you display a digital photo, the monitor simply uses one screen pixel to display one image pixel. For example, Figure 3-14 shows the screen of a 19-inch monitor as it appears when set to a display resolution of 1024 x 768 pixels. The photo inside the e-mail window contains 640 x 480 pixels — and therefore consumes 640 of the available 1024 horizontal screen pixels and 480 of the 768 vertical pixels.

Figure 3-14: You don't need many pixels to fill a computer screen.

Clearly then, a photo that contains enough pixels to produce even a medium-size print is too large for screen use. Send someone a photo captured at, say, 6 megapixels, and only a small portion of it will be visible without scrolling. Thankfully, the latest e-mail programs and online photo-sharing sites automatically downsize images to make them more viewable, but if your photo recipient is using an older program, viewing high-resolution images is difficult.

ppi is not dpi!

The capabilities of printers are also described in terms of resolution. Printer resolution is measured in *dots per inch,* or *dpi,* rather than pixels per inch. But the concept is similar: Printed images are made up of tiny dots of color, and dpi is a measurement of how many dots per inch the printer can produce. Generally, the higher the dpi, the smaller the dots, and the better the printed image, although gauging a printer solely by dpi can be misleading. (Chapter 9 talks more about evaluating printers.)

Some people, including some printer manufacturers and software designers, mistakenly interchange dpi and ppi. *But a printer dot is not the same thing as an image pixel.* Most printers, in fact, use multiple printer dots to reproduce one image pixel.

So what do you do if you want to be able to print your pictures *and* share them online or use them for other screen purposes? Always set the camera resolution to match the print size you have in mind. As illustrated in the preceding section, you can't add pixels later successfully to achieve a good print. You can, however, use about any photo-editing program to dump pixels from a high-resolution original to create a copy that's appropriately sized for the screen.

A few cameras offer a setting that enables you to record two copies of each image, an original, full-size one for print and one significantly smaller image for onscreen use. And some models offer a built-in photo-editing tool that you can use to create e-mail sized versions of high-resolution images, too. Check your camera manual to find out whether your camera offers these time-saving features.

Pixels and file size

Many factors affect the size of the data file needed to store a digital picture, including the complexity of the scene (the level of detail, the number of colors, and so on). The file format in which the image is stored, usually either JPEG or Raw, explained later in this chapter, also affects file size. But all other things being equal, an image with lots of pixels has a larger file size than a low-resolution image.

Of course, if your digital camera is relatively new, it creates images that contain tons of pixels, which means whopping file sizes. A 10-megapixel photo, for example, has an average file size of about 4.5MB (megabytes) when saved as a high-quality JPEG image.

Large files present the digital photographer with a number of problems:

- **Large files require more storage space.** When you're shooting huge files, it doesn't take too long to fill up a camera memory card or computer hard drive. And if you archive your files on DVD, as I recommend, you can wind up with a huge disc collection after only a year or so of shooting. Keep in mind that a DVD has a capacity of about 4.7GB, or gigabytes. (One GB equals 1,000MB.)

- **Large files take longer for the camera to capture.** The more pixels you ask your camera to capture, the longer it needs to process and record the picture file to your memory card. That additional capture time can be a hindrance if you're trying to capture action shots at a fast pace.

- **Large files strain your computer.** Large files make bigger demands on your computer's memory (RAM) when you edit them. You also need lots of empty hard drive space for editing because the computer uses that space as temporary storage while it's processing your images.

- **Large files are inappropriate for online use.** When placed on a web page or sent via e-mail, photos that contain bazillions of pixels are a major annoyance. First, the larger the file, the longer it takes to download. And if you send people a high-resolution image in an e-mail, they may not be able to view the whole image without scrolling. Remember, most computer monitors can display only a limited number of pixels. (See the preceding section for details.)

All that said, large files are a fact of life if you want to capture images at your camera's highest resolution and quality settings. But do consider whether you *always* need to max out your pixel count. Are you really going to want to print the picture of your grandma's birthday cake or your new car at 8 x 10 inches or larger? If not, dialing down resolution a notch makes sense.

Setting the File Type

Your camera may offer a choice of file types, or *file formats,* in computer lingo. The format determines how the camera records and stores all the bits of data that comprise the photo, and the format you choose affects file size, picture quality, and what types of computer programs you need to view and edit the photo.

Although many formats have been developed for digital images, most camera manufacturers have settled on just two: JPEG and Camera Raw. A handful of high-end cameras also offer a third format, called TIFF, although that option has largely been replaced by Camera Raw.

Each of these formats has its pros and cons, and which one is best depends on your picture-taking needs. The next sections tell you what you need to know to make a file-format decision.

Be careful not to confuse your camera's *file format* control with the one that *formats* your camera memory card. The latter erases all data on your card and sets it so that it's optimized for your camera. Don't freak out about this possibility: When you choose the card format option, your camera displays a warning to let you know that you're about to dump data. You get no such message for the file format control.

As for how you select a file format, the process varies from camera to camera, so check your manual. On some cameras, you set the format and resolution together; on others, the two are controlled separately. Either way, the settings typically have vague names, such as Good, Better, Best — or, for cameras that control resolution and format together, Large/Fine, Small/Basic, and the like.

JPEG

Pronounced *jay-peg,* this format is standard on every camera. JPEG stands for *Joint Photographic Experts Group,* the organization that developed the format.

JPEG is the leading camera format for two important reasons:

- ✔ **Web- and computer-friendly photos:** All web browsers and e-mail programs can display JPEG images, which means that you can share your pictures online seconds after you shoot them. Furthermore, every image-editing program for both the Mac and Windows supports working with JPEG photos.

- ✔ **Small file sizes:** JPEG files are *compressed* and, therefore, have smaller file sizes than those captured in the Camera Raw or TIFF formats (explained later). That means that you can store more pictures on your memory card as well as on your computer's hard drive or whatever image-storage device you choose. Smaller files also take less time to transmit over the web.

The drawback to JPEG is that in order to trim file size, it applies *lossy compression,* a process that eliminates some original image data. (Many digital-imaging experts refer to this process as simply *JPEG compression.*) Heavy JPEG compression can significantly reduce image quality, especially when the image is printed or displayed at a large size.

Figure 3-15 offers an example of the bad things that can happen with excessive JPEG compression. The image takes on a parquet tile look and often exhibits random color defects — notice the bluish tinges around the eyelashes and near the jaw line. These defects are known collectively in the biz as *JPEG artifacts,* or simply *artifacts.*

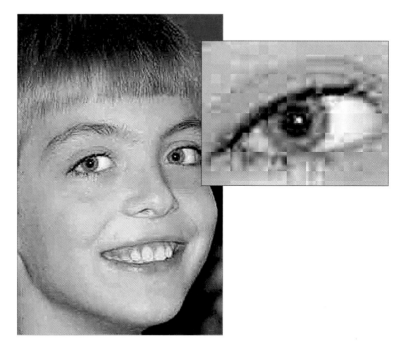

Figure 3-15: Too much JPEG compression destroys picture quality.

Now for the good news: Most cameras enable you to specify the level of JPEG compression that you want to apply, and at the highest-quality setting, the file undergoes only a little bit of compression. The result is a file that provides the benefits of the JPEG format with little, if any, noticeable damage to picture quality, as evidenced by the example in Figure 3-16. Sure, your file size is larger — the high-quality JPEG in Figure 3-16 has a file size of 400K (kilobytes) versus the 33K size of the low-quality version in Figure 3-15 — but what good does that small file size do you if the picture is lousy? Both pictures contain the same number of pixels, by the way, so the quality differences you see are purely a result of compression amounts.

To sum up, as long as you stick with the highest-quality JPEG file your camera can produce, this format is the right choice for all but the most demanding photographers. (If you fall in the latter camp, explore the Camera Raw format, explained in the next section.) And note that even if you choose your camera's lowest-quality JPEG setting, it's highly unlikely that you'll see the level of destruction shown in Figure 3-15 — the defects in the picture are exaggerated so that you can more easily see what JPEG artifacts look like.

Figuring out which camera setting delivers the top-quality JPEG file requires a look at your camera manual because the options differ between models. Typically, compression settings are given vague monikers: Good/Better/Best or High/Normal/Basic, for example.

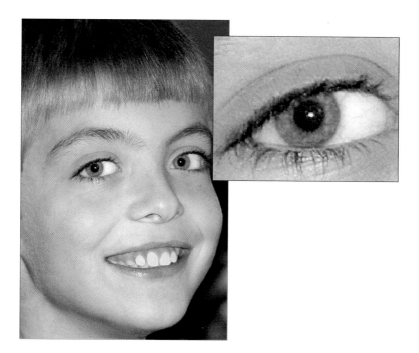

Figure 3-16: But a lightly compressed JPEG produces excellent images while keeping file sizes small.

These names refer not to the amount of compression being applied, but to the resulting image quality. If you set your camera to the Best setting, for example, the image is compressed less than if you choose the Good setting. Also, some cameras may use similar names to refer to image-size (resolution) options rather than JPEG quality options.

You should find a chart in your manual that indicates how many images you can fit into a certain amount of memory at different compression settings. But you need to experiment to find out exactly how each setting affects picture quality. Shoot the same image at all the different settings to get an idea of how much damage you do if you opt for a higher degree of compression.

If your camera offers several resolution settings, do the compression test for each resolution setting. ***Remember:*** Resolution and compression work together to determine image quality. You can usually get away with more compression at a higher resolution. Low resolution combined with heavy compression yields results even a mother couldn't love.

When you edit your images in a photo editor, you can save your altered file in the JPEG format. If you do, though, you apply another round of lossy compression. Each pass through the JPEG compression machine does further damage, and if you edit and save to JPEG repeatedly, you *can* wind up

with the level of artifacting shown in Figure 3-15. So you should instead save works in progress in a format such as TIFF (explained later in this chapter), which does a much better job of preserving picture quality. Should you want to share your edited photo online — which requires a JPEG image — you can create a copy of your final TIFF image and save the copy in the JPEG format.

Camera Raw

When you shoot in the JPEG format, your camera takes the data collected by the image sensor and then applies certain enhancements — exposure correction, color adjustments, sharpening, and so on — before recording the final image. These changes are based on the picture characteristics that the manufacturer believes its customers prefer.

The Camera Raw format, sometimes called simply *Raw,* was developed for photo purists who don't want the camera manufacturer to make those decisions. Camera Raw records data straight from the sensor, without applying any post-capture processes. After transferring the files to a computer, you then use special software known as a *raw converter* to translate the sensor data into the actual photograph.

Unlike JPEG, Camera Raw isn't a standardized format. Each manufacturer uses different data specifications and names for its Raw format. Nikon Raw files are called NEF files, for example, while Canon's versions go by the name CRW or CR2, depending on the camera model.

Whatever the specific name, Raw image capture offers the following advantages:

- **No risk of JPEG compression artifacts:** Unlike JPEG files, Raw files don't undergo lossy compression. That means that when you "shoot Raw," you don't have to worry about the quality loss that can sometimes occur with JPEG compression. Again, though, as long as you stick with your camera's highest-quality JPEG setting, you may have difficulty detecting much difference in quality between the JPEG and Raw version of an image unless you greatly enlarge the photo.

- **Greater creative control:** When you process your "uncooked" picture data in a raw converter, you can specify characteristics such as brightness, color saturation, sharpness, and so on, instead of dining on whatever the JPEG version might serve up. To keep up the cooking analogy, imagine that you put together a special dish and you realize after it comes out of the oven that you accidentally used cayenne pepper when your recipe didn't call for any. If your dish were like a Raw file, you'd be able to go back to the beginning of your cooking session and remove the pepper. With JPEG, that pepper would be a done deal. And that's what photographers like about Raw — files captured in this format give you much more control over the final look of your images.

✔ **Greater latitude for editing the picture:** Raw capture also gives you a bit of a photographic safety net. Suppose that you don't get the exposure settings quite right, for example, when you shoot a picture. With JPEG, the camera decides how brightly to render the shadows and highlights, which can limit you in how much you can retouch that aspect of your picture later. With Raw, you can specify what brightness value should be white, what should be black, and so forth, giving you greater ability to achieve just the image brightness and contrast you want — a benefit that's especially great for pictures taken in tricky light.

✔ **Higher bit depth:** *Bit depth* is a measure of how many distinct color values an image file can contain. With JPEG, your pictures contain 8 bits each for the red, blue, and green color components, or *channels,* that make up a digital image, for a total of 24 bits. That translates to roughly 16.7 million possible colors.

On most cameras, choosing the Raw setting delivers a higher bit count. You may be able to set the camera to collect 12 or more bits per channel, for example. However, you may not really ever notice any difference in your photos — that 8-bit palette of 16.7 million values is more than enough for superb images. Where having the extra bits can come in handy is if you really need to adjust exposure, contrast, or color after the shot in your photo editing program. In cases where you apply extreme adjustments, having the extra original bits sometimes helps avoid a problem known as *banding* or *posterization,* which creates abrupt color breaks where you should see smooth, seamless transitions. (A higher bit depth doesn't always prevent the problem, however, so don't expect miracles.)

Of course, like most things in life, the benefits of Raw do come at a price. First, most low-priced cameras don't offer the format. But Raw also costs you in the following ways, which may be enough for you to stick with JPEG even if your camera is dual-natured in terms of file format:

✔ **Raw files require some post-capture computer time.** You can't take a Raw image straight from the camera and share it online, use it in a PowerPoint presentation, retouch it in a photo editor, or, well, do much of *anything* with it until you process it in a Raw converter such as the one shown in Figure 3-17, which is the one included with Adobe Photoshop. As part of the conversion process, you specify critical image characteristics: color, sharpness, contrast, and so on. Then you save a copy of the processed Raw file in a standard file format, such as JPEG or TIFF (explained in the next section).

Processing Raw files isn't difficult, but it does take time that you may prefer to spend behind the camera. And if you have a hate-hate relationship with computers, Raw is definitely not for you. Some cameras do have a built-in "mini converter" — that is, you can create a JPEG copy of a Raw image right in the camera. That feature makes the process faster

and simpler, but it's not ideal because you have to make judgments about the picture based on a small camera monitor and you typically can specify only a handful of image characteristics. In other words, it's all the inconvenience of Raw without the creative-control benefits.

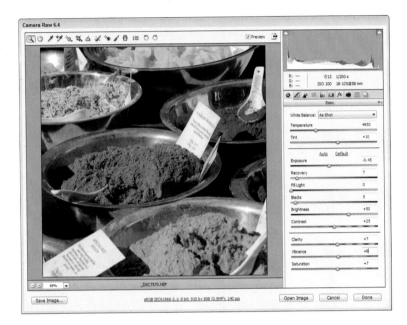

Figure 3-17: Before you can share, print, or use Raw images, you have to process them in a Raw converter; this one is part of Adobe Photoshop.

✓ **You may not be able to view thumbnails of your images on your computer without converting them, either.** If you're used to looking at thumbnails of your photos in Windows Explorer, for example, or iPhoto on the Mac, you may not be able to do so with Raw files, depending on the camera make and model. You will still see the Raw filenames, but no image thumbnails.

However — and here's some good news — most camera companies offer their own image-browsing software for free. (Look on the CD that came with your camera.) You should be able to view and maybe even print Raw images by using those manufacturer-created programs — just not in most third-party programs.

✓ **You may need to buy a separate Raw converter program.** Some camera companies include a good raw-conversion tool on the software CD that ships with the camera. But others provide only a minimally equipped

converter for free, enabling you just to change from Raw to JPEG but using only a standard set of conversion settings, with no control over specific image characteristics. So you may need to buy a third-party program to really take advantage of the picture control that Raw offers.

If you already own a photo-editing program, however, check to see whether it offers a converter. For example, Adobe Photoshop and Photoshop Elements both provide a very capable converter, although the one in Photoshop is naturally more complex. Note that some photo programs are especially designed to speed up the Raw conversion process, and some programs offer more picture controls than others. So shop around and investigate all your options before you buy.

If your software has a Raw converter but balks at displaying or opening the Raw files from your camera, check the software manufacturer's website. You may need to download an update that provides a Raw-file translator for your model of camera. (Note that some software companies are quicker than others at posting updates when new camera models are released.)

✔ **Raw files are larger than JPEG files.** Again, Raw files aren't compressed, so they can be significantly larger than JPEG files, even if you capture the JPEG image at the lowest possible amount of compression. So you can store fewer Raw files on a memory card than JPEG files. (If your camera offers the Raw format, the manual should provide details on the size of its Raw files versus JPEG versions.) In addition, because you probably want to hang onto your original Raw files after you convert them, just for safety's sake, you ultimately wind up with at least two copies of each image — the Raw original and the one that you converted to a standard format.

In short, because of the added complication of working with Raw files, you're better off sticking with JPEG if you're a photo-editing novice, a computer novice, or both. Frankly, the in-camera processing that occurs with JPEG is likely to produce results that are at least as good as, if not better than, what you can do in your photo editor if you're not skilled at the task. (Just remember the earlier warning about saving files that you edit in the TIFF format instead of JPEG.)

Some cameras offer a setting called Raw+JPEG (or Raw+Basic, or something similar). With this option, the camera creates both a Raw file and a JPEG file so that you have a version of the image that you can use immediately and another that you can use if you're inclined to spend hours editing it. Of course, you consume even more camera memory with this option because you're creating two files — and later, you'll have yet one more file after you process the Raw file on your computer.

DNG: Format of the future?

Adobe Systems offers another digital-image file format, DNG. Short for *Digital Negative Format,* DNG was created in response to growing concerns about the fact that every camera manufacturer uses its own, specially engineered flavor of Camera Raw. This Photo Tower of Babel makes it difficult for software designers to create programs that can open every type of Raw file, which in turn makes it difficult for people to share Raw files. That issue isn't a huge problem for the average consumer, but it's a pain for professionals who sometimes must work with Raw images from many photographers. In addition, the possibility exists that future software may not support earlier generations of Raw files, leaving people with images they can no longer open (think Betamax videotapes and 8-track audio recordings).

The idea of DNG is to create a standard raw-data format that all camera manufacturers can embrace. That goal is still being pursued by Adobe, but if you want to translate your current Raw files to DNG, the Adobe website (www.adobe.com) offers a free converter that can handle files from many current digital cameras. Of course, there's no guarantee that DNG will be around 100 years from now, either, and some photo programs can't yet open DNG files. But with Adobe backing the format, it's a reasonable bet that DNG will one day be as common as JPEG or TIFF.

TIFF

The third player in the image file format game is TIFF, which stands for *Tagged Image File Format.* Like Camera Raw, TIFF is a *lossless* image format, meaning that it retains your picture at its highest quality — as opposed to JPEG's lossy compression, which can dump critical image data. TIFF has long been the standard format for images destined for professional printing, where the highest quality is required.

Before the emergence of Camera Raw, some high-end cameras offered TIFF as an alternative to JPEG. Most cameras, now, though, don't offer the option to record images as TIFF files. Instead, TIFF is a *destination format:* You save an edited JPEG file in TIFF format, for example, so that no more compression and data loss occur. Or if your camera offers the ability to save files in the Camera Raw format, you can save them in TIFF format after you process them so that you preserve the best image quality.

TIFF does present two problems: First, TIFF files are much larger than JPEG files. In addition, web browsers and e-mail programs can't display TIFF photos. If you do want to share a TIFF file online, you need to open the file in a photo editor and save a copy of it in the JPEG format.

4

Easy Does It: Great Photos in Automatic Mode

In This Chapter

▸ Reviewing the basics of good photo composition

▸ Choosing an automatic exposure mode

▸ Selecting the shutter-release mode and a few other picture settings

▸ Framing, focusing, and taking your first shots

*L*earning all there is to know about digital photography — heck, learning a hundredth of all there is to know — isn't a quick or easy proposition. There are so many technical terms and camera settings to consider that it's just not possible to sort everything out in a few weeks or a single read of this book.

The good news — and the point of this chapter — is that while you're getting up to speed, you can still take great pictures by using your camera's automatic exposure modes. In these modes, the camera takes care of selecting the critical picture-taking settings, from exposure options to color controls. That leaves you free to concentrate on the composition of the photo, which I would argue is even more important than technical mastery of your equipment. You can have the best technical skills in the world, but if you don't also have an eye for composition, your photos will be yawners at best.

Not sure what you're doing as far as composition goes, either? No worries — the first part of this chapter lays out a few simple compositional guidelines that can have an immediate impact on your

images. Following that, the remainder of the chapter explains how to get the best results when shooting in your camera's automatic exposure modes.

Composing a Stronger Image

You don't have to be an art major to understand that your camera angle and distance, as well as how you position elements of a scene, can make the difference between a well-composed image and one that falls flat. Of course, not everyone agrees on the best ways to compose an image — art being in the eye of the beholder and all that. For every composition rule, you can find an incredible image that proves the exception. That said, the next several sections offer five basic compositional tips that can help you create images that rise above the ho-hum mark on the visual interest meter. Be sure to also visit Chapter 7 for more tips on taking specific types of pictures.

Following the rule of thirds

For maximum impact, don't place your subject smack in the center of the frame. Instead, mentally divide the frame into thirds like a tic-tac-toe game, as illustrated in Figure 4-1. Then position the main subject elements at spots where the dividing lines intersect. In the sample image, the point of interest, the bee in the large daisy, falls at that placement, for example.

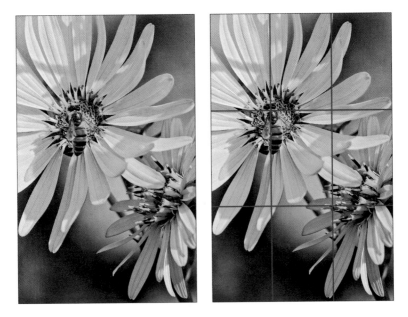

Figure 4-1: One rule of composition is to divide the frame into thirds and position the main subject at one of the intersection points.

Figure 4-2 offers another example of how following the rule of thirds can improve a picture. In the first image, putting the horizon line at dead center makes for a boring shot, even though the sunset is beautiful. Reframing to shift the horizon line down to the bottom third of the frame creates the more dynamic composition shown on the right.

Figure 4-2: Putting the horizon line at dead center makes for a dull image (left); reframing to follow the "rule of thirds" leads to a more dynamic shot.

Creating movement through the frame

To add life to your images, compose the scene so that the viewer's eye is naturally led from one edge of the frame to the other. For example, in Figure 4-3, the winding canal takes the eye from the boat in the foreground all the way to the back of the frame, while in Figure 4-4, the strong diagonal lines of the walkway and the curving arches that frame it do the trick. You can also move the eye through the frame by finding repeating patterns of color, as shown in Figure 4-5, or with patterns of light and shadow, as in Figure 4-6.

Figure 4-3: Here, the winding canal leads the eye vertically through the frame.

Figure 4-4: The strong diagonals in the walkway, framed by the curved archways, create movement in this shot.

Figure 4-5: In this photo, the repeating pattern of blue leads the eye from one corner to the other.

Working all the angles

Resist taking the predictable shot: the front-and-center view of the monument, the shot looking down at the top of the birthday cake, the front-facing portrait of two people standing side by side and saying "cheese." Instead, spend some time studying your subject *before* you even pick up your camera. What's the most interesting viewpoint to capture? As an example, see Figure 4-7. This image accurately represents the statue. But the picture is hardly as captivating as the images in Figure 4-8, which show the same subject from more unusual angles.

Professional photographers "work the angles," experimenting with shooting their subject from above, below, from the side, and so on. Only by moving around and really seeing your subject from all sides can you find the most interesting angle. And doing that bit of extra work is what can separate your photos from the ones taken by 99 percent of the other people photographing the same subject.

Figure 4-6: The strong contrast between the dark background and the bright foreground emphasizes the curves of the calla lily.

Editing out the clutter

Know that claustrophobic feeling you get when you walk in a store that is jam-packed to the rafters with goods — so cluttered that you can't even move through the aisles? That's the same reaction most people have when looking at a photo like the one in Figure 4-9. There's simply too much going on. The eye doesn't know where to look, except away.

Figure 4-7: The standard-issue front-and-center view equals "yawn."

Figure 4-8: Looking at the statue from different angles reveals more interesting shots.

As a photographer, you must decide what you want your main subject to be and then try to frame the shot so that distracting elements aren't visible. For example, in Figure 4-10, reframing the shot to include just a portion of the ride creates a much better image. All the energy of the fair is captured in the whirling chairs, and the composition is such that the eye moves around the curve of the frame to take it all in. To add an even greater sense of motion, I used a shutter speed slow enough to slightly blur the whirling riders while keeping the rest of the ride sharp. (Chapter 5 explains how to use shutter speed to control motion blur.)

Figure 4-9: This shot looks chaotic because there's too much going on for the eye to land on any one subject.

Being aware of the subject's surroundings is especially critical in portraits. If you're not paying attention, you can wind up with "plant on the head" syndrome, as illustrated in Figure 4-11. The window blinds and computer monitor further distract from the subject's beautiful face in this picture.

Long story short: Pick a subject — a *single subject* — and then work to find an angle that eliminates unwanted clutter from the background. If you can't move the subject, move your feet and keep looking until you find the best angle to flatter that subject. If all else fails, see Chapter 6 to find out how to blur the background so that it's less distracting. (Using Portrait or Close-up scene modes, discussed later in this chapter, may also result in a blurred background.)

Giving them room to move

For pictures that portray movement, don't frame your images so tightly that your subject looks cramped. For example, suppose you're shooting a cyclist racing along a street course. Frame the image with extra margin in the direction the biker is riding, as shown in Figure 4-12. Otherwise, it appears that there's nowhere for the subject to go. Similarly, when shooting animals or people in profile, leave extra padding in the direction that the subjects' eyes are focused, as shown in Figure 4-13. This helps the eye follow the focus of the subjects across the frame and then causes the viewer to imagine what is just out of sight.

One note regarding this compositional point: as you look through this book or browse through other photography books and magazines, you'll see lots of examples of very tightly framed images that work very well. But in many cases, the images were

Figure 4-10: Concentrating just on a small portion of the ride captures its energy without all the distracting background.

Figure 4-11: Scan the background for distracting objects to avoid "plant on the head" syndrome in portraits.

originally framed loosely and then cropped to the final composition. Why not just frame tightly to begin with? Because if you want to later print your images at traditional frame sizes — 4 x 6, 5 x 7, 8 x 10, and so on — you may be out of luck.

Here's the deal: Most digital cameras create originals with either a 3:2 or 4:3 aspect ratio. A 3:2 original translates perfectly to a 4 x 6-inch snapshot print, but at any other frame size or if you start with a 4:3 original, you have to crop out some of the image to fit the proportions of the print. For example, the original scene in Figure 4-14 has a 3:2 aspect ratio. The red outline in the left photo shows you how much of the portrait would fit into a 5 x 7-inch frame; the one in the right photo, an 8 x 10-inch frame. Had I composed the original with a very tight frame, I wouldn't have been able to crop to a different frame size without cutting off important parts of the picture. So especially when I'm shooting portraits, I always leave some extra padding around the edges of the frame. (Some people refer to this margin area as "head room" when discussing portraits.)

Figure 4-12: Give moving subjects some-where to go in the frame.

Nancy Nauman

Figure 4-13: Leaving extra space on the right causes the viewer to follow the bear cubs' glance across the frame.

5 x 7 frame area 8 x 10 frame area

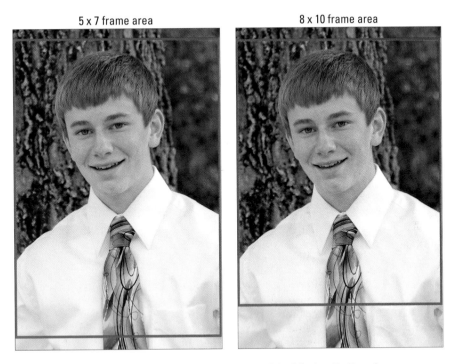

Figure 4-14: This image illustrates how much of a 3:2 original fits in a 5 x 7- and 8 x 10-inch frame.

Don't be put off by the idea of having to crop your picture, either – it's not a difficult task and even the most basic photo software programs offer easy-to-use crop tools. You can also crop the image before printing at a retail print kiosk, and many cameras even have a built-in tool that duplicates your original and then enables you to crop the copy.

Taking Your First Pictures

After thinking about how you want to compose your image, you're ready for the big moment: time to actually take some pictures. Again, if you're just getting your photographic feet wet, you can take advantage of your camera's automatic exposure modes to make life easier. In fact, most cameras offer several fully automatic, point-and-shoot modes.

Although you no doubt can figure out the basics of using these modes, there are a few tricks that can help you get the best performance from your camera's automated offerings. The rest of this chapter lays out these tips, explains the most common automated shooting modes, and covers a couple camera settings you need to consider no matter what mode you choose.

Setting the focus mode: Auto or manual?

Most point-and-shoot digital cameras offer only autofocus, but a few do permit manual focusing. When you're just getting comfortable with your camera, stick with autofocus — with manual focusing on a point-and-shoot camera, you usually have to dig through menus and specify an exact camera-to-subject distance, which is tricky.

If you own a dSLR, you can either take advantage of autofocus or focus manually by twisting a focusing ring on the lens barrel. Typically, you use a switch on the lens barrel or the camera body to specify which focusing option you want to use. Look for a switch that has the labels A or AF and M or MF. Figure 4-15 shows the switch as it appears on some Nikon lenses, for example.

On some dSLR lenses, you also get a switch for enabling or disabling image stabilization, a feature designed to prevent blurring caused by camera movement that can occur when you handhold the camera. (The VR switch shown in Figure 4-15 represents Vibration Reduction, the Nikon version of this feature.) See Chapter 1 for more information about image stabilization, and check your camera or lens manual to find out how to best take advantage of it with your equipment.

Vibration Reduction switch

Auto/manual focus switch

Figure 4-15: Lenses on dSLR cameras typically contain a lens switch that sets the focus mode to manual or automatic.

Most, but not all, compact system camera lenses also have a focusing ring for manual focusing. You may need to set the focusing mode via a menu option rather than via a switch on the lens, however. Again, your camera and lens manual should spell everything out for you.

TIP

More focus factors to consider

When you focus the lens, either in autofocus or manual focus mode, you determine only the point of sharpest focus. The distance to which that sharp-focus zone extends — what photographers call the *depth of field* — depends in part on the *aperture setting,* which is an exposure control, and the aperture setting varies depending on the automated photography mode you select.

For example, many cameras offer a Portrait scene mode, which uses an aperture setting that shortens the depth of field so that background objects are softly focused — an artistic choice that most people prefer for portraits. On the flip side of the coin, the Landscape mode selects an aperture that produces a large depth of field so that both foreground and background objects appear sharp.

Another exposure-related control, *shutter speed,* plays a focus role when you photograph

moving objects. Moving objects appear blurry at slow shutter speeds; at fast shutter speeds, they appear sharply focused. Many cameras have a Sports or Action scene mode that automatically selects a high shutter speed to help you "stop" action, producing blur-free shots of the subject.

A fast shutter speed can also help safeguard against overall blurring that results when the camera is moved during the exposure. The faster the shutter speed, the shorter the exposure time, which reduces the time that you need to keep the camera absolutely still. Using a tripod is the best way to avoid the problem when you use a slow shutter speed.

For an explanation of the role of shutter speed and aperture in exposure, check out Chapter 5. Chapter 6 discusses various issues related to focusing.

Choosing an automatic exposure mode

Most digital cameras offer a variety of automatic exposure modes, which you select either via menus or an external dial or switch. In all these modes, the camera handles critical exposure decisions, such as selecting the aperture setting and shutter speed. Shooting in automatic mode also typically means that the camera handles most other settings, too, including those that affect color and autofocusing.

Although the number and type of automatic exposure modes vary from camera to camera, they can be broken down into two general categories:

- **Full Auto:** This setting is designed to deliver good results no matter what your subject. Think of it as one-size-fits-all shooting. Some cameras also have a Flash Off setting, which is just like Full Auto but with the

flash disabled. (It's designed for shooting in places that don't permit flash, such as most museums.)

✔ **Scene modes:** These settings are specialized modes geared to specific subjects — people, landscapes, and so on.

The next few sections offer some more information about shooting in Full Auto mode and give you an overview of four of the most common scene modes: Portrait, Landscape, Close-up, and Sports.

One word of advice before you move on: automatic exposure modes are great in that you don't have to know much about photography or have to worry about setting a bunch of controls before you shoot. But the downside is that you typically lose access to some features that may be helpful for capturing your subject. For example, the camera usually decides whether or not a flash is needed, and you can't override that decision. And some cameras don't let you tweak color or exposure, either.

So if your camera offers more advanced exposure modes, such as aperture-priority autoexposure, shutter-priority autoexposure, or manual exposure, it's worth your time to learn how to use them. They may take a while to fully grasp, but they make your life easier in the long run because you can easily tweak exposure, color, and focus settings to precisely suit your subject. See Chapters 5 through 7 for a look at the many picture-taking options you can access when you shift out of fully automatic exposure modes.

Full Auto mode

In Full Auto mode, the camera selects all settings based on the scene that it detects in front of the lens. Some cameras use different settings if they detect motion in the scene, for example, than if they detect a stationary subject. You may be able to specify the image resolution and a few other settings, but for the most part, you get no input into how the picture is captured. (See Chapter 3 for help with resolution.)

If you have exposure or color problems in this mode, check out Chapters 5 and 6 to discover some possible remedies. But again, whether you have access to the techniques covered in those chapters depends on your camera and how it implements Full Auto mode.

Portrait mode

Portrait mode attempts to select exposure settings that produce a blurry background, which puts the visual emphasis on your subject, as shown in Figure 4-16. Keep in mind, though, that in certain lighting conditions, the camera may not be able to choose the exposure settings that produce the soft background.

Additionally, the background blurring requires that your subject be at least a few feet from the background. The extent to which the background blurs also depends on the other depth-of-field factors that you can explore in Chapter 6. Remember, too, that cameras that use smaller image sensors, such as compact point-and-shoot models, typically can't produce an extremely short depth of field. (The photo in Figure 4-16 was taken with a dSLR.) But you should at least notice some background blurring in Portrait mode.

Figure 4-16: The portrait setting produces a softly focused background.

Keep in mind that you can use Portrait mode anytime you want a slightly blurry background, not just for people pictures. Try this mode when shooting statues, still-life arrangements (such as a vase of flowers on a kitchen table), insects, and the like. It's also a possible solution for softening the impact of a busy background when you can't relocate the subject — the blurrier the objects, the less distracting they become.

Check your manual to find out what other image adjustments may be applied in Portrait mode. Some cameras, for example, tweak color and sharpness in a way designed to produce flattering skin tones and soften skin texture. And one more tip: If you're not sure that your subject will remain motionless, the Sports mode, which is designed to capture moving subjects without blur, may deliver better results. The background may not be blurred in that mode, however.

Landscape mode

Whereas Portrait mode aims for a very shallow *depth of field* (small zone of sharp focus), Landscape mode, which is designed for capturing scenic vistas, city skylines, and other large-scale subjects, produces a large depth of field. As a result, objects both close to the camera and at a distance appear sharply focused. Figure 4-17 offers an example; notice that the walkway remains in sharp focus throughout the entire frame.

Like Portrait mode, Landscape mode achieves the greater depth of field by manipulating the exposure settings — specifically, the aperture, or f-stop setting. So the extent to which the camera can succeed in keeping everything in sharp focus depends on the available light and the range of aperture settings provided by the lens. To fully understand this issue, see Chapter 5, and in the meantime, know that you also can extend depth of field by zooming out and moving farther from your subject, too.

On most cameras, Landscape mode also adjusts colors to emphasize blues and greens. If you don't care for that color choice, you can try changing the camera's white-balance setting, a color control covered in Chapter 6. However, some cameras put that control off limits in automatic exposure modes. Additionally, flash is usually disabled in Landscape mode, which presents a problem only if you need some extra light on an object in the front of the scene.

Figure 4-17: Landscape mode produces a large zone of sharp focus and also boosts color intensity slightly.

Again, think beyond the Landscape moniker when you look for good ways to put this mode to use: Try it when shooting long-range pictures of animals at the zoo, for example, so that critters both near and far appear sharp. It's also good for shooting a group of people (such as a team sitting in bleachers) where you want to be able to see every smiling face crisply.

Close-up mode

On most cameras, Close-up mode — also known as *macro* mode — is represented by a little flower icon. On some point-and-shoot cameras, selecting this mode enables you to focus at a closer distance than usual. For a dSLR, the close-focusing capabilities of your camera depend entirely on the lens you're using. But in either scenario, your camera or lens manual should spell out exactly how close you can get to your subject.

Choosing this mode typically results in exposure settings designed to blur background objects so that they don't compete for attention with your main subject, as with the wedding cake in Figure 4-18. Again, notice that the background table is significantly blurry — a big help to this image because if all those objects were in sharp focus, they would compete with the cake for the eye's attention. As with Portrait mode, though, how much the background blurs varies depending on the capabilities of your camera, the distance

between your subject and the background, and on the lighting conditions. Should you prefer a greater or shorter depth of field, see Chapter 6 for other ways to adjust this aspect of your pictures.

As with the other scene modes, the camera may tweak colors slightly and may or may not allow you to use flash. The region of the frame that's used to establish focus also varies, so check that manual.

Sports mode

Sports mode, sometimes also called Action mode, results in a number of settings that can help you photograph moving objects such as the soccer player in Figure 4-19. First, the camera selects a fast shutter speed, which is needed to "stop motion." *Shutter speed* is an exposure control that you can explore in Chapter 5.

With some cameras, dialing in Sports mode also selects some other settings that facilitate action shooting. For example, if your camera offers *burst mode* or *continuous capture,* in which you can record multiple images with one press of the shutter button, Sports mode may automatically shift to that gear. And flash is usually disabled, which can be a problem in low-light situations; however, it also enables you to shoot successive images more quickly because the flash needs a brief period to recycle between shots.

The other critical thing to understand about Sports mode is that whether the camera can select a shutter speed fast enough to stop motion depends on the available light and the speed of the subject itself. On the other hand, a little blurring in an action photo can sometimes be acceptable and add to the effect of motion.

For more tips on action photography, check out Chapter 7.

Figure 4-18: Close-up mode also produces short depth of field. Notice how all the objects on the background table are blurred.

Figure 4-19: To capture moving subjects without blur, try Sports mode.

Reviewing other critical capture settings

In addition to choosing a focus mode and exposure mode, you should review the following settings before you shoot. Other chapters get into these options in more detail, but here's a quick introduction to the most critical ones so that your first photos are at least close to being perfect:

✔ **Resolution:** This option, detailed in Chapter 3, determines how many *pixels* the image will contain. The more pixels you have, the larger you can print your photos and expect good picture quality.

Most cameras enable you to select from two or more resolution settings. For now, just select the camera's top resolution setting — it's better to have too many pixels than too few. You can also refer to the chart in Chapter 3 to find out how many pixels you need to produce different sizes of prints.

The resolution option is presented in different ways, depending on the camera. You may be given a choice of pixel dimensions or total pixel count in megapixels (1 *megapixel* equals 1 million pixels). Some cameras take another approach, using vague option names such as Large, Medium, or Small. Your camera manual should spell out exactly how you go about changing the resolution and how many pixels you get with each setting.

✔ **File format:** Chapter 3 fully explores the issue of file formats, which simply refers to the type of data file the camera produces. Until you have time to digest that information, consult your camera manual to find out what setting results in a JPEG *(jay-pegg)* file at the highest image quality. (It will be the JPEG setting that produces the largest file.) This setting ensures the best quality images without some of the complications created by the other file type that may be available to you, called Camera Raw.

Your camera might combine the resolution and format options into one setting. For example, on some Canon cameras, you select Large/Fine to dial in the highest resolution with the top-quality JPEG setting.

✔ **ISO:** This setting, fully explained in Chapter 5, adjusts the camera's sensitivity to light. The higher the ISO number, the less light the camera needs to expose the image. But higher ISO settings also can result in a speckly looking defect called *noise.* So whenever possible, use the lowest ISO your camera offers. Note that in automatic exposure modes, the camera may lock you out of controlling ISO, however, and raise and lower the ISO according to the lighting conditions.

✔ **Shutter-release mode:** Many cameras offer a choice of shutter-release modes, which simply control what happens when you press the shutter button. Common modes include

- *One-shot or single-frame mode:* The camera records one image every time you fully depress the shutter button. In other words, this is normal photography mode.

- *Continuous or burst mode:* You press and hold the shutter button down to record a continuous series of images at a rapid pace. (How many frames you can capture per second and how many images can be captured in a single burst varies from camera to camera.)

- *Self-timer mode:* You fully press and release the shutter button, and the image is captured several seconds later. (This is the mode you use when you want to put yourself in the picture.)

- *Remote-control mode:* Some cameras enable you to trigger the shutter button with a remote control unit; if so, this mode sets up the camera for that option.

The name of the option that controls the shutter-release mode varies; it may be named something like Drive mode, Release mode, or Shooting mode, for example.

✓ **White balance:** This option is designed to compensate for the various colors of light — warm candlelight, bluish flash light, and so on. Chapter 6 explains it fully; until you visit that chapter, keep the White Balance option set to Auto (often presented as AWB). The camera typically does a good job of sorting out colors in Auto White Balance mode. If you do have color issues, you may need to switch to an advanced exposure mode because many cameras limit you to Auto White Balance in the fully automatic exposure modes.

Pressing the shutter button

With all your initial picture-taking settings dialed in, all that's left to do is frame the shot and press the shutter button.

Anytime you take advantage of autoexposure, autofocus, or both, however, the way you press the shutter button is critical. In order for the automatic mechanisms to work, you must use the following two-stage approach, illustrated in Figure 4-20:

1. **After framing the shot, press and hold the shutter button halfway down.**

 The camera's autofocus and autoexposure meters begin to do their thing. In dim light, the flash may turn on or pop up if the camera thinks additional light is needed.

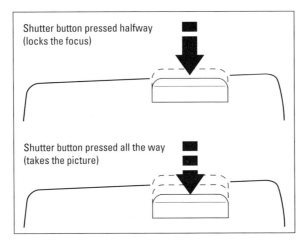

Shutter button pressed halfway
(locks the focus)

Shutter button pressed all the way
(takes the picture)

Figure 4-20: It's important to press the shutter button in two
stages, pausing halfway to let the camera set focus and exposure.

Be sure to check your manual to verify how your camera establishes focus. In some cases, for example, you need to compose your image so that your subject is within a certain area of the frame, and some cameras adjust their autofocusing behavior depending on whether they think you're shooting a still or moving subject. For still subjects, the camera may lock its focus when you depress the shutter button halfway. But if the camera senses motion, it may continually adjust focus from the time you depress the shutter button halfway.

When focus is established, the camera will likely beep at you and display a focus-confirmation light in the viewfinder or on the monitor.

2. **Press the shutter button the rest of the way and then release it to record the image.**

While the camera sends the image data to the camera memory card, another light on your camera may illuminate. Don't turn off the camera or remove the memory card while the lamp is lit, or you may damage both camera and card.

When the recording process is finished, most cameras display the picture briefly. If you want a longer look at the image, you'll need to put the camera into playback mode.

If the picture didn't work out as planned, move on to Part III of the book to discover all the myriad ways you may be able to manipulate exposure, color, focus, and other characteristics of your photo.

Part III
Moving Beyond Full Auto

The 5th Wave — By Rich Tennant

©RICHTENNANT

"Remember, when the subject comes into focus, the camera makes a beep. But that's annoying, so I set it on vibrate."

*Y*ou can take good pictures by using your camera's fully automatic exposure modes — Part II shows you how. But if you want to put your own creative stamp on a photo, you need to step beyond automatic modes so that you can take more control over exposure, focus, and color.

Chapters in this part of the book provide the information you need to do just that. Chapter 5 explains the fundamentals of exposure and discusses some common exposure controls, and Chapter 6 introduces you to ways to manipulate focus and color. Chapter 7 helps bring all this information together by providing recipes for shooting specific types of pictures, including portraits, action shots, and close-ups. In other words, this part helps put *you* in charge of your camera so that you can make the leap from snapshooter to real photographer.

5

Taking Control of Exposure

Getting a grip on the digital characteristics of your camera — resolution, file type, and so on — is critical. But don't get so involved in this side of digital photography that you overlook traditional photography fundamentals such as proper exposure and lighting. All the megapixels in the world can't save a picture that's too dark or too light.

To that end, this chapter tackles all things exposure-related, explaining such basics as how shutter speed, aperture, and ISO affect your pictures and how you can solve common exposure problems. Also look here for information about flash photography, advanced exposure features such as shutter-priority autoexposure and aperture-priority autoexposure, and ways to manipulate exposure to meet your creative goals.

Understanding Exposure

Entire books have been written on the subject of exposure, which may lead you to believe that exposure is an incredibly complex issue. And you *can* get into lots of arcane details about the science behind how cameras turn light into photographs if you're interested. If you're into that kind of technical stuff, go for it. But

if you're not the science-y type, I have good news for you: You don't need a degree in exposure to be a great photographer. In fact, you can take a huge leap forward in your photographic skills by familiarizing yourself with just three exposure controls: aperture, shutter speed, and ISO.

The next several sections get you up to speed on these three critical exposure settings.

Introducing the exposure trio: aperture, shutter speed, and ISO

Any photograph, whether taken with a film or digital camera, is created by focusing light through a lens onto a light-sensitive recording medium. In a film camera, the film negative serves as that medium; in a digital camera, it's the image sensor, which is an array of light-responsive computer chips.

Between the lens and the sensor are two barriers, known as the *aperture* and *shutter,* which together control how much light makes its way to the sensor. The actual design and arrangement of the aperture, shutter, and sensor vary depending on the camera, but Figure 5-1 offers an illustration of the basic concept.

The aperture and shutter, along with a third feature known as *ISO,* determine *exposure* — what most would describe as the picture's overall brightness. This three-part exposure formula works as follows:

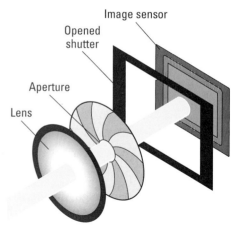

Figure 5-1: The aperture size and shutter speed determine how much light strikes the image sensor.

✏ **Aperture (controls amount of light):** The *aperture* is an adjustable hole in a diaphragm set just inside the lens. By changing the size of the aperture, you control the size of the light beam that can enter the camera. Aperture settings are stated as *f-stop numbers,* or simply *f-stops,* and are expressed with the letter *f* followed by a number: f/2, f/5.6, f/16, and so on. The lower the f-stop number, the larger the aperture, and the more light is permitted into the camera, as illustrated by Figure 5-2. To put it another way, raising the f-number stops more light.

The range of possible f-stops depends on your lens and, if you use a zoom lens, on the zoom position (focal length) of the lens. Your camera or lens manual should spell out the f-stops you can use.

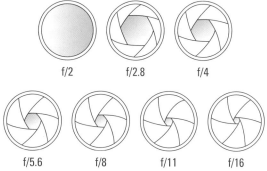

Figure 5-2: As the f-stop number increases, the aperture size shrinks, stopping more light from entering the camera.

✓ **Shutter speed (controls duration of light):** The shutter works something like, er, the shutters on a window. When you aren't taking pictures, the camera's shutter stays closed, preventing light from striking the image sensor, just as closed window shutters prevent sunlight from entering a room. When you press the shutter button, the shutter opens briefly to allow light that passes through the aperture to hit the image sensor. The exception to this scenario is when you compose images using the camera's monitor instead of a viewfinder — the shutter remains open so that your image can form on the sensor and be displayed on the camera's LCD. Then, when you press the shutter release, you hear several clicks as the shutter first closes and then reopens for the actual exposure.

This description, however, applies to a traditional, mechanical shutter similar to the one represented in Figure 5-1. Many digital cameras instead forgo a mechanical shutter in favor of an *electronic shutter.* With this design, the image sensor simply passes the current image data to the memory card for the duration of the exposure.

Either way, the exposure time is referred to as the *shutter speed* and is measured in seconds: 1/60 second, 1/250 second, and so on. On most cameras, an inches mark is used to indicate shutter speeds of 1 second or more: 1", for example, means a shutter speed of 1 second. The range of shutter speeds varies from camera to camera; again, check your manual for specifics.

Some cameras also offer a feature called *bulb* exposure. At this setting, the shutter stays open indefinitely as long as you press the shutter button. Usually, you must set the camera to full manual exposure control to access the bulb setting.

✔ **ISO (controls light sensitivity):** ISO, which is a digital function rather than a mechanical structure, enables you to adjust how responsive the image sensor is to light. The term ISO is a holdover from film days, when an international standards organization rated each film stock according to light sensitivity: ISO 200, ISO 400, ISO 800, and so on. As with the range of f-stops and shutter speeds, the range of ISO settings varies from camera to camera.

On a digital camera, the sensor itself doesn't actually get more or less sensitive when you change the ISO — rather, the light "signal" that hits the sensor is either amplified or dampened through electronics wizardry, sort of like how raising the volume on a radio boosts the audio signal. But the upshot is the same as changing to a more light-reactive film stock: A higher ISO means that less light is needed to produce the image, enabling you to use a smaller aperture, faster shutter speed, or both. (In other words, from now on, don't worry about the technicalities and just remember that ISO equals light sensitivity.)

Distilled to its essence, the image-exposure formula is just this simple:

✔ Aperture and shutter speed together determine the quantity of light available to expose the image.

✔ ISO determines how much the image sensor reacts to that light and, therefore, how much light you need to expose the picture.

The tricky part of the equation is that aperture, shutter speed, and ISO settings affect your pictures in ways that go *beyond* exposure. You need to be aware of these side effects, explained in the next section, to determine which combination of the three exposure settings will work best for your picture.

The next three sections dig more deeply into the side effects of each component of the exposure trio.

Aperture also affects depth of field

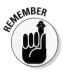

Along with altering exposure, the aperture setting also affects *depth of field*, or the distance over which objects in the picture appear sharply focused. Chapter 6 explores depth of field in detail; for now, just know that the higher the f-stop, the greater the depth of field. Figure 5-3 illustrates this issue. Notice that the background in the left image, captured at an f-stop of f/16, is much sharper than its sibling, taken at f/5.6. The left image has a greater depth of field due to the higher f-stop.

You can use this aperture side effect to your creative advantage: For exam-
ple, if you're shooting a landscape and want to keep both near and distant
objects as sharply focused as possible, you choose a high f-stop number. Or
if you're shooting a portrait and want objects in the background to be softly
focused, you choose a low f-stop number, which reduces depth of field.

One point to note, though: how much depth of field you get at any f-stop
varies depending on the camera and the lens. For reasons that aren't impor-
tant to get into, cameras that use small image sensors produce a greater
depth of field than those with larger sensors. That means that the back-
ground blurring you see at f/5.6 may be more or less than what you see in my
example, so you need to do some experimenting to gauge depth of field pos-
sibilities with your camera and lens.

f/16, large depth of field f/5.6, shallow depth of field

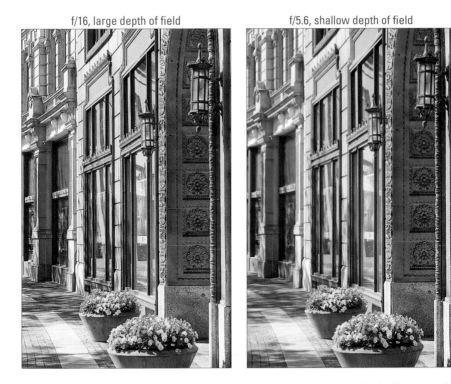

Figure 5-3: A higher f-stop increases depth of field, or the distance over which objects remain
sharply focused.

Shutter speed also affects motion blur

Like the aperture setting, shutter speed also affects the apparent focus of your image, but in a different way. Shutter speed determines whether any moving objects in the scene appear blurry or sharp. A fast shutter speed "freezes" action; at slow shutter speeds, the action is blurred. The speed you need to stop action depends on how fast your subject is moving. In the left image in Figure 5-4, for example, a shutter speed of 1/100 second left the jumping children blurry. Setting the shutter speed to 1/300 second caught them cleanly in mid-jump. For the second image, I raised the ISO setting to enable the faster shutter speed because the camera was already set to its lowest f-stop (most open aperture).

1/100 second 1/300 second

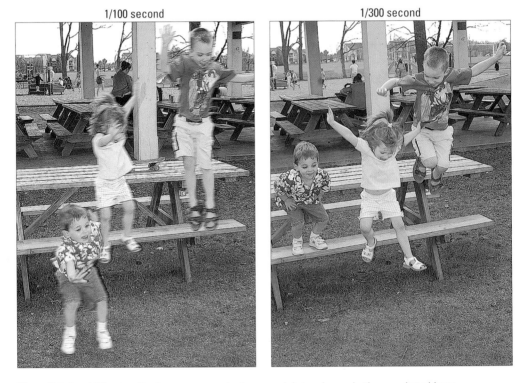

Figure 5-4: In addition to affecting exposure, shutter speed determines whether moving objects appear blurry.

Here's one other critical shutter-speed factoid: For very slow shutter speeds, you should use a tripod or otherwise steady the camera so that it doesn't move during the exposure. Otherwise, camera shake during the time the shutter is open can cause the whole photo to be blurry, as shown in Figure 5-5. The length of time that people can successfully handhold a camera varies, so experiment to see where you enter the danger zone. Also turn on image stabilization, if your camera or lens offers it; that feature can enable sharper handheld shots at slower shutter speeds. (Check your manual, though, to find out whether you should turn off image stabilization when using a tripod; in some cases, the feature can actually cause blur in tripod shots.)

Figure 5-5: Allover blur is caused by camera shake during a long exposure.

ISO also affects image noise

As ISO increases, making the image sensor more reactive to light, you increase the risk of producing noise. *Noise* is a defect that looks like sprinkles of sand and is similar in appearance to film *grain,* a defect that often mars pictures taken with high ISO film.

Figures 5-6 and 5-7 illustrate the impact of ISO on quality, showing the same subject captured at ISO 200, 400, 800, and 1600. When you print pictures at a small size, as in Figure 5-6, noise may not be apparent to the eye; instead, the image may have a slightly blurry look, as in the ISO 800 and 1600 examples in Figure 5-6. Figure 5-7 shows close-up views of each image so that you can more easily compare the loss of detail and increase in noise.

ISO 200 ISO 400

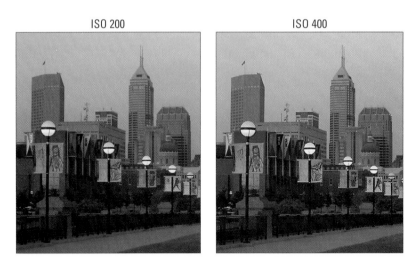

ISO 800 ISO 1600

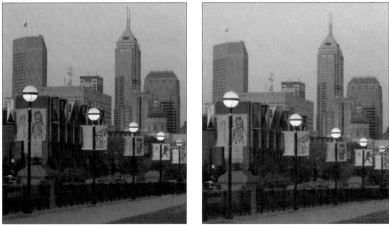

Figure 5-6: Raising the ISO setting increases light sensitivity, but also can produce a defect known as *digital noise*.

Of course, for some shooting scenarios, you may be forced to use a higher ISO. For example, if you're trying to capture a moving subject in less than ideal lighting, you may need to raise the ISO in order to use the fast shutter speed necessary to freeze the action.

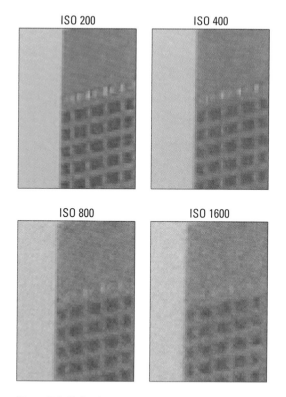

Figure 5-7: Noise becomes more apparent when you enlarge images.

A few other critical points about ISO and noise:

- **Noise levels vary from camera to camera.** The examples you see here illustrate noise produced by a specific camera. Some cameras, especially newer models, produce much better high-ISO images than others. Bottom line: Experiment with ISO settings if your camera gives you control over this feature. Then evaluate your test shots to see how much quality you can expect to give up when you raise ISO. And if you're in the market for a new camera, read reviews to find out how models you're considering perform at different ISO settings.

- **Auto ISO adjustment may not be your friend.** When you shoot in automatic exposure modes, the camera typically adjusts ISO for you. Some cameras, however, give you a choice between automatic ISO adjustment and manual ISO control. If you have the option, sticking with manual is the best idea. In automatic mode, the camera may ramp up the ISO to

a point that produces more noise than is acceptable to you. Some cameras do allow you to limit the top ISO that can be selected in auto mode or to specify the shutter speed at which ISO increase occurs, which makes Auto ISO more palatable. But if you're a stickler for image quality, it's better to control this aspect of your picture-taking yourself.

✔ **Long exposure times also can cause noise.** A high ISO isn't the only cause of noise; a long exposure time (slow shutter speed) can also produce the defect. So how high you can raise the ISO before the image gets ugly varies depending on shutter speed.

Doing the exposure balancing act

As you change any of the three exposure settings — aperture, shutter speed, and ISO — one or both of the others must also shift in order to maintain the same image brightness. Say that you're shooting a soccer game, for example, and you notice that although the overall exposure looks great, the players appear slightly blurry at your current shutter speed. If you raise the shutter speed, you have to compensate with either a larger aperture, to allow in more light during the shorter exposure, or a higher ISO setting, to make the camera more sensitive to the light — or both.

As the previous sections explain, changing these settings impacts your image in ways beyond exposure. As a quick reminder:

✔ **Aperture** affects depth of field, with a higher f-stop number producing a greater zone of sharp focus.

✔ **Shutter speed** affects whether motion of the subject or camera results in a blurry photo. A faster shutter "freezes" action and also helps safeguard against overall blur that can result from camera shake when you're handholding the camera.

✔ **ISO** affects the camera's sensitivity to light. A higher ISO makes the camera more responsive to light but also increases the chance of image noise.

So when you boost that shutter speed to capture your soccer subjects, you have to decide whether you prefer the shorter depth of field that comes with a larger aperture or the increased risk of noise that accompanies a higher ISO.

Everyone has their own approach to finding the right combination of aperture, shutter speed, and ISO, and you'll no doubt develop your own system as you become more practiced at using the advanced exposure modes. In the meantime, here's how I handle things:

✔ I always use the lowest possible ISO setting unless the lighting conditions are so poor that I can't use the aperture and shutter speed I want without raising the ISO.

✔ If my subject is moving (or might move, as with a squiggly toddler or antsy pet), I give shutter speed the next highest priority in my exposure decision. I might choose a fast shutter speed to ensure a blur-free photo or, on the flip side, select a slow shutter to intentionally blur that moving object, an effect that can create a heightened sense of motion.

✔ For images of nonmoving subjects, I make aperture a priority over shutter speed, setting the aperture according to the depth of field I have in mind. For portraits, for example, I use the largest aperture (the lowest f-stop number, known as shooting *wide open,* in photographer speak) so that I get a short depth of field, creating a nice, soft background for my subject. For landscapes, I usually go the opposite direction, stopping down the aperture as much as possible to capture the subject at the greatest depth of field.

I know that keeping all this straight is a little overwhelming at first, but the more you work with your camera, the more the whole exposure equation will make sense to you. You can find tips for choosing exposure settings for specific types of pictures in Chapter 7.

Adjusting f-stop, shutter speed, and ISO

Most cameras give you control over ISO, but whether or not you have full control over aperture and shutter speed depends on your camera. And the exact steps you take to change your camera's f-stop, shutter speed, and ISO vary from camera to camera, of course. If your camera offers only automatic exposure, you may not even have any control over these settings.

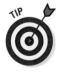

However, even if your camera is fully automatic, you may still have some input over the final exposure; you may be able to request a slightly darker or brighter image through a feature called *exposure compensation,* for example. Keep cruising through this chapter for a look at all the possibilities and then check your manual to see what's possible.

If you own a higher-end camera, you may be able to shoot in autoexposure mode, manual exposure mode, or "semiautomatic" mode, where you select the shutter speed and the camera selects the appropriate f-stop (or vice versa). The level of control you have in the nonmanual modes varies, so again, look for your camera instruction book.

Also check that book to find out how the camera indicates to you the current exposure settings. On cameras that have a viewfinder, you may see the current shutter speed, f-stop, and ISO in the viewfinder display, as shown on the left side of Figure 5-8. Some cameras also display the settings in the camera monitor, as shown on the right. And with some cameras, you can check exposure settings either way. (The viewfinder and monitor may also display several other pieces of information related to other camera settings, as they do here.)

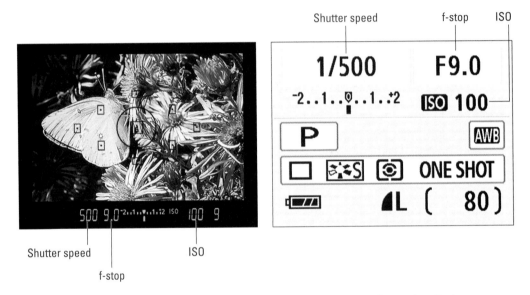

Figure 5-8: You may be able to view exposure settings in the viewfinder or on the monitor display.

If you use a point-and-shoot camera, however, you may be able to view the current settings on the monitor only, even if the camera has a viewfinder. And if you have a very basic, fully automatic camera that handles exposure for you, you may not be able to view the aperture and shutter speed settings at all until *after* you take the picture and download it to your computer. Then you can open the photo in a program that can read the camera *metadata*, which records the settings you used to take the picture. See Chapter 8 for more about viewing metadata. Doing so, by the way, is a great way to learn more about how aperture, shutter speed, and ISO affect the look of your pictures.

Finally, remember that if your camera offers lots of different exposure modes — full automatic, manual, semiautomatic, and specialty modes such as Portrait and Landscape — the aspects of exposure that you can control depend on the mode you choose. See the next section for a rundown of the standard exposure modes for an overview of this issue.

Choosing an Exposure Mode

Many digital cameras offer a choice of *exposure modes.* The mode you choose affects the level of control you have over shutter speed, f-stop, and ISO.

You may be able to select the exposure mode from a camera menu, or your camera may sport a mode dial like the one shown in Figure 5-9, which is the type found on some Nikon dSLRs. The initials and symbols that represent the different modes vary from camera to camera, of course (although some have become almost universal, such as a picture of a flower representing Close-up mode and a running figure indicating Sports mode).

Figure 5-9: Exposure modes are typically represented by symbols such as you see here.

Wherever and however you access them, exposure modes can be broken down into a few standard categories:

✔ **Full automatic:** In this mode, the camera takes care of all aperture and shutter speed decisions for you. You may or may not be able to adjust ISO. Whether or not you can use flash also depends on the camera; some models enable flash only if the camera thinks extra light is needed. You may not be able to *dis*able flash, either; if the camera says you need flash, you're stuck with it, even if your creative eye says differently.

Certain other camera options, such as those affecting color or file format, may also be off limits. For example, some cameras don't enable you to shoot in the Camera Raw format in automatic exposure mode. (Chapter 3 explains file formats.)

✔ **Automatic scene modes:** These modes are designed to automatically select the right exposure settings for different types of subjects: portraits, landscapes, sports pictures, and so on. Many times, scene modes also adjust color, contrast, and sharpness according to the subject as well. As with full automatic mode, you normally give up control over flash and some other camera options.

If you're interested in exploring scene modes, Chapter 4 describes the most common ones and tells you of specific pitfalls you may encounter when you use them.

✔ **Semiautomatic modes:** The two standard modes in this category, *shutter-priority autoexposure* and *aperture-priority autoexposure,* ask you to specify one-half of the f-stop/shutter speed equation. The camera then assists you by selecting the other half. For example, if you set the camera to shutter-priority autoexposure, you dial in the shutter speed you want, and the camera then chooses the appropriate f-stop to expose the image properly at your chosen shutter speed. The camera makes that calculation based on the current ISO setting.

In addition to offering more control over exposure, these modes typically free you to adjust all the other camera settings (color options, file format, and so on).

✔ **Manual exposure:** In this mode, you specify f-stop, shutter speed, and ISO. After you become experienced in the ways of these controls, manual mode is often the fastest way to manipulate exposure. And even in manual mode, most cameras display an exposure meter to let you know whether you're on-target with your settings.

Depending on your camera, you may have access to several other variations on these themes. Some models offer something called *flexible programmed autoexposure* or *variable programmed autoexposure* (usually represented by the letter P, as in Figure 5-9). In this semiautomatic mode, the camera presents you with several different combinations of f-stop and shutter speed, all guaranteed to deliver a good exposure. You then can choose the combination that best matches your creative goals. And many Canon cameras offer a mode called A-DEP, which attempts to choose an f-stop that results in a depth of field that keeps all objects in the frame in sharp focus. (A-DEP stands for *automatic depth of field.*)

Chapter 4 offers overall tips for using the automatic modes, but the next section offers some tips specifically related to exposure issues. Following that, you can find tips on using aperture-priority autoexposure and shutter-priority autoexposure.

Getting good autoexposure results

Today's autoexposure mechanisms are incredibly capable, but in order for the feature to work correctly, you need to take this three-step approach to shooting pictures:

1. **Frame your subject in the viewfinder or monitor.**

2. **Press the shutter button halfway and hold it there.**

 The camera analyzes the scene and selects initial exposure settings. If you're working in autofocus mode, focus is set at the same time. After the camera makes its decisions, it signals you in some fashion — usually with a light in the viewfinder or display and with a beep.

3. **Press the shutter button the rest of the way to take the picture.**

Reading the meter

An *exposure meter* is a little bar graph like the one below that indicates whether your exposure is correct — at least, the camera's idea of correct. When you shoot in manual exposure mode, if your camera offers that feature, the meter should appear either in the viewfinder or the monitor display. In autoexposure modes, the meter typically appears only if the camera anticipates an exposure problem.

Either way, little bars under the meter tell you where you stand, exposure-wise. When you see

bars falling toward the minus sign of the meter, as in the left example here, the camera's telling you that you're about to underexpose the photo. Bars falling toward the plus sign, as in the middle example, indicate the opposite problem. And when you see just a single bar at the zero point, as in the final example, you're good to go. Note that some cameras place the positive end of the meter on the left while other models put it on the right, so inspect that meter closely to see which is which on your camera.

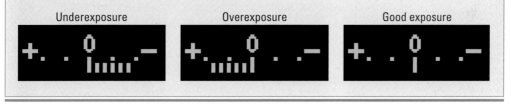

Underexposure Overexposure Good exposure

Normally, autoexposure works well if you use this technique, but a few points are worth noting:

- ✔ **Locking exposure:** On some cameras, exposure is locked at the point you press the shutter button halfway. On other models, the camera continues to monitor the light and continually adjusts the exposure settings as necessary up to the point at which you fully depress the shutter button. If you want to lock exposure at a certain setting on this second type of camera, you can switch to manual exposure, if your camera offers that option. Or your camera may offer a feature called *autoexposure lock* or *AE lock*, which enables you to lock in the exposure settings before the shutter button is pressed all the way. Using autoexposure lock can be a little cumbersome, though, so using manual exposure is often easier if you want to specify certain exposure settings.

- ✔ **Looking for exposure warnings:** Check your camera manual to find out how the camera warns you if it can't select any combination of exposure settings that will produce a good image. Some models beep at you or display a flashing light; others display a warning screen or exposure meter on the monitor. When shutter speeds drop very low, many cameras display a little "shaky hand" symbol to alert you that you should use a tripod to avoid the blurring caused by camera shake during long exposures.

✔ **Changing the exposure metering mode:** The exposure settings that the camera's autoexposure system selects are based on the current *metering mode.* That's just a fancy name for the control that determines which part of the screen the camera analyzes when calculating exposure. See the upcoming section "Choosing the exposure metering area" for more information. Usually, cameras use whole-frame metering in automatic exposure modes, and if you want to use a different metering method, you must switch to an advanced exposure mode.

✔ **Solving exposure problems:** If you're not happy with your autoexposure results, find out whether your camera offers a feature called *exposure compensation.* Described later in this chapter, this option enables you to tell the camera that you want a darker or lighter picture than the autoexposure system delivered. You may need to switch out of full autoexposure mode to take advantage of this feature, however.

Using "priority" exposure modes

In addition to regular autoexposure modes, where the camera sets both aperture and shutter speed, your camera may offer *aperture-priority* autoexposure or *shutter-priority* autoexposure.

On some cameras, aperture-priority autoexposure is abbreviated as A; on others, Av. The *a,* of course, stands for aperture; the *v* stands for value. Shutter-priority autoexposure is abbreviated either by the letter S or Tv, for time value. (Shutter speed determines the exposure time.) Oh, and if you see the letters AE, as you will if you read many photography magazines, it's an abbreviation for autoexposure.

Whatever they're labeled, these options offer more control while still giving you the benefit of the camera's exposure brain. Here's how they work:

✔ **Aperture-priority autoexposure:** This setting gives you control over the aperture (f-stop). After setting the aperture, you frame your shot and then press and hold the shutter button halfway as you do when shooting in fully automatic mode. But this time, the camera checks to see what aperture you chose and then selects the shutter speed necessary to correctly expose the image at that f-stop, taking the current ISO setting into account when making its decision.

By altering the aperture, you change depth of field — the range of sharp focus. The section "Aperture also affects depth of field," earlier in this chapter, explores this relationship between aperture and depth of field. Aperture isn't the only way to adjust depth of field, though, so see Chapter 6 for the whole story.

✔ **Shutter-priority autoexposure:** In shutter-priority mode, you choose the shutter speed, and the camera selects the correct f-stop. This mode is good for times when your scene contains moving objects because shutter speed determines whether those objects appear blurry or are "frozen" in place. See the section "Shutter speed also affects motion blur" for more details about shutter speed.

Assuming that your ISO value doesn't change, you theoretically should wind up with the same exposure no matter what aperture or shutter speed you choose, because as you adjust one value, the camera makes a corresponding change to the other value, right? Well, yes, sort of. Remember that you're working with a limited range of shutter speeds and apertures (your camera manual provides information on available settings). So depending on the lighting conditions, the camera may not be able to properly compensate for the shutter speed or aperture that you choose.

Suppose that you're shooting outside on a bright, sunny day. You take your first shot at an aperture of f/11, and the picture looks great. Then you shoot a second picture, this time choosing an aperture of f/4. The camera may not be able to set the shutter speed high enough to accommodate the larger aperture, which means an overexposed picture.

Here's another example: Say that you're trying to catch a tennis player in the act of smashing a ball during a gray, overcast day. You know that you need a high shutter speed to capture action, so you switch to shutter-priority mode and set the shutter speed to 1/500 second. But given the dim lighting, the camera can't capture enough light even with the aperture open to its maximum setting, so your picture turns out too dark unless you increase the ISO setting, making the camera more sensitive to light.

As long as you keep the camera's shutter speed and aperture range in mind, however, switching to shutter-priority or aperture-priority mode is a great way to expand your creative control over your photos until you're ready to move up to manual-exposure mode. So try them out in the following scenarios:

✔ **You're trying to "stop" action and require a specific shutter speed.** In this case, the shutter speed is your top *priority*, so choosing *shutter-priority* autoexposure is a good choice. In dim lighting, remember that you may need to raise the ISO value in order to use a really fast shutter speed.

✔ **You *want* moving objects to be blurred so that you convey a sense of motion.** When shooting fountains and waterfalls, for example, you can give the water a misty look by slowing down the shutter, as shown in Figure 5-10. The shutter speed for the left image was 1/25 second; the right image, 1/125 second. Here again, shutter speed is critical to the

look of your photo, so shutter-priority autoexposure is the right choice. Note that in these examples, I stuck with ISO 200 for both shots, so the camera adjusted f-stop to compensate for the change in shutter speed. And the change in f-stop also affects depth of field — notice that the background in the first image, taken at f/13, is much sharper than the right image, recorded at f/5.6.

For a very slow shutter speed, use a tripod or set your camera on something that's not moving (like a rock or a ledge — just be careful that your camera doesn't fall off!). If you try to handhold the camera at slow shutter speeds, camera shake during the exposure may result in blurring of the entire scene.

- **You want to control depth of field.** Depth of field, as you may remember if you read the first part of this chapter, determines the distance over which objects in the scene stay sharply focused. And one way to control depth of field is via the aperture setting (f-stop). So if depth of field is your primary creative concern, set the camera to aperture-priority mode and dial in the f-stop that gives the depth-of-field result you're after.

Do be careful to also monitor the shutter speed that the camera selects, making sure that it doesn't drop so low that you risk blurring the image due to camera shake. If that happens, you can either increase the ISO, which should allow a faster shutter speed, or grab a tripod.

f/13, 1/25 second, ISO 200 f/5.6, 1/125 second, ISO 200

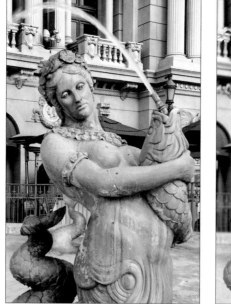 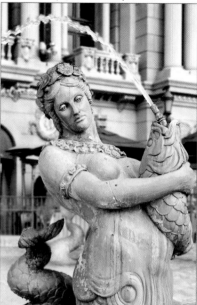

Figure 5-10: A slow shutter speed blurs motion, giving the water a softer, mistier look.

Solving Autoexposure Problems

If you use manual exposure and your picture turns out too dark or too bright, you simply dial in different aperture, shutter speed, or ISO settings and try again. But if you use any autoexposure mode, whether full auto or shutter- or aperture-priority auto, you use different tools to let the camera know that it needs to do something different on your next shot.

The two main ways to correct autoexposure problems are to apply exposure compensation and to select a different exposure metering mode. Check your camera manual to find out whether you have access to these features and, if so, how and when you can implement them. Some cameras don't let you use either feature if you're shooting in full automatic or scene modes, but other models give you access to both regardless of exposure mode. Of course, if the picture is too dark, you also may have the option of adding flash; see the later section "Adding Flash" for tips on that subject.

Keep in mind that you often can correct minor lighting and exposure problems in the photo-editing stage or even by using in-camera retouching tools found on some models. Generally speaking, making a too-dark image brighter is easier than correcting an overexposed (too bright) image. So if you can't seem to get the exposure just right, opt for a slightly underexposed image rather than an overexposed one.

Applying exposure compensation

Whether you're working in fully automatic mode, an automatic scene mode, or using shutter- or aperture-priority automatic exposure mode, you may be able to tweak the exposure by using *exposure compensation,* often referred to as EV *(exposure value)* compensation. This control bumps the exposure up or down a few notches from what the camera's autoexposure computer thinks is appropriate.

How you get to the exposure compensation settings varies from camera to camera. But the setting is often marked with a little plus/minus symbol, and you typically choose from settings such as +0.7, +0.3, 0.0, –0.3, –0.7, and so on, with 0.0 representing the default autoexposure setting. (If you're an old-school photographer, it may help you to know that these settings represent exposure stops. For example, EV –0.3 reduces the exposure by one-third of a stop.)

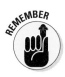

Regardless of how you access the EV control, the adjustment works the same way:

- ✔ To produce a **brighter** image, raise the EV value.
- ✔ To produce a **darker** picture, lower the EV value.

Figures 5-11 and 5-12 give you an idea of the impact you can make with EV compensation. In the left example in Figure 5-11, the sky was properly exposed, but the palm tree was too dark. So I applied EV compensation of +1.0 to produce the brighter result on the right.

<div align="center">EV 0.0 EV +1.0</div>

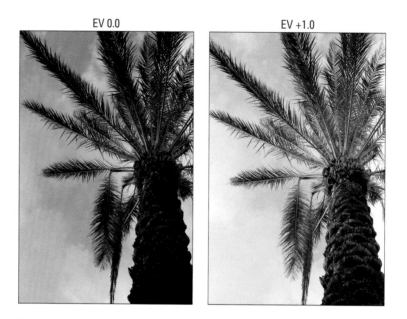

Figure 5-11: The original autoexposure setting left the palm tree too dark; raising the EV setting to +1.0 produced the brighter result.

The candle scene in Figure 5-12 offers another example of how exposure compensation comes in handy for creating just the exposure you have in mind. In the left image, the camera's autoexposure system selected exposure settings that rendered the darkest areas properly, but left the candle flame and areas lit by sunlight overexposed. In photospeak, the highlights are *blown out.* So in this case, I set the EV setting to –1.0 to create the version shown on the right, which created the mood I wanted for this scene.

These examples may raise two questions: First, why did the camera get it wrong? Well, technically speaking, it didn't. By default, autoexposure systems calculate exposure based on the light throughout the entire frame and then choose settings that provide an average exposure of both the brightest and darkest areas. The camera has no way of knowing that you're interested in just the dark or light areas or want a slightly under- or overexposed image, so it gives a one-size-fits-all exposure solution. Depending on your camera, you may be able to specify exactly what part of the frame you want it to consider when calculating exposure; for details, see the next section.

EV 0.0 | EV −1.0

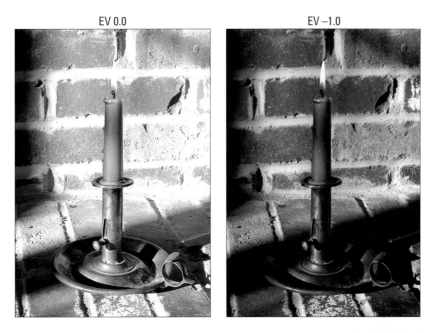

Figure 5-12: Here, the autoexposure system blew out the highlights; lowering the EV value solved the problem.

The other question that logically comes to mind with examples like the one in Figure 5-11 is "Can't it brighten the too-dark areas without also lightening the highlights?" In other words, can you tell the camera to leave the bright blue sky as is and lighten up just the palm tree? The answer to this one is maybe. Some cameras have a feature that does just that; see the upcoming section "Expanding Tonal Range" for details.

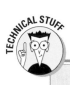

What's a "stop?"

Ready for another bit of photography lingo? The word *stop* is used to indicate a specific amount of exposure change. Increasing exposure by one stop means to select an f-stop or shutter speed that doubles either the amount of light (f-stop) or the duration of the light (shutter speed). Decreasing exposure by one stop means to cut the light in half. On a digital camera, you can also increase exposure by a stop by doubling the ISO value or decrease it by a stop by halving the ISO value.

Choosing the exposure metering area

Many cameras offer a choice of exposure *metering modes*. (Check your manual to find out what buttons or menu commands to use to access the different modes.) In plain English, *metering mode* refers to the way in which the camera's exposure mechanism *meters* — measures — the light in the scene in order to calculate the proper exposure for your photograph. The typical options are as follows:

- ✔ **Matrix metering:** Also known by other names, including *multizone metering, evaluative metering,* or *pattern metering,* this mode divides the image frame into a grid (matrix) and analyzes the light at many different points on the grid. The camera then chooses an exposure that best captures both shadowed and brightly lit portions of the scene. This mode is typically the default setting and works well in most situations.

- ✔ **Center-weighted metering:** When set to this mode, the camera measures the light in the entire frame but assigns a greater importance — weight — to the center of the frame. Use this mode when you're more concerned about how stuff in the center of your picture looks than stuff around the edges. (How's that for technical advice?)

- ✔ **Spot metering:** In this mode, the camera measures the light only at the center of the frame — or on some high-end cameras, a specific spot in the frame that you specify.

Spot and center-weighted metering are especially helpful when the background is much brighter or darker than the subject. In matrix metering mode, your subject may be under- or overexposed because the camera adjusts the exposure to account for the brightness of the background.

Figure 5-13 offers an example. The left image was taken using matrix metering. Because the camera saw so much darkness in the frame, it used an exposure that left the white rose very overexposed — almost no detail remains in the petals.

Changing to spot metering corrected the white rose, but left the red rose too dark, as shown in the middle image. For this scene, center-weighted metering produced the best exposure balance. However, if that red rose were out of the picture, the spot-metering image would be preferable because the white rose retains more detail.

Of course, when you switch to spot or center-weighted metering, your background may become too dark or too bright. On some newer cameras, you may find an option that brightens the shadows without also making the highlights too bright — again, see the upcoming section "Expanding Tonal Range" for details. But if your camera doesn't offer such options, you just have to choose which part of the scene is the most important, exposurewise.

Keep in mind, too, that you can usually accomplish the same exposure shift by simply using exposure compensation, as explained in the preceding

section. Most people find that solution easier to use and understand. But if you're shooting a series of photos in which the subject is much darker or brighter than the background, it makes sense to choose the metering mode that will give you better results from the get-go.

Matrix (whole frame) metering Spot metering Center-weighted metering

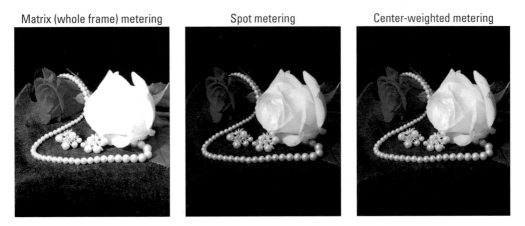

Figure 5-13: Try center-weighted or spot metering when your subject is much darker or brighter than the background.

Expanding Tonal Range

A scene like the one in Figure 5-14 presents the classic photographer's challenge: Choosing exposure settings that capture the darkest parts of the subject appropriately causes the brightest areas to be overexposed. And if you instead *expose for the highlights* — that is, set the exposure settings to capture the brightest regions properly — the darker areas are underexposed.

In the past, you had to choose between favoring the highlights or the shadows. But now photographers have a couple ways to get around the problem:

✔ **In-camera image manipulation:** Some cameras now have tools that brighten the shadows without altering the highlights, enabling you to stretch a photo's *tonal range* — the range of shadows to highlights, also called *dynamic range*. Some Nikon cameras, for example, offer a feature called Active D-Lighting, which tackles the problem in two stages: First, the original exposure is slightly underexposed to ensure that highlights are properly rendered. Then, before the image is written to the memory card, it undergoes a software process that brightens just the darkest shadows. I used this tool to create the improved seal image in Figure 5-14. Some Canon cameras offer a similar tool called Highlight Tone Priority; check your camera manual to find out whether you have this sort of option at your disposal.

Original image　　　　　　Image with expanded tonal range

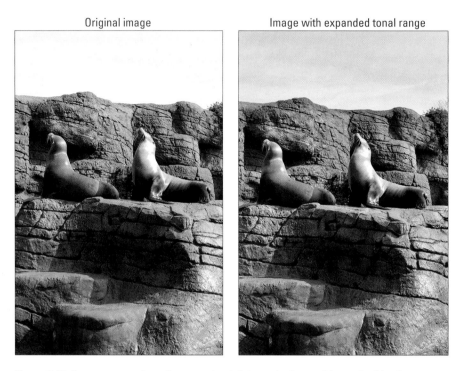

Figure 5-14: Some cameras have features that brighten shadows without also blowing out highlights.

✔ **HDR (high dynamic range) imaging:** One popular new way to expand tonal range is to use *high dynamic range* computer software to combine multiple exposures of the same subject in a way that reveals brighter shadows while hanging onto highlights. You photograph the same subject multiple times, exposing some for the darkest areas, some for the *midtones* (areas of medium brightness), and some for the highlights. Then you use the HDR software to combine the exposures, specifying which parts of the frame to pull from which exposure.

For a great example of HDR work, take a look at the images in Figures 5-15 and 5-16, both from photographer Dan Burkholder. In the first image, you see the scene captured at a single exposure. The waterfall is beautiful, but you can't see much detail in the shadows. The second image offers the HDR version, created by combining the shot from Figure 5-15 with seven additional exposures. With the expanded tonal range possible through HDR, you now can see the moss-covered rocks that water is spilling over.

If you want to learn more about Dan's techniques, see images from an amazing book of HDR photographs featuring post-Katrina New Orleans, or (better yet) to attend one of his workshops, visit www.danburkholder. com.

Dan Burkholder

Figure 5-15: Here you see one of the exposures that photographer Dan Burkholder used to create the HDR image in Figure 5-16.

Dan Burkholder

Figure 5-16: The final HDR image includes a much greater tonal range than can be captured in a single exposure.

Reading an exposure histogram

Many cameras can display an exposure tool called a *histogram,* which is a chart that plots out the brightness values of all pixels in the photo, during picture playback or on the monitor during shooting. You can see a sample histogram, along with the photo it represents, in the figures here.

The horizontal axis of the chart displays brightness values, with shadows on the left and highlights on the right. The vertical axis shows you how many pixels fall at each brightness value. So a spike at any point indicates that you have lots of pixels at that particular brightness value.

By reading the histogram, you can quickly see whether your picture may be underexposed or overexposed. Why not just see how the picture looks in the monitor, you ask? Because the photo may look brighter or darker than it actually is depending on the ambient light in which you view it and on the inherent brightness of the monitor itself. A histogram, on the other hand, is a scientific measurement of the actual image brightness. In fact, for some professional photographers, the histogram has replaced the light meter as a better on-the-fly measurement and representation of what they're shooting.

Normally, a histogram that resembles a bell-shaped curve, or something that looks close to it, is good because well-exposed photos typically contain more *midtones* (areas of medium brightness) accented by highlights and shadows. This isn't true exclusively, of course, and sometimes you may want more shadows or highlights in an image depending on your subject.

However, if you look at your camera's histogram and it has a big spike to the left, it may be that your photo is too dark, in which case you need to adjust your exposure settings or add a flash. If it's spiked to the right, your photo may be too bright. It's normal to have a few odd spikes here and there, though; don't demand that every image be a perfect curve. In other words, a histogram is a general guideline and reference tool, not an absolute determining factor for how your image needs to be adjusted. Sorry, you statisticians out there — we're talking art here!

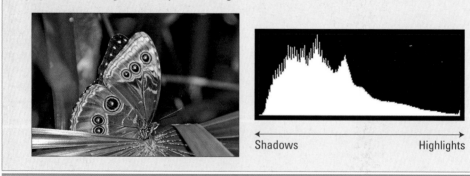

Shadows Highlights

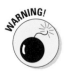

While this approach can ultimately yield an image much closer to what your eye might see rather than the more limited tonal range that a camera can capture, it's an involved process that isn't a procedure for the computer or software novice. The resulting image file is a 32-bit image that often can't be viewed or used with some less-advanced image-editing applications.

Bracketing Exposures

For tricky exposures, it's a good idea to take the pro's route and always *bracket* your shots. Bracketing simply means to record the same scene at several different exposure settings, usually one brighter and one darker than your main shot, as shown in Figure 5-17. For this series, I adjusted shutter speed between captures.

How you accomplish bracketing depends on what exposure modes are available to you:

- In **manual** exposure mode, you can just change the shutter speed, aperture, or ISO between each shot.

- In the **automatic** exposure modes (including shutter- and aperture-priority autoexposure modes), shoot the subject using three different exposure compensation settings.

Of course, this assumes that you have the luxury of taking three shots of the same subject. It might be tough to set this up if you're trying to get a shot of your sister kissing her new husband at the altar — she's not likely to wait for you to take three shots.

f/5.6, 1/20 second, ISO 100

f/5.6, 1/40 second, ISO 100

f/5.6, 1/60 second, ISO 100

Figure 5-17: Automatic bracketing records the same subject several times, using different exposure settings for each shot.

TIP

Some cameras also offer *automatic exposure bracketing*. With this feature, often abbreviated as AEB, you take three successive shots, and the camera automatically adjusts exposure between each capture. Some cameras even let you adjust the amount of difference between the shots. Check your camera instruction book to find out what your camera offers and how it works.

Excuse me; can you turn down the sun?

Adding more light to a scene is considerably easier than reducing the light. If you're shooting outdoors, you can't exactly hit the dimmer switch on the sun. If the light is too strong, you really have only a few options. You can move the subject into the shade (in which case you can use a flash to light the subject) lower the ISO setting, or, on some cameras, reduce the exposure by lowering the EV value.

If you do need to shoot in bright sunlight and you can't find a suitable shady backdrop, you can create one with a piece of cardboard. Just

have a friend hold the cardboard between the sun and the subject. *Voilà!* — instant shade. By moving the cardboard around, you can vary the amount of light that hits the subject. You can also buy relatively inexpensive, collapsible, and very portable photographic reflectors that are made to do this. Some of them are made of gold- or silver-colored material so that they can do dual duty: When you need to add light instead of obscure it, you can use them to bounce the available light onto your subject.

Adding Flash

The word *photograph* literally means writing *(graph)* with light *(photo)*. And when the environment doesn't provide enough light to expose your photo, your camera's flash provides the easiest way to shed light on the situation.

As with the general topic of exposure, entire books are devoted to the subject of flash photography, and I encourage you to devour as many as you can. Also pay a visit to the website www.strobist.com, which is dedicated to flash photography. (*Strobe* is another word for *flash.*) In the meantime, the rest of this chapter provides just a broad overview of ways to get better results when using flash.

Using a built-in flash

Most cameras have a built-in flash that operates in several modes. In addition to automatic mode, in which the camera gauges the available light and fires the flash if needed, you typically get the choice of a couple flash modes: fill flash, no flash, red-eye reduction, and slow-sync flash. The next several sections explain these basic flash modes. Also check out the later section "Adjusting flash power" for information on an additional flash feature found on some cameras.

Fill flash (or force flash)

This mode triggers the flash regardless of the light in the scene. Fill-flash mode is especially helpful for outdoor portraits such as the one in Figure 5-18. The

first image shows the result of using automatic flash mode. Because the picture was taken on a sunny day, the camera didn't see the need for a flash. But without flash, the shadow from the hat obscured the subject's face. Switching to fill-flash mode forced the flash to fire and throw some additional light on her face, producing the perfectly exposed portrait.

Without flash With fill flash

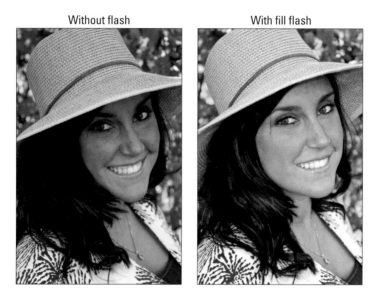

Figure 5-18: Adding flash light brings the face out from the shadows created by the hat.

One word of caution about fill flash outdoors: Because of the way that the camera must synchronize the burst of flash light with the action of the shutter, most cameras limit you to a top shutter speed in the 1/200 to 1/300 second range. Some go even lower, limiting you to a mere 1/60 second. That means that in very bright daylight, you may overexpose the photo by using flash even if you stop the aperture down to its smallest opening and use the lowest ISO setting. There are three possible fixes to this problem:

- **Use high-speed flash, if your camera has that capability.** Some higher-end cameras enable you to use *high-speed flash* when you attach an external flash head. In that mode, you can access the full range of shutter speeds and raise the shutter speed high enough to properly expose the photo. (This is how professional portrait photographers use flash in their outdoor work.)

- **Add a neutral density filter to your lens.** Like sunglasses for your lens, a neutral density filter cuts the amount of light that can enter the lens, allowing you to use a slower shutter speed and still expose the image correctly.

> ✓ **Shoot in the shade.** The simplest fix? Just move your subject into the shade — problem solved.

No flash

Choose this setting when you don't want to use the flash, no way, no how. You may also want to turn off the flash simply because the quality of the existing light is part of what makes the scene compelling, for example. Or you may want to go flashless when you're shooting highly reflective objects, such as glass or metal, because the flash can cause *blown highlights* (areas that are completely white, with no tonal detail). And of course, some venues, such as museums and churches, often don't permit flash photography.

When you turn off the flash in an autoexposure mode, the camera may reduce the shutter speed to compensate for the dim lighting. That means that you need to hold the camera steady for a longer period to avoid blurry images. Use a tripod or otherwise brace the camera for best results. You also can consider raising the ISO setting to increase the camera's sensitivity to light (but be aware that you may introduce noise into the photo).

Flash with red-eye reduction

Anyone who's taken people pictures with a point-and-shoot camera — digital or film — is familiar with the so-called red-eye problem. The flash reflects against the subject's retinas, and the result is a demonic red glint in the eye. Red-eye reduction mode aims to thwart this phenomenon by firing a low-power flash before the "real" flash goes off or by emitting a beam of light from a lamp on the camera body for a second or two prior to capturing the image. The idea is that the prelight, if you will, causes the pupil of the eye to shut down a little, thereby lessening the chances of a reflection when the final flash goes off.

Unfortunately, red-eye reduction flash doesn't always work perfectly. Often, you still wind up with fire in the eyes — hey, the manufacturer promised only to *reduce* red-eye, not eliminate it, right? Worse, your subjects sometimes think the prelight is the actual flash and start walking away or blink just when the picture is being captured, so if you shoot with red-eye mode turned on, be sure to explain to your subjects what's going to happen.

The good news is that, because you're shooting digitally, you can repair red-eye easily. Some cameras have an in-camera red-eye remover that you can apply after you take a picture. If not, the fix is easy to make in a photo-editing program. Many online printing sites and in-store photo kiosks even have tools that let you do the job before you order your prints.

Slow-sync flash

Slow-sync flash is a specialty flash mode that increases the exposure time beyond what the camera normally sets for flash pictures. The name comes

from the way that the timing of the flash light is synchronized with the shutter action.

With a normal flash, your main subject is illuminated, but background elements beyond the reach of the flash are dark, as in the first example in Figure 5-19. The longer exposure time provided by slow-sync flash allows more ambient light to enter the camera, resulting in a brighter background, as shown in the second example in the figure.

Whether a brighter background is desirable depends upon the subject and your artistic mood. However, remember that the slower shutter speed required for slow-sync flash can easily result in a blurred image; both camera and subject must remain absolutely still during the entire exposure to avoid that problem. As a point of reference, the exposure time for the normal flash example in Figure 5-19 was 1/60 second, while the slow-sync exposure time was a full second. In addition, colors in slow-sync pictures may appear slightly warmer because you're mixing ambient light with flash light, and the two have different *color temperatures*. For more on the subject of color temperature and how to use your camera's white-balance control to compensate, see Chapter 6.

Normal flash Slow-sync flash

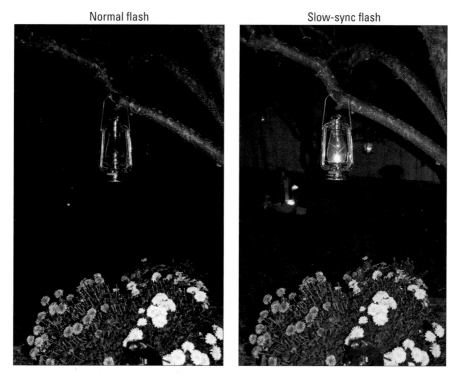

Figure 5-19: Slow-sync flash produces a brighter background than normal flash mode.

Using an external flash

Although your camera's built-in flash offers a convenient alternative for lighting your scene, the light it produces is typically narrowly focused and fairly harsh. When you're shooting your subject at close range, a built-in flash can leave some portions of the image overexposed or even cause *blown highlights* — areas that are so overexposed that they are completely white, without any detail. Moving farther from your subject isn't always an option, either, because the range of most built-in flashes is about 8 to 10 feet. And a built-in flash often leads to red-eyed people, as all of us know too well.

Some digital cameras can accept an auxiliary flash unit, which helps reduce blown highlights and red-eye because you can move the flash farther away from, or at a different angle to, the subject. (The closer the flash is to the lens, and the more direct the angle to the subject's eyes, the better the chance of red-eye.) Additionally, external flash heads typically produce a more pleasing result, illuminating the subject with a more widespread, and thus softer, light. Auxillary flash heads also have a longer reach than a built-in flash. And if you buy a flash with a rotating head like the one shown in Figure 5-20, you can bounce the light off the ceiling for an even more diffused effect. Figure 5-21 has an example: Notice that in the first shot, taken with the flash angled directly

at the subject, there are strong shadows behind the subject, and the light is harsh on the skin. For the second shot, I aimed the flash head upward, so the light hit the ceiling and then fell down softly on the subject, eliminating background shadows and producing much more pleasing lighting. (Be sure that the ceiling is white if you try this technique — otherwise, the bounced light will take on the color of the ceiling.)

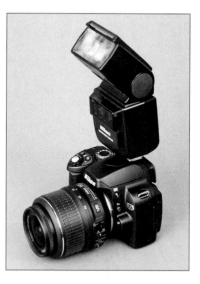

When you attach an external flash, the camera's on-board flash is disabled (if the camera has one), but the auxiliary flash can work automatically with the camera, just like an on-camera flash can. This option is great for professionals and photo enthusiasts who have the expertise and equipment to use it; check your camera manual to find out what type of external flash works with your camera and how to connect the flash.

Figure 5-20: An external flash with a rotating head offers more flexibility and better illumination than a built-in flash.

If your camera doesn't offer an external flash connection, you can use so-called "slave" flash units. These small, self-contained, battery-operated flash units have built-in photosensitive eyes that trigger the supplemental flash when the camera's flash goes off. If you're trying to photograph an event in

a room that's dimly lit, you can put several slave units in different places. All the units fire when you take a picture anywhere in the room.

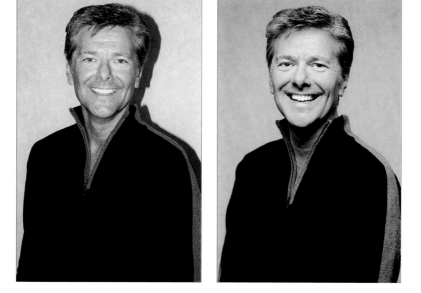

Direct flash Bounce flash

Figure 5-21: Here you see the difference between direct (left) and bounced (right) flash lighting.

Adjusting flash power

Many cameras enable you to adjust the strength of the flash light through a feature called *flash exposure compensation* or *flash EV* for short. This feature works just like exposure compensation, which adjusts overall exposure to produce a darker or brighter image, but instead varies the strength of the flash. Usually, the option is represented by a little plus/minus symbol alongside a lightning bolt — the universal symbol for flash. It's easy to use: As with exposure compensation, settings are stated in numerical terms, such as +1.0, –1.0, and so on. If you want more flash power, you use a positive flash EV value: +0.3, +0.7, and so on. For less flash power, you select a negative value.

Figure 5-22 offers an example of how this feature works. I shot this picture at an outdoor farmers' market, in a stall that was shaded by a large awning. I wanted to add flash to bring a little more light to the scene, but at the default flash power, the flash light was just too hot, blowing out the highlights in the fruit. So I reduced the flash power by setting the flash compensation value to –1.3, which added just a small pop of light without overpowering the subject.

No flash | Flash EV 0.0 | Flash EV –1.3

Figure 5-22: Flash exposure compensation enables you to adjust the strength of the flash.

In addition to using flash compensation, you also can diminish flash power by using a mechanical solution: You can put a diffuser over the flash head, as shown in Figure 5-23. This particular diffuser, from LumiQuest (about $13; www.lumiquest.com), is designed to work with the pop-up flashes on digital SLR cameras, but you can find diffusers for just about any type of flash. The diffuser not only cuts the flash light but also spreads and softens it, helping to eliminate harsh shadows and create more flattering light. If you do much flash photography, especially portrait photography, adding a diffuser to your camera bag is one of the best investments you can make.

Figure 5-23: You also can buy diffusers that soften the harsh light of a built-in flash.

6

Manipulating Focus and Color

*T*oday's digital cameras offer an abundance of focus and color features. But for many new digital photographers, sorting through all the options is so overwhelming that they throw up their hands, set everything to automatic, and let the camera take the focus and color reins. That's a shame, because taking just a little time to understand these features can lead to much more artful photographs — not to mention a greatly reduced number of pictures that are spoiled by focus or color miscues.

This chapter puts you on the path to mastering both focus and color. The first part details the most important aspects of focus, covering such topics as getting the best results from your camera's auto-focusing system and achieving different creative goals by manipulating *depth of field* (the distance over which sharp focus is maintained). Following that discussion, the second part of the chapter dives into the color pool, explaining how to deal with off-kilter colors and offering tips about some subtle color adjustments that you can use to enhance different subjects.

Diagnosing Focus Problems

Several factors can affect focus, so to find the right solution to a focusing concern, you first have to identify the cause. Here's a quick symptom list that will point you in the right direction:

✔ **My entire picture is blurry.** This problem is easy to diagnose: Either the camera moved during the exposure or, if you're shooting close-ups, you were too close to the subject and so exceeded the minimum close-focusing distance of the lens. In the left photo in Figure 6-1, camera shake was the problem; I used a tripod to steady the camera and get the sharply focused shot on the right. See the sidebar "Hold that thing still!" (later in this chapter) for a list of other tricks to avoid camera shake; for close-up shooting, check your camera manual to determine the minimum close-focusing distance of your lens.

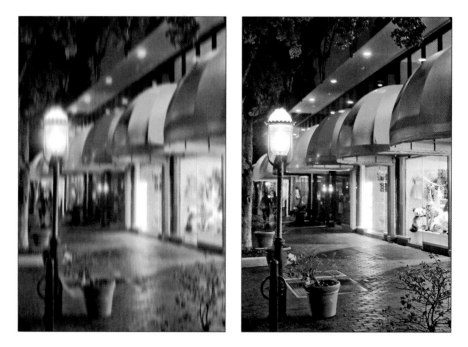

Figure 6-1: Camera shake causes allover blur (left); use a tripod to ensure sharp shots (right).

✔ **My subject is blurry, but the rest of the picture is sharp.** This problem can be caused by a couple of errors:

• *The subject moved.* To catch a tack-sharp picture of a moving subject, you need a fast shutter speed; how fast depends on your subject's speed. Take the duck photos in Figure 6-2 as an example.

Notice that the stationary objects are sharp in both shots, but in the first image, the duck on the left was moving his head too fast to be captured cleanly at a shutter speed of 1/60 second. Bumping the shutter speed up to 1/250 second froze the action successfully.

f/6, 1/60 second, ISO 100 f/6, 1/250 second, ISO 400

Figure 6-2: If moving objects are blurry, the cause is usually a too-slow shutter speed.

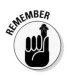

Don't think of fast shutter speed only when shooting typical action or wildlife shots like this one — watch out for movement with *any* subject. When shooting flowers in a garden, for example, even a gentle breeze can be enough to blur the subject at a slow shutter speed. And a baby's laugh can cause enough motion to wreck an otherwise great portrait. So deciding whether your subject might move is one of the first considerations to make when you're choosing your exposure settings.

Remember that in order to maintain the proper exposure when you raise the shutter speed, you need to either choose a lower f-stop setting (to allow more light into the camera) or raise the ISO setting (to make the camera more sensitive to light). In Figure 6-2, for example, I adjusted ISO to allow the faster shutter speed.

Chapter 5 talks more about shutter speed, including some advice on using shutter-priority exposure mode, which enables you to set the shutter speed while letting the camera select the proper f-stop (aperture setting). You can also set the camera to Sports scene mode to select a higher shutter speed automatically, although you lose control over the exact shutter setting in that mode. Chapter 4

discusses this scene mode. For more tips on shooting a moving target, check out Chapter 7.

- *The subject is outside the focusing zone.* The camera establishes focus based on a particular area of the frame, and on some cameras, that area varies, depending on certain focusing options that you can select. For example, some autofocusing systems enable you to establish focus on the center of the frame or some other specific point in the frame. Or you may be able to base focus on the average position of all objects throughout the entire frame. So you need to study your manual to find out what focusing zone the camera is using and then make sure that your subject is within the required area when you set focus. See the upcoming section "Taking advantage of autofocus" for a bit more information on this subject.

✔ **I want more or less of the scene to be sharply focused.** When you focus the camera, whether you do it manually or by using autofocus, you establish the point of sharpest focus. You also can control the distance over which that sharp focus is maintained, otherwise known as the *depth of field.* For example, you can create a composition in which your main subject is sharp, but everything a few feet in front of or behind the subject is in soft focus. Or you can do the opposite, keeping the distant objects sharp as well.

You manipulate depth of field not by using focusing controls, but by adjusting aperture (f-stop), focal length, and camera-to-subject distance. See the section "Showing Some Depth of Field," later in this chapter, for details.

✔ **I can't get the camera to focus at all.** Assuming that your camera isn't broken, you may simply be too close to your subject. Again, every camera has a close-focusing limit, which you should be able to determine with a look at your camera manual. Another possible cause is the subject itself: In autofocus mode, some subjects can also give the camera fits, causing the autofocus motor to "hunt" continuously for a target. One fix is to focus manually, if your camera permits it. Another option is to look for an easy-to-focus object that's the same distance from the camera as your subject, lock focus on that object, and then reframe to your desired composition and take the picture. See the section "Taking advantage of autofocus" for more on this technique.

✔ **The focus of my pictures is fine, but things look blurry through the viewfinder.** Try adjusting the viewfinder to your eyesight. You do this by using a *diopter adjustment control,* typically found near the viewfinder. Chapter 3 explains how to take this critical step. The other possibility is that your viewfinder is simply dirty; you can wipe it clean by using a cloth or tissue specially made for use with cameras.

Understanding Focusing Systems

Like film cameras, digital cameras offer a variety of focusing features to help you capture sharp images with ease. The following sections describe the most common focusing schemes and how you can make the most of them.

Working with fixed-focus cameras

Fixed-focus cameras are just that — the focus is set at the factory and can't be changed. The camera is designed to capture sharply any subject within a certain distance from the lens. Subjects outside that range appear blurry.

Fixed-focus cameras sometimes are called *focus-free* cameras because you're free of the chore of setting the focus before you shoot. But this term is a misnomer, because even though you can't adjust the focus, you have to remember to keep the subject within the camera's focusing range. There is no such thing as a (focus-) free lunch.

Be sure to check your camera manual to find out how much distance to put between your camera and your subject. Blurry images usually result from having your subject too close to the camera; most fixed-focus cameras are engineered to focus sharply from a few feet away from the camera to infinity.

Taking advantage of autofocus

Most digital cameras or lenses used with them (in the case of interchangeable lens cameras) offer autofocus, which means that the camera automatically adjusts the focus after measuring the distance between the lens and subject. For autofocus to work, you need to take a two-stage approach to pressing the shutter button, as follows:

1. **Be sure that autofocusing is enabled.**

 On an interchangeable lens camera, you may find a control on the lens or camera body that switches the system from manual to autofocus. For example, Figure 6-3 shows the switch as it appears on one Canon dSLR and lens combo. You may also need to enable autofocusing through a menu option.

 If your camera offers image stabilization, remember to turn it on, as shown for the Canon example, when handholding the camera. This feature helps compensate for small amounts of camera shake, which can blur the image.

 On a point-and-shoot camera that offers the choice between manual and autofocusing, check your manual to find out how to switch between the two — you likely establish the setting through a camera menu.

2. **Frame the picture so that your subject is within the current autofocus area.**

The *autofocus area* refers to the part of the frame that the camera uses to establish focus. This area can vary, depending on the auto-focus system and settings you're using; see the notes following these steps for help.

3. **Press the shutter button half-way and hold it there.**

Your camera analyzes the picture and sets the focus. To let you know that focus is established, the camera sends you some sort of signal: Usually, a little light in or near the viewfinder turns green, or the camera makes a beeping noise (some cameras let you turn off the beep, which can be annoying in a quiet place). Some cameras also display one or more little lighted squares or brackets in the viewfinder to tell you what part of the frame the camera used when setting focus.

Auto/manual focus switch

Image Stabilizer switch

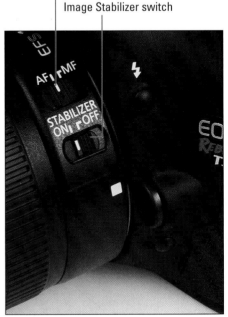

Figure 6-3: Some SLR lenses have a switch that sets the camera to autofocus mode.

Whether or not focus is locked at this point depends on the *autofocus mode.* Some cameras offer a continuous autofocus mode that adjusts focus as needed if the subject moves after focus is initially established. Again, see the list of upcoming tips for details.

4. **After focus is established, press the shutter button the rest of the way to take the picture.**

Press, don't jab, the shutter button or you risk moving the camera at the time the shutter is open, resulting in a blurry picture due to camera shake.

Although autofocus is a great photography tool, you need to understand a few things about how your camera goes about its focusing work in order to take full advantage of this feature. Here's the condensed version of the auto-focusing manual:

✔ **Autofocus systems:** The most common autofocusing schemes found on today's digital cameras fall into two main categories:

- *Single-spot focus:* With this type of autofocus, the camera reads the distance of the element that's at a specific position of the frame. Usually, the focus area is the center of the frame, but on some cameras, you can select from several different focus areas throughout the frame.

- *Multi-spot focus:* The camera measures the distance at several spots around the frame and sets focus relative to the nearest object or multiple points on an object taking up a large percentage of the frame (such as a group of people posing).

You need to know how your camera adjusts focus so that before you lock in the focus with the press-and-hold method just described, you frame the picture so that the subject is within the area that the autofocus mechanism reads.

Some cameras enable you to choose which of these two types of focusing you want to use for a particular shot, so check your camera manual for details. Look for something that goes by a name such as *AF mode, AF-area mode, Focus mode,* and the like. (The AF stands for *autofocus.*)

✔ **Autofocus area indicators:** Depending on its autofocusing system, your camera may display little dots or brackets in the viewfinder or monitor to indicate the areas used to establish focus. As an example, Figure 6-4 shows you how the markers appear on a Canon camera that has a nine-point autofocusing system and a Nikon camera that has a three-point autofocusing system. When you press the shutter button halfway, these indicators light or blink to tell you where the camera set focus.

Figure 6-4: The autofocus areas may be indicated by little squares or brackets.

Check your camera manual to see what the different viewfinder and monitor marks mean, though; not all are related to focusing. The center circle in the viewfinder shown on the left in Figure 6-4, for example, indicates the spot-metering zone, an exposure feature offered on some Canon cameras. And on cameras that don't offer through-the-lens viewfinders, marks are provided to help you frame the picture. (See Chapter 1 for more about viewfinder types.)

🖝 **Single-servo autofocus:** The default autofocus setup on most digital cameras is to lock focus when you press and hold the shutter button halfway down. As long as you keep that button halfway down, focus remains locked. This focusing scheme is sometimes called *single-servo* autofocus but also goes by certain other names, such as *one-shot* autofocus.

Single-servo autofocus enables you to focus on a subject even if you want to frame the shot so that the subject doesn't fall into the autofocus area. For example, suppose that your camera bases focus on the center of the frame, but you want your subject to appear off-center in the picture. Frame the picture initially so that the subject is centered and then press the shutter button halfway. After focus is established, keep the button halfway down, reframe the shot as desired, and then press the shutter button the rest of the way. Figure 6-5 illustrates this technique, known as *focus lock*.

🖝 **Continuous-servo autofocus:** Using single-servo autofocus to shoot a moving subject can be difficult. Say that you're trying to photograph a child running up the driveway toward you, for example. You frame the shot and lock focus at the point the little one starts off, but by the time you actually take the shot, the child is halfway up the driveway — and no longer in focus.

Figure 6-5: After locking focus on your subject, you can reframe the shot if you want.

You can just keep locking and then relocking focus as needed, but that's difficult to accomplish and also a bit of a pain — press halfway, release, press halfway, release, mutter under breath, press halfway . . . you get the idea. To offer a

better solution, some cameras offer *continuous-servo* autofocus. In this mode, you still press the shutter button halfway to establish the initial focusing distance. But if the camera detects motion in front of the lens, it automatically adjusts focus as needed right up to the time you press the button the rest of the way to snap the picture.

Note that this autofocusing feature goes by different names depending on the manufacturer. Canon calls it AI Servo, for example — the AI standing for *artificial intelligence.* And some other manufacturers use the term *dynamic autofocus.*

Whatever its name, this autofocusing feature still requires some input from you after you depress the shutter button halfway. In order for the camera to correctly track focus, you typically must keep your moving target within the active autofocus area, which may mean reframing the shot after you initially establish focus.

⮑ **Auto-servo autofocus:** In some cases, you also get a third autofocus mode in which the camera automatically shifts from single-servo auto-focus to continuous-servo autofocus if it detects movement in front of the lens. Again, the mode name depends on the camera maker; on Canon cameras, this mode is called AI Focus, for example.

⮑ **Infinity and macro focusing modes:** Some point-and-shoot cameras that offer autofocus provide you with one or both of these specialty focus modes. *Macro* mode allows you to focus at a closer distance than you normally could; it's designed for shooting close-ups, in other words. *Infinity mode*, sometimes also called *landscape focusing mode,* does the opposite: It sets focus at the farthest point possible and is designed for shooting subjects at a long distance. When you switch to these modes, you need to make sure that your subject falls within the focusing range of the selected mode. Check your camera's manual to find out the proper camera-to-subject distance.

Also, don't confuse these specialty focus modes with the automatic exposure scene modes that go by the same name (Close-Up and Landscape). Those modes are also geared to shooting close-ups and landscapes, but they typically affect exposure, color, contrast, and other picture characteristics, not focus distance. They may, however, affect depth of field, which controls the zone of sharp focus. See Chapter 4 for more about scene modes.

Finally, remember that even the most capable autofocus system may have trouble doing its job in dim lighting. Certain types of subjects also confuse autofocus mechanisms: objects behind vertical bars (such as a lion at the zoo), low-contrast scenes (think gray boat sailing in foggy weather), and highly reflective objects are among the biggest trouble-makers.

If your camera offers manual focusing, the easiest solution is to switch to that mode and do the focus work yourself. The next section offers some manual focusing tips. If your camera doesn't offer manual focus, you can fool the

autofocus system by locking focus on something else that's the same distance away from the lens as your subject. After you lock focus, reframe the shot if needed.

Focusing manually

On dSLRs and compact system cameras, you can opt out of autofocus and instead twist the focusing ring on the lens to focus manually. You first may need to set a switch on the lens or camera body to the manual-focus mode, select manual focusing from a camera menu, or both. The steps here vary, as does the placement of the focusing ring, from camera to camera, so check out that instruction manual for details. (Note that a few compact system camera lenses, including those made for the Nikon 1 system models, don't have this focusing ring; instead, you enable manual focusing via a menu item and then use a lever on the camera itself to adjust focus.)

A few, higher-end point-and-shoot digital cameras also offer manual focusing. Although some models offer a traditional focusing mechanism where you twist a focusing ring on the lens barrel, most require you to use menu controls to select the distance at which you want the camera to focus.

Even when you focus manually, many cameras offer feedback to let you know when the subject is in focus. The normal focus-indicator lamp may light, for example, or the focus-achieved beep may sound. And a few cameras let you swap out the exposure meter for a focusing aid called a *rangefinder*. Figure 6-6 gives you a look at the rangefinder design used on some Nikon cameras, for example. The bars under the rangefinder meter indicate whether focus is set behind, in front of, or dead on your subject. Just keep in mind that because the rangefinder is based on the same focusing system that the autofocus system employs, subjects that confuse the autofocus system also render the rangefinder unable to find a focusing target.

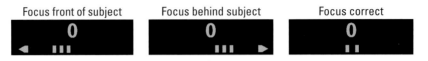

Figure 6-6: A rangefinder is a focusing aid that provides feedback when you focus manually.

Showing Some Depth of Field

One way to become a more artful photographer is to learn how to control *depth of field,* which refers to the distance over which sharp focus is maintained. With short, or shallow, depth of field, the subject is sharp but objects at a distance are blurred, as in the left image in Figure 6-7. This treatment is perfect for portraits because it prevents the background from drawing attention from the subject.

Hold that thing still!

A blurry image isn't always the result of poor focusing; you can also get fuzzy shots if you move the camera during the time the image is being captured.

Holding the camera still is essential in any shooting situation, but it becomes especially important when the light is dim because a longer exposure time is needed. That means that you have to keep the camera steady longer than you do when shooting in bright light.

To help keep the camera still, try these tricks:

- Press your elbows against your sides as you snap the picture.

- Squeeze, don't jab, the shutter button. Use a soft touch to minimize the chance of moving the camera when you press the shutter button.

- Place the camera on a countertop, table, or other still surface. Better yet, use a tripod. Chapter 2 offers tripod-buying advice.

- If your camera offers a self-timer feature, you can opt for hands-free shooting to eliminate any possibility of camera shake. Place the camera on a tripod, set the camera to self-timer mode, and then press the shutter button (or do whatever your manual says to activate the self-timer mechanism). Then move away from the camera. After a few seconds, the camera snaps the picture for you automatically.

Of course, if you own a camera that offers remote-control shooting, you can take advantage of that feature instead of the self-timer mode.

- If your camera or lens offers an image stabilization (or *anti-shake*) mode, make sure that it's turned on when you don't use a tripod. This feature can help you get crisper handheld results, especially when you're using a slow shutter speed, a long, heavy lens, or both. Check your manual to find out whether the manufacturer recommends disabling the stabilization feature when the camera is mounted on a tripod, however.

When you want to give equal importance to everything in the frame, on the other hand, try a large depth of field, which extends the sharp focus zone over a greater distance from your point of focus. Landscapes and architectural shots like the one on the right in Figure 6-7 typically benefit from a large depth of field. Focus in this image was set on the foreground figure, but the ones in the distance look nearly as sharp.

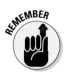

You can manipulate depth of field in three ways:

- **Adjust the aperture (f-stop).** Chapter 5 introduces you to the aperture setting, or f-stop, which is an exposure control. The f-stop also affects depth of field; the higher the f-stop number, the greater the depth of field. The water lily images in Figure 6-8 show an example. Notice that at f/6.3, the leaf and the watery background are much blurrier than in the f/20 example.

Short depth of field

Large depth of field

Figure 6-7: Shallow depth of field is ideal for portraits (left); landscapes benefit from a longer zone of sharp focus (right).

f/6.3, 1/1250 second, ISO 400

f/20, 1/125 second, ISO 400

Figure 6-8: Changing the aperture is one way to adjust depth of field.

A couple pertinent points about aperture's role in depth of field:

- *As you change the f-stop, either the shutter speed or ISO must also change to maintain the same exposure.* Remember that f-stop, shutter speed, and ISO are forever interwoven in the exposure equation. As you raise the f-stop, which reduces the size of the aperture, you must use a slower shutter speed or higher ISO to compensate for the reduced light that results from the smaller aperture opening. See Chapter 5 for a primer in balancing these three exposure settings.

- *Both foreground and background objects are blurry when the depth of field is short.* The examples of short depth of field used in Figure 6-7 and 6-8 may lead you to believe that short depth of field is all about blurring out the background. But if any objects are in front of the subject, they blur as well if they're beyond the sharp focus zone.

- *Try using aperture-priority autoexposure mode when you want to play with depth of field.* In this mode, (normally identified by an *Av* or *A* on your camera's mode dial), you set the f-stop, and the camera selects a shutter speed that will deliver a good exposure. The range of f-stops you can choose depends on your lens; check the camera manual for the specifics.

- *Some scene modes also are designed to deliver a short or long depth of field.* Even if your camera doesn't offer manual or aperture-priority control, you may be able to control depth of field to some extent by using scene modes. For example, Portrait mode typically selects a wide aperture setting to produce a shallow depth of field, and Landscape mode typically selects a narrow aperture to produce a greater depth of field. Additionally, some Canon cameras offer an automatic depth-of-field setting (A-DEP), which attempts to select an aperture that will keep all major objects in the frame in the sharp focus zone. The extent to which these automatic modes can adjust aperture depends on the light, of course, so they're not always going to produce the desired results in terms of depth of field. Chapter 4 talks more about scene modes.

- *The depth-of-field result you get at any f-stop varies depending on the type of camera you use.* I mention this issue in Chapters 1 and 5, but it bears repeating: On cameras that use small image sensors, you typically can't produce extremely shallow depth of field even if you use a very wide aperture. The reasons are too complex to dive into here, so just know that if you can't get the really blurry effects you see in some of my examples, it's probably your camera and not some error on your part. (Most of my photos were taken with a dSLR that uses a large image sensor.)

Finally, here's an easy way to remember which way to adjust the f-stop to extend or shorten depth of field: For a larger *focus* zone, use a higher *f*-stop setting. For less *focus*, use a smaller *f*-stop.

↳ **Change the lens focal length.** *Focal length,* measured in millimeters, determines the camera's angle of view, how large objects appear in the frame, and, the important point for this discussion, depth of field. A long focal length, such as you get from a telephoto lens, produces a shallow depth of field. A wide-angle lens, on the other hand, has a short focal length and produces a large depth of field.

Figure 6-9 offers an example. Both photos were taken at an aperture of f/5.6; however, the top image was taken at a shorter focal length (wider angle), so more of the scene remains in the sharp-focus zone. Note that both focal lengths here are in the telephoto range, which means that depth of field is relatively shallow even in the top image.

174mm

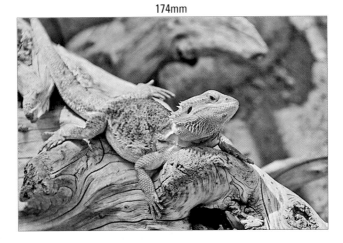

270mm

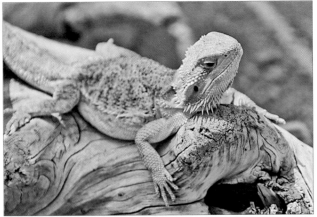

Figure 6-9: Zooming to a longer focal length also decreases depth of field.

If you have an optical zoom lens, you can change focal length just by zooming in and out. (Your manual should spell out the range of focal lengths for the lens.) Or if you own an interchangeable lens camera, you can buy different lenses with different focal lengths or even a couple of lenses that each offer a different zoom range. If your camera doesn't have an optical zoom, though, you're stuck with a single focal length.

Digital zoom, a feature found on some cameras, does *not* produce a shift in depth of field; digital zoom simply results in cropping and enlarging your existing image. (See Chapter 1 for more about camera lenses and types of zooms.)

✔ **Change the distance between camera and subject.** As you move closer to your subject, you decrease depth of field; as you move away, you extend depth of field.

Practicing these depth-of-field techniques is important because they help you achieve different compositional aims. Consider the pictures in Figure 6-10, for example. The subjects look great in both images. But notice the backgrounds: In the left image, a section of a gutter downspout extends up from the boy's shoulder, and there's a strong break in the light in the upper-left corner. Both distract the eye from the subjects. The photo on the right, where these annoyances are no longer visible, was achieved by moving the camera farther from the subjects and then zooming in. Any time you zoom in, you include less of the background in the shot because of the change in angle of view, and the background also becomes noticeably softer because of the reduction in depth of field, too, lessening the visual impact of the brick.

It's important to emphasize that the subjects were in the same place for both shots, and the aperture used for both was the same (f/5.6). The huge difference between the two images is solely due to a change of camera position and focal length. If you wanted to further soften that background, you could open the aperture further (assuming that your camera offered a lower f-stop setting). Or you could zoom in without moving away from the subjects, although that choice would mean that you could no longer fit as much of their bodies in the shot.

Putting it all together, then, decide how much depth of field best suits your subject and then combine aperture, focal length, and camera-to-subject distance to create the look you want. Remember the following formulas, illustrated in Figure 6-11:

✔ **For minimum depth of field (subject sharp, distant objects blurry):** Use a wide aperture (low f-stop number), a long focal length (telephoto lens), and get as close as possible to your subject. Be sure not to exceed the minimum close-focusing distance of your lens, though.

✔ **For maximum depth of field (subject and distant objects sharp):** Use a small aperture (high f-stop number), a short focal length (wide-angle lens), and move back from your subject as much as possible.

f/5.6, 42mm f/5.6, 300mm

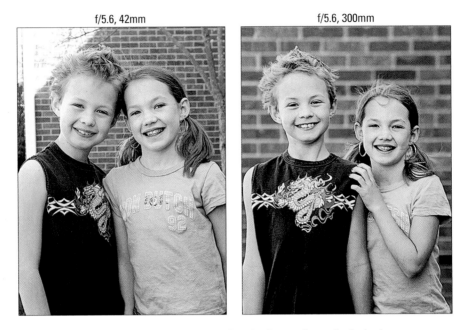

Figure 6-10: A longer focal length also means less background area fits in the frame.

Greater depth of field:
Select higher f-stop
Decrease focal length (zoom out)
Move farther from subject

Shorter depth of field:
Select lower f-stop
Increase focal length (zoom in)
Move closer to subject

Figure 6-11: Combining all three techniques enables you to achieve the minimum or maximum depth of field.

Controlling Color

In the film photography world, expert photographers manipulate color by using different films and lens filters. If you want landscapes that feature bold blues and vivid greens, for example, you choose a film known to emphasize those hues. If you're shooting portraits, on the other hand, you might add an amber-tinted filter onto your lens to infuse the scene with a warm, golden glow that flatters skin tones.

Things work differently in the digital world, but you still have lots of options for manipulating color — in fact, more so than in the film world, and without having to lug around a bagful of different films and filters, too. The rest of this chapter explains the standard digital-camera color features and also helps you solve some common color problems.

Exploring the world of digital color

Like film cameras, digital cameras create images by reading and recording the light reflected from a scene. But how does the camera translate that brightness information into the colors you see in the final photograph?

The next sections explain this mystery and decode some of the color-related techie terms you may encounter when you browse digital photography magazines, websites, and other forums.

RGB: A new way of thinking about color

A digital camera translates light into color pretty much the same way as the human eye. To understand the process, you first need to know that light can be broken into three color ranges: reds, greens, and blues. Inside your eyeball, you have three receptors corresponding to those color ranges. Each receptor measures the brightness of the light for its particular range. Your brain then combines the information from the three receptors into one multi-colored image in your head.

Because most of us didn't grow up thinking about mixing red, green, and blue light to create color, this concept can be a little hard to grasp. Here's an analogy that may help. Imagine that you're standing in a darkened room and have one flashlight that emits red light, one that emits green light, and one that emits blue light. Now suppose that you point all the flashlights at the same spot on a white wall. Where the three lights overlap, you get white, as shown in Figure 6-12. Where no light falls, you get black.

In the illustration, the flashlights emit full-intensity light with no fade over the spread of the beam, so mixing the three lights produces only three additional colors: magenta, cyan, yellow. But by varying the intensity of the beams, you can create every color that the human eye can see.

Just like your eyes, a digital camera analyzes the intensity — sometimes referred to as the *brightness value* — of the red, green, and blue light in a scene. Then the camera's computer brain mixes the brightness values to create the full-color image.

Pictures created using these three main colors of light are *RGB images* — for red, green, and blue. Computer monitors, television sets, digital projectors, and scanners also create images by combining red, green, and blue light.

Figure 6-12: RGB images are created by blending red, green, and blue light.

Digging through color channels

After your camera analyzes the amount of red, green, and blue light in a scene, it stores the brightness values for each color in separate portions of the image file. Digital-imaging professionals refer to these collections of brightness information as *color channels*.

In sophisticated image-editing programs such as Adobe Photoshop, you can view and edit the individual color channels in a digital photograph. Figure 6-13 shows a color image broken down into its red, green, and blue color channels. Notice that each channel contains nothing more than a grayscale image. That's because the camera records only light — or the absence of it — for each channel.

In any of the channel images, light areas indicate heavy amounts of that channel's color. For example, the red portion of the left flag appears nearly white in the red channel image, but nearly black in the green and blue channel images. Likewise, the blue flag poles appear very light in the blue channel images. Moreover, the center portion of the left flag is bright in all three channel images, which translates to white in the color image.

Photoshop and some other high-level programs enable you to manipulate the red, green, and blue color channels independently in order to tweak the colors in your photo. Thankfully, though, you don't need to dig that deep into imaging science to adjust the colors in the pictures you shoot; most programs, especially those designed for beginners, provide simple color-adjustment tools that do all this channel-changing for you in the background. You just tell the program that you want your photo to have a touch more of this color and a tad less of that.

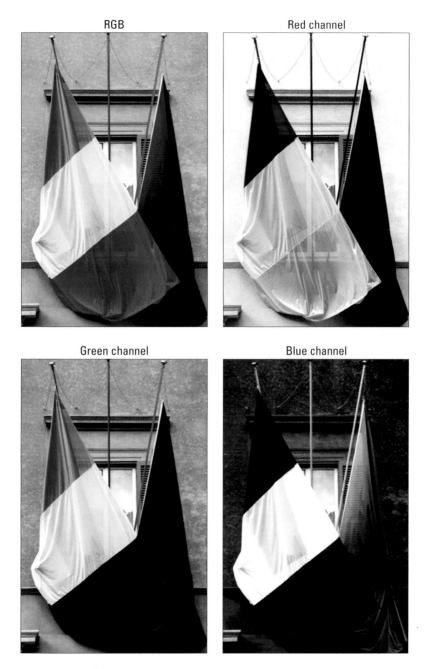

Figure 6-13: An RGB image has three color channels, one each for the red, green, and blue light values.

Don't let this channel stuff intimidate you, because until you become a seasoned photo editor, you don't need to give it much thought, if then. I bring the topic up only so that when you see the term *color channel* — which often crops up in camera reviews and photo-editing how-to articles — you have some idea what it means.

More colorful terminology

RGB is just one of many color-related acronyms and terms you may encounter on your digital photography adventures. So that you aren't confused when you encounter these buzzwords, the following list offers a brief explanation:

✔ **RGB:** Just to refresh your memory, RGB stands for red, green, and blue. RGB is the *color model* — that is, a method for defining colors — used by digital images, as well as any device that transmits or filters light. Figure 6-14 shows you how full-intensity red, green, and blue are mixed to create white, cyan, yellow, and magenta.

Image-editing gurus also use the term *color space* when discussing a color model, something they do with surprising frequency.

✔ **CMY/CMYK:** Whereas light-based devices mix red, green, and blue light to create images, printers mix ink to emblazon a page with color. Instead of red, green, and blue, however, printers use cyan, magenta, and yellow as the primary color components, as illustrated in Figure 6-15. This color model is called the CMY model, for reasons you no doubt can figure out.

Because inks are impure, producing a true black by mixing just cyan, magenta, and yellow is difficult. So most photo printers and commercial printing presses add black ink to the CMY mix. This model is called CMYK (the *K* is used to represent black because commercial printers refer to the

Figure 6-14: The RGB color model is based on red, green, and blue light.

Figure 6-15: The print color model is based on cyan, magenta, and yellow ink.

black printing plate as the *Key* plate). Four-color images printed at a commercial printer may need to be converted to the CMYK color mode before printing.

One important note here: the colors you see in the RGB model in Figure 6-14 and the colors in the CMYK model in Figure 6-15 appear the same here. But in reality, the RGB colors are much more vibrant; what you're seeing in Figure 6-14 is the RGB chart converted to the CMYK model for printing. You simply can't reproduce in print the most vivid hues in an RGB image, which is one reason why those colors you see on your monitor never exactly match what you see in your printed photos. For more on this issue and printing in general, check out Chapter 9.

✔ **sRGB:** A variation of the RGB color model, sRGB offers a smaller *gamut,* or range of colors, than RGB. One reason this color model was designed was to improve color matching between onscreen and printed images. Because RGB devices can produce more colors than printer inks can reproduce, limiting the range of available RGB colors helps increase the possibility that what you see onscreen is what you get on paper. The sRGB color model also aims to define standards for onscreen colors so that images on a web page look the same on one viewer's monitor as they do on another. In fact, the *s* in sRGB stands for *standard.* Today, sRGB is the color model used by most digital cameras.

✔ **Adobe RGB:** Many imaging purists don't like to limit their color palettes to the smaller spectrum of sRGB. For that reason, some digital cameras, especially high-end models, also enable the photographer to capture images in the Adobe RGB color model. This model, developed by Adobe, includes a wider range of colors than sRGB. Figure 6-16 offers an illustration that approximates the differences between the two spectrums; note that neither can capture all the colors that the human eye can perceive.

The potential downside of Adobe RGB is that some colors included in its gamut can't be reproduced in print. If a printer encounters a color that it can't handle — such colors are said to be *out-of-gamut* — it substitutes the closest possible color. However, the sRGB color space excludes some colors that *can* be printed. So if capturing the widest spectrum is more important to you than color matching, you can opt for Adobe RGB over sRGB.

If you do decide to use Adobe RGB, study your photo software and printer software manuals to find out how to work with that color model when you edit, view, and print your images. Some lower-end programs can't deal with different color models and simply convert everything to sRGB when you open the images. (You will need programs that support a thing called *color management.*) In other words, Adobe RGB may be a subject for you to explore when you become more advanced in your digital photography adventures.

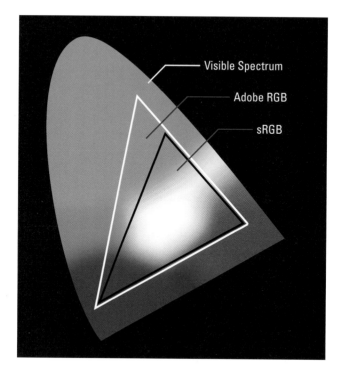

Figure 6-16: The Adobe RGB spectrum includes more colors than sRGB.

Note, too, that color-matching problems between printed and onscreen images can occur with either sRGB or Adobe RGB because those discrepancies can result from many issues other than the original color model. Chapter 9 offers more on this subject.

✏ **Grayscale:** A grayscale image is comprised solely of black, white, and shades of gray. Some people (and some photo-editing programs) refer to grayscale images as black-and-white images, but a true black-and-white image contains only black and white pixels, with no shades of gray in between. Graphics professionals often refer to black-and-white images as *line art*.

Many digital cameras enable you to capture grayscale images — well, sort of. What they really do is capture a full-color image and then convert that photo to grayscale as it's saved to the camera memory card. Some cameras instead offer a feature that enables you to create a copy of a color image that's on your memory card and then convert that copy to a grayscale version, so you end up with both a color original and a grayscale copy. You may want to bypass these in-camera grayscale options and instead do your own color-to-grayscale conversions in your photo-editing program, however. Assuming that you own a capable program, you'll have much more control over how the colors in your image

are translated to grayscale. At the very least, if your camera captures the original file in grayscale instead of creating a grayscale copy, take one shot of the subject in color and one in grayscale. You can always go from color to grayscale after the fact, but you can't do the opposite.

✒ **CIE Lab, HSB, and HSL:** These acronyms refer to three other color models for digital images. Until you become an advanced digital-imaging guru, you don't need to worry about them. But just for the record, CIE Lab defines colors using three color channels. One channel stores luminosity (brightness) values, and the other two channels each store a separate range of colors. (The *a* and *b* are arbitrary names assigned to these two color channels.) HSB and HSL define colors based on hue (color), saturation (purity or intensity of color), and brightness (in the case of HSB) or lightness (in the case of HSL).

About the only time you're likely to run into these color options is when mixing paint colors in a photo-editing program. Even then, the onscreen display in the color-mixing dialog boxes makes it easy to figure out how to create the color you want.

Using white balance to solve color problems

If the colors in your picture are decidedly out of whack — skin tones are green or pink, for example — you no doubt have an issue related to *white balance.* This is a feature on your camera that is designed to compensate for the fact that different light sources have varying *color temperatures,* which is a fancy way of saying that they contain different amounts of red, green, and blue light and thus cast their own color bias on a scene.

Color temperature is measured on the Kelvin scale, illustrated in Figure 6-17. The midday sun has a color temperature of about 5500 Kelvin, which is

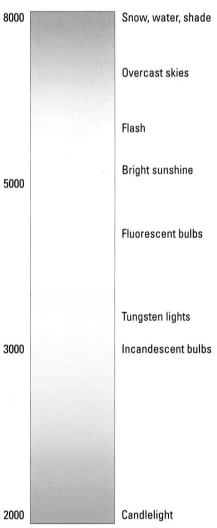

8000	Snow, water, shade
	Overcast skies
	Flash
5000	Bright sunshine
	Fluorescent bulbs
	Tungsten lights
3000	Incandescent bulbs
2000	Candlelight

Figure 6-17: Each light source emits its own color cast.

sometimes abbreviated as 5500K — not to be confused with 5500 kilobytes, also abbreviated as 5500K. When two worlds as full of technical lingo as photography and computers collide, havoc ensues. If you're ever unsure as to which *K* is being discussed, just nod your head thoughtfully and say, "Yes, I see your point."

At any rate, the human eye manages the perception of color temperature naturally, and no matter if you're in an office with fluorescent light, under a bright sun, or in a living room with house lamps, when you see red, it looks red (assuming no difficulties with color blindness, of course). However, cameras aren't as sophisticated as your brain at accommodating various lighting conditions and the colors being illuminated by them.

Film photographers use special films or lens filters designed to compensate for different light sources. But digital cameras, like video cameras, get around the color-temperature problem by using a process known as white balancing. *White balancing* simply tells the camera what combination of red, green, and blue light it should perceive as pure white, given the current lighting conditions. With that information as a baseline, the camera can then accurately reproduce the other colors in the scene.

On many digital cameras, white balancing is handled automatically, but many models provide manual white-balance controls as well. Why would you want to make manual white-balance adjustments? Because sometimes, automatic white balancing doesn't go quite far enough in removing unwanted color casts, especially when a scene is lit by multiple light sources that have different color temperatures. If you notice that your whites aren't really white or that the image has an unnatural tint, you can usually correct the problem by shifting out of automatic mode and dialing in a manual white-balance setting that's tailored to a specific light source. Table 6-1 shows some common manual settings. These settings are usually represented by graphic icons; the ones in the table are generic, but most cameras use similar symbols to represent the white-balance settings.

Table 6-1	Manual White-Balance Settings	
Icon	*Setting*	*Use*
☀	Daylight or Sunny	Shooting outdoors in bright light
☁	Cloudy	Shooting outdoors in overcast skies
💡	Fluorescent	Taking pictures in areas with fluorescent lights
💡	Incandescent	Shooting under incandescent lights (standard household lights)
⚡	Flash	Shooting with the camera's on-board flash

Figure 6-18 gives you an idea of how image colors are affected by white-balance settings. As with most cameras, the one used to take these pictures handles color pretty well in automatic white-balancing mode. But this shooting location threw the camera a curve ball because the subject was lit by three different light sources. The room had fluorescent lights, which lit the subject from above; to the subject's left (the right side of the picture), bright daylight was shining through a large picture window. Adding flash made things even more complicated. In this case, the image took on a slightly yellowish cast at the Automatic setting. Because the scene was predominately lit by fluorescent lights, switching to that setting produced the most accurate colors.

That's the short story on white balance: Turn to this control any time your colors look out of whack. But also investigate the tactics explored in the next few sections, which present some additional white-balance features and uses.

Get in the habit of setting your white balance back to AWB (automatic white balance) after you're done using a manual setting. Otherwise, if you shoot another photo in different light, the color is likely to appear wrong in that photo.

White-balance shift

Some cameras offer a way to refine white balance beyond what you can do with the six or seven usual manual settings. For example, suppose you're using incandescent lamps but the Incandescent setting on your camera doesn't quite produce neutral colors. You may be able to nudge the white-balance adjustment in small increments to eliminate the problem. For example, on some Canon cameras, you can tweak the white-balance adjustment by moving a little marker inside a color grid, shifting hues along both a blue/amber axis and a green/magenta axis, as shown in Figure 6-19. The setting in the figure shifts the white balance three steps toward amber and one toward magenta.

This feature sometimes goes by the name *white-balance shift;* on other models, it may go by the name *white-balance fine-tune* or something similar. But regardless of the label, this feature offers very precise control over white balance.

Typically, the shift increments are geared to a measure called a *mired (my-redd)*, which indicates the degree of color correction applied by a traditional colored lens filter. Each white-balance adjustment increment equals so many mireds (usually, five). If you're hip to the whole mired issue, check the fine print in your camera manual for details on how your model handles things.

Auto White Balance (AWB) Sunny

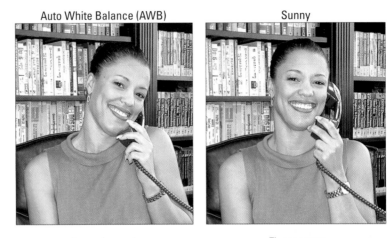

Incandescent Fluorescent

Flash Cloudy

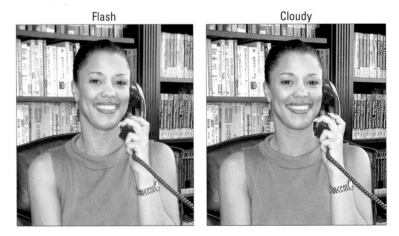

Figure 6-18: The white-balance control affects how the camera "sees" white.

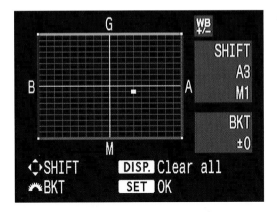

Figure 6-19: On some cameras, you use this type of control to adjust white balance in small increments.

Custom white balancing based on a gray card

Some cameras allow you to shoot a reference photo that the camera analyzes to determine the right amount of white balancing needed to completely remove any color casts. This feature is usually the most reliable and efficient way to ensure accurate color.

Here's how it works: You take a picture of a neutral gray card, illuminating the card with the same lighting that you plan to use for your shot. (You can buy cards made just for this purpose at your local camera store for under $20.) The camera then determines what white-balance adjustment is needed to get that image to a neutral color state. The adjustment information is stored as a custom setting, and any time you shoot in that same light, you select that custom setting as your white-balance option, and the camera applies the same correction to ensure color accuracy.

White-balance bracketing

If you're unsure about the light illuminating your subject, you may want to try *white-balance bracketing*. This high-falootin' term simply means that you take a picture of the same thing several times with different white-balance settings.

Say that your family is sitting on the couch in your living room, and a mix of sunlight and a few lamps is shining on them. One of the lamps has a regular incandescent bulb, while another has one of those new, efficient, curly CFL bulbs. Depending on who's sitting in what light, your camera's color brain is very likely to get quite confused about how to render the image.

Assuming that your camera offers manual white-balance control, as explained in the preceding section, try taking the shot using a variety of settings to see which one produces the best overall colors. Later, on your computer, you can look at the photos in more detail and decide which one you prefer.

Managing colors (and color expectations)

One concern often voiced by digital photographers is that the colors they see on their camera monitors often look very different when the picture is displayed on a computer monitor. An even bigger complaint is that printed colors don't look the same as what's displayed on the monitor.

The first step to solving the problem is to get your expectations in line, which means understanding the different color worlds involved in the process: the colors that your eyes see, the colors that your camera can capture, and the colors that can be reproduced in print.

Unfortunately, no camera is as capable as the human eye at capturing certain shades and intensities of reds, greens, blues, and yellows. And no printer can reproduce with ink all the colors that can be displayed by a camera or computer monitor, which create colors by projecting red, green, and blue light. In other words, you're dealing with three different color *spaces,* or *gamuts,* which can be compared to three boxes of crayons that each hold a slightly different assortment of colors. When your camera doesn't have the right crayon to record a color in a scene, it simply uses the closest available one — the same way you might draw with a midnight-blue crayon if you lost your navy blue one. The printer does the same thing when outputting your photos.

To sum up, perfect color matching simply isn't possible. You can, however, do a number of things to get the best possible color consistency. See Chapter 9 for a list of steps to take to get printed colors more in line with screen colors, and review the camera color-control topics discussed in this chapter to bend the colors your camera produces to better mirror the colors that you see in a scene.

Some cameras offer automatic white-balance bracketing that's based on white-balance shifting (explained earlier in this chapter). With this feature, you first select a white balance setting — Sunny, Cloudy, whatever. Then you tell the camera to take one shot at that setting, take a second shot at a setting that slightly shifts colors in one direction, and a third that shifts colors in the other direction.

Using white balance for effect

Colors are often described as being either "cool" or "warm." Cool colors fall into the blue/green range of the color spectrum; warm colors, the red/yellow/orange spectrum. Light, too, is often said to be cool or warm: Candlelight, for example is a very warm light, whereas flash is a very cool light.

Talking about colors as being cool and warm can get confusing if you're also pondering the Kelvin scale. Colors that give off the bluish light have a higher Kelvin temperature than those that give off a warmer light, and most of us are used to thinking of a higher temperature as warmer. Don't think too much about it — it's more important that you are aware of the colors of different light sources than their Kelvin temperatures.

Back to the discussion at hand: Film photographers often apply tinted filters to the ends of their lenses to purposefully add a warm or cool cast to their subjects. With digital, however, you may be able to do the same thing simply by using your camera's white-balance controls.

Assuming that your camera offers manual white-balance settings, you can simply experiment with different settings to see which ones provide the warming and cooling effects you want. The trick is to choose a white-balance setting that's actually designed for a light source that has a different color temperature than your actual light source, as follows:

✓ **For warmer colors:** Choose a white-balance setting designed for the bluish light sources that fall at the top of the Kelvin scale, such as flash or clouds. The camera, thinking that the light is very blue, shifts colors to the warmer side of the scale. And if you're shooting in light that's actually *not* cool, the resulting colors wind up being shoved slightly past neutral to warm.

✓ **For cooler colors:** Choose a white-balance setting designed for the warm-colored light sources at the bottom of the Kelvin scale, such as Incandescent. Again, the camera applies what it thinks is the right amount of cooling needed to make your whites white, but the adjustment again takes your colors past neutral, this time to the cooler side of the color range.

As an example, take a look at Figure 6-20. The actual light in this scene was from strong, bright daylight coming in through the overhead windows. At the Daylight white-balance setting, the colors were neutral — or to put it another way, rendered without a color cast from the light. Shooting the scene using the Cloudy setting produced the result you see in the right figure. The camera applied an overly strong warming effect, thinking that it needed to compensate for the bluish tint of cloudy skies. The change is most evident in the green ironwork at the top of the scene and in the walls, which appear almost tan in the original but golden in the Cloudy version.

Of course, this trick only works to a certain degree. If you select Cloudy, for example, hoping to make colors warmer, you won't see any effect if you're actually shooting in cloudy conditions. Instead, the setting just neutralizes the cloudy light. So the degree of color change that occurs when you select a different white-balance setting depends on how far your actual light source is from that setting.

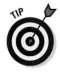

If your camera offers white-balance shift, however, you may be able to tell the camera that you always want to push colors slightly to the warm or cool side any time you select a certain white-balance setting. So if you find that your camera consistently produces colors that are too cool for your liking at the Cloudy setting, you can dial in a correction that slightly increases warming in cloudy light.

Balanced for actual light (daylight) Balanced using Cloudy setting

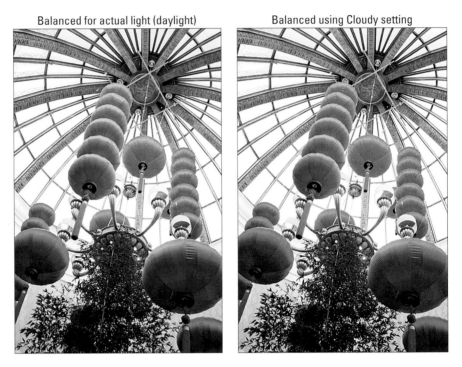

Figure 6-20: You can trick your white-balance control into serving as a digital warming filter.

Shooting Raw for absolute color control

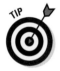

Does your camera enable you to capture images in the Camera Raw format? In this format, fully explained in Chapter 3, the camera actually applies *no* white balancing — or any other color adjustments — as it does when you shoot in the JPEG format. Instead, you specify the color attributes of your picture when you convert the Raw file to a standard format (such as TIFF) on your computer.

The color controls available during conversion depend on the raw-conversion software you use; Figure 6-21 highlights those available in the Adobe Photoshop Elements version. In this program, you can apply one of your camera's preset white-balance settings (Cloudy, Sunny, and so on) or use color sliders to fine-tune those settings. You also can manipulate color saturation and vibrancy.

Although Raw capture involves more time behind the computer and has a few other complications you can explore in Chapter 3, it does provide an even finer degree of color control than you get from most cameras. More importantly, it provides a color safety net. If you shoot JPEG and get the white balance wrong, you can wind up with an ugly color cast that may be difficult to fully remove in a photo editor. But with Raw, the color isn't locked in when the file is created, so you always get a second chance.

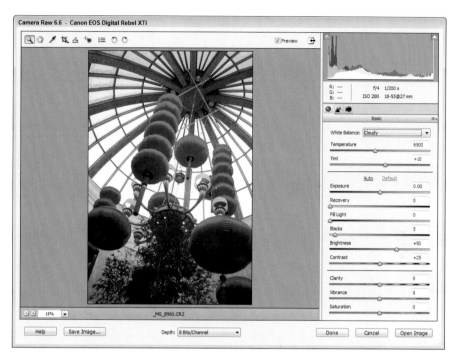

Figure 6-21: You can set white balance for Raw files during the conversion process.

That's not to say that you can totally ignore white balance when you shoot Raw, however. First, the picture you see during playback on the camera monitor is a JPEG preview of the image as it will appear if you stick with the current white-balance setting. So if the color is way off, judging the overall result of the picture is a little difficult. It's hard to tell whether a red flower is properly exposed, for example, if the entire image has a blue color cast. And when you open your picture file in a Raw converter, the software initially translates the picture data according to the recorded white-balance setting. Getting as close as possible from the get-go can thus save you some time tweaking colors during the conversion stage.

Exploring even more color options

Especially if your camera is relatively new, you may have access to several color controls in addition to those already laid out in this chapter. Browse through your camera manual to look for features such as these:

- ✓ **Automatic scene modes:** Explained in Chapter 4, these exposure modes are geared to best capture specific types of scenes: landscapes, portraits, and so on. Primarily, these modes are meant to assist you with choosing the right exposure settings, but many also manipulate colors.

Landscape mode may emphasize blues and greens, for example, while Portrait mode may slightly enhance skin colors.

✓ **Color enhancement presets for advanced exposure modes:** If you prefer to work in an advanced exposure mode, such as shutter-priority autoexposure or manual exposure, you still may be able to apply automatic color adjustments to your images. Usually, you can choose from color presets, each of which renders colors a different way. One preset may be geared to richer colors, another may produce a more neutral color palette, and others may emphasize different parts of the color spectrum. On some Canon cameras, for example, you make this adjustment through a feature called Picture Styles; on some Nikon cameras, the feature is called Optimize Image, and on others, Picture Controls.

✓ **Saturation adjustments:** Many cameras, even entry-level models, enable you to boost *color saturation,* or the intensity of the colors. However, use discretion: By increasing color saturation too much, you can lose picture detail. A flower petal that should reflect a variety of reds, at different saturations, for example, can become one big, lifeless blob of fully saturated red.

✓ **Color effects:** Many cameras offer effects filters that can turn your full-color photo into a grayscale or tinted monochrome image (blue and white, for example, or sepia-toned). Figure 6-22, for example, shows an original full-color image along with grayscale and sepia-toned versions produced this way. In some cases, you select the filter before you press the shutter button. Some cameras enable you to preview the effect; in other cases, you can't see

Figure 6-22: Many cameras can produce grayscale or sepia-toned images.

the results of the filter until picture playback. On other cameras, you apply the effect to an existing image on your memory card rather than before you shoot.

These in-camera filters are fun and convenient, but if you want better control over your results, capture the image as usual and then apply the color effects in your photo editor. In many photo editors, you can choose which of your original colors to emphasize in your monochrome version, and you also can make the exposure and contrast adjustments that are often needed after making the move from color to monochrome. If you do use the in-camera filters, be sure that your camera preserves the full-color version of the image; you can always go from color to monochrome, but the opposite isn't true.

7

Getting the Shot: How the Pros Do It

*E*arlier chapters in this book explain the most common digital camera features, from settings that affect exposure to controls for manipulating focus and color. This chapter takes things a step further, sharing more tips for shooting specific types of pictures: portraits, landscapes, action shots, and close-ups. In addition, this chapter explains how to stitch several shots together into a panoramic image and offers a few tips for capturing tricky subjects such as fireworks.

Just one note before you dig in: Keep in mind that there are no hard and fast rules as to the right way to shoot a portrait, a landscape, or whatever. So feel free to wander off on your own, tweaking this exposure setting or adjusting that focus control, to discover your own creative vision. Experimentation is part of the fun of photography, after all — and thanks to your camera monitor and the option to delete images that don't work, it's an easy, completely free proposition.

Capturing Captivating Portraits

The classic portraiture approach is to keep the subject sharply focused while throwing the background into soft focus, as shown in Figure 7-1. In other words, the picture features a shallow *depth of field* — only objects very close to the subject are within the zone of sharp focus. This artistic choice emphasizes the subject and helps diminish the impact of any distracting background objects in cases where you can't control the setting.

Figure 7-1: A blurry background draws attention to the subject and diminishes the impact of any distracting background objects.

Chapter 6 explains depth-of-field techniques fully, but here's a quick recap on how to achieve that blurry-background look:

- ✏ **Set your camera to Portrait or aperture-priority exposure mode.** One way to shorten depth of field is to use a low f-stop setting, which opens the aperture. Portrait mode, found on many cameras, automatically opens the aperture as much as possible. This scene mode also usually applies some color and sharpness adjustments that are well suited to rendering skin tones.

 However, if you want to precisely control depth of field, switch to aperture-priority autoexposure mode, if available. In this mode, you choose the f-stop setting, and the camera selects a shutter speed to properly expose the photo. (This mode is usually abbreviated as A or Av on the camera dial; Chapter 5 has details.) Of course, if you're comfortable with manual exposure mode, in which you set both aperture and shutter speed, that's an option as well.

- ✏ **Zoom in, get closer, or both.** Zooming to a longer focal length also reduces depth of field, as does moving physically closer to your subject.

 Avoid using a lens with a short focal length (a wide-angle lens) for portraits. They can cause features to appear distorted — sort of like how people look when you view them through a security peephole in a door.

- ✏ **Move your subject farther from the background.** The greater the distance between the two, the more background blurring you can achieve. Increasing the distance also helps eliminate shadows that may occur behind the subject if you use flash.

One other word of caution related to depth of field: Be careful when shooting group portraits not to go *so* shallow that the zone of sharp focus doesn't extend to everyone in the group. With extremely short depth of field, the people in the front row may be in sharp focus while anyone in rows behind them may appear blurry.

In addition to considering depth of field, these other tips can also improve your people pics:

✔ **Pay attention to the background.** Scan the entire frame looking for intrusive objects that may distract the eye from the subject. If necessary, reposition the subject against a more flattering backdrop. Inside, a softly textured wall works well; outdoors, trees and shrubs can provide nice backdrops as long as they aren't so ornate or colorful that they diminish the subject (for example, a magnolia tree laden with blooms).

When you're shooting children indoors — where it can be hard to find an area that isn't cluttered with toys and other kid paraphernalia — try this trick: Photograph your subjects while they're resting their heads against a plain-colored sofa cushion, as in Figure 7-2. As another option, you can toss a few cushions on the floor, have the kids lie down on them, and then shoot them from above.

Figure 7-2: A plain sofa cushion can provide a clutter-free backdrop for kid pics.

✔ **For indoor portraits, shoot flash-free if possible.** Shooting by available light rather than flash produces softer illumination and avoids the problem of red-eye. To get enough light to go flash-free, turn on room lights or, during daylight, pose your subject next to a sunny window. Do remember that the camera may need a fairly slow shutter speed to expose the image in low light, however, so you may want to use a tripod and ask your subject to remain as still as possible. Or you can try raising the ISO setting to increase the camera's light sensitivity, although that can also produce noise (the defect that gives your image a speckled look).

In Portrait mode, the camera may not allow you to shoot without flash in dim lighting. If your camera offers a No Flash scene mode (it may be called Museum mode or something similar), you can try that instead, although the camera may not choose an aperture setting that throws the background into soft focus in that mode.

✔ **If using a flash for your indoor and nighttime portraits is necessary, try these techniques for best results:**

- *Turn on as many room lights as possible.* The more ambient light, the less flash light is required. The additional light also causes the pupils to constrict, reducing the chances of red-eye.

- *Try using red-eye reduction flash mode.* Red-eye is caused when light from the flash is reflected by the subject's retinas. In red-eye reduction flash mode, the camera emits a brief preflash light to constrict the subjects' pupils and thus reduce the amount of light that can hit the retina. Just be sure to warn your subject not to stop smiling until after the real flash fires!

 One other trick for lessening red eye when you use a built-in flash is to pose your subjects so that they're not looking directly at the camera lens, as in Figure 7-2. That way, the flash doesn't strike the eyes directly. You can also shoot your subjects in profile or look-ing upward toward the ceiling — after all, a face-forward pose isn't a requirement of a great portrait.

- *For subjects that can stay perfectly still, try slow-synch flash.* This flash mode simply lets you use a shutter speed that's slower than what is normally used for flash pictures. This enables the camera to soak up more ambient light, producing a brighter background and reducing the flash power that's needed to light the subject.

 If your camera has a Nighttime Portrait mode, choosing that set-ting automatically enables slow-synch flash. You can also use shutter-priority autoexposure mode or manual exposure mode, if available on your camera, to set the shutter speed yourself.

 Figure 7-3 illustrates how slow-sync flash can really improve an indoor portrait. In the left image, shot in Portrait scene mode with normal flash, the camera selected a shutter speed of 1/60 second. At that speed, the camera has little time to soak up any ambient light, so the scene is lit primarily by the flash. That caused two problems: The strong flash created some *hot spots* (areas of over-exposure) on the subject's skin, and the window frame is much more prominent because of the contrast between it and the bushes outside the window. Although I shot this photo during the daytime, the bushes appear dark because the exposure time was brief and they were beyond the reach of the flash.

 For the second example, I used shutter-priority autoexposure and set the shutter speed to 1/4 second. This exposure time was long enough to permit the ambient light to brighten the exteriors to the point that the window frame almost blends into the background, and because less flash power was needed to expose the subject, the lighting is much more flattering. In this case, the bright back-ground also helps to set the subject apart because of her dark hair and shirt. If the subject had been a pale blonde, this setup wouldn't have worked as well, of course.

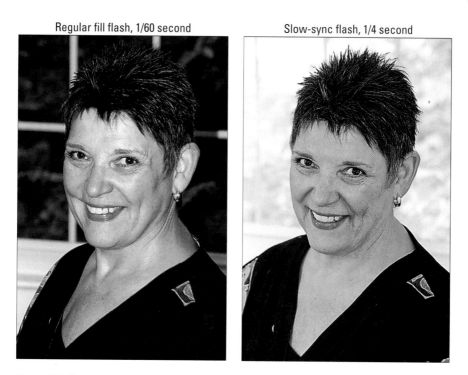

Regular fill flash, 1/60 second Slow-sync flash, 1/4 second

Figure 7-3: Slow-sync flash produces softer, more even lighting and brighter backgrounds.

Any time you use slow-sync flash, don't forget that a slower-than-normal shutter speed means an increased risk of blur due to camera shake. So always use a tripod or otherwise steady the camera, and remind your subjects to stay absolutely still, too, because they will appear blurry if they move during the exposure. I was fortunate to have both a tripod and a cooperative subject for my examples, but I probably wouldn't try slow-sync for portraits of young children or pets.

- *Soften the flash light by attaching a diffuser.* A diffuser is just a piece of translucent material or plastic that spreads and softens the light. The more diffused the flash, the more flattering the light. You can get a look at one type of diffuser in the flash section of Chapter 5.

- *If you have an external flash, rotate the head to bounce the light off the ceiling.* Again, this diffuses the light so that it falls back softly on the subject. Chapter 5's discussion on using external flash offers an example portrait. Only use this technique if the ceiling is white, however — if you bounce flash off a colored ceiling, the light will take on that color.

- *To reduce shadowing from the flash, move your subject farther from the background.* Adding distance between the background and

subject also softens the background when you use settings that produce a short depth of field.

- *Shoot with your camera in a horizontal position.* When a camera is held vertically with the flash on, it's very common to get a strong, unattractive shadow along one side of your subject. If you use a flash with a rotating head, you may be able to adjust the angle of the flash to avoid this issue, however.

✔ **Experiment with using flash in outdoor daytime portraits.** I know this sounds counter-intuitive — why would you need flash during daytime? But think about the direction of the light: It's coming from overhead, which means that there may not be any light directed toward the face.

Consider Figure 7-4 as an example. In this photo, I posed the girls under a shade tree with their backs toward the sun — an option that helps eliminate squinting. In the first image, shot without flash, the subjects are underexposed for a couple reasons. First, their faces weren't being hit directly by the sunlight. And second, I was using normal exposure metering, where the camera bases exposure on the entire frame, and the very bright background caused the camera to choose an exposure that left the subjects too dark. (Chapter 5 discusses exposure metering.) Notice, too, that in a few areas, sunlight filtering through the leaves of the trees left distracting bright spots on the faces. Adding flash for the second shot produced a much better result. The flash not only brightened the subjects but also evened out the light and virtually eliminated the overexposed areas on the skin. Additionally, because the camera knew that it would have the advantage of the extra light from the flash, it chose a faster exposure time — 1/125 second as opposed to 1/80 second for the first shot. And with that faster exposure time, the background grass isn't so bright and thus is less distracting.

Chapter 5 talks more about the art of using flash outdoors, but here are just two important points to remember:

- Most cameras don't let you use flash in Portrait mode if the light is very bright, unfortunately. You may be able to move your subject into a shady enough area that the camera thinks flash is needed, however.

- If your subjects are lit by strong daylight, be careful about overexposing them. When you use built-in flash, most cameras limit you to a shutter speed in the neighborhood of 1/200–1/320 second, and in very bright light, that may be too long of an exposure time. Again, try moving the subjects into the shade for better results.

No flash With flash

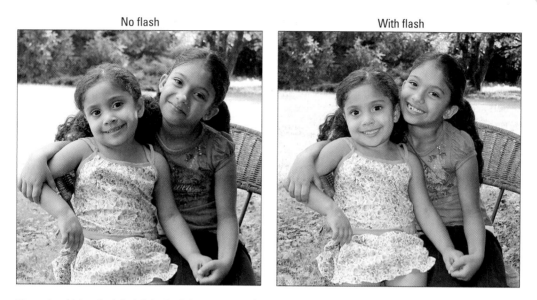

Figure 7-4: Using flash in bright daylight helps eliminate shadows caused by strong overhead light.

✓ **Check image colors if your subject is lit by both flash and ambient light.** If you set the camera's white-balance setting to automatic, enabling the flash tells the camera to warm colors to compensate for the cool light of a flash. If your subject is also lit by a secondary light source such as room lights or daylight, the result may be colors that are slightly warmer or cooler than neutral. In Figures 7-3 and 7-4, for example, colors became warmer. This warming effect typically looks nice in portraits, giving the skin a subtle glow, but if you aren't happy with the result or want even more warming, you may need to try a different white-balance setting or adjust the image color in your image-editing application. See Chapter 6 for help.

✓ **Frame your subject loosely to allow for later cropping to a variety of frame sizes.** If you capture a great portrait, chances are you'll want to print and frame it. To give yourself the flexibility of choosing from different frame sizes — 4 x 6, 5 x 7, and so on — remember to leave a little *head room,* or margin or empty background around the top and sides of the photo. That way, you can crop the picture to different aspect ratios without having to cut off part of the subject's head. See the Chapter 4 section discussing composition for more on this topic.

✔ **Don't say "cheese."** The most boring portraits are those in which the subjects pose in front of the camera and say "cheese" on the photographer's cue. If you really want to reveal something about your subjects, catch them in the act of enjoying a favorite toy, using the tools of their trade, or interacting with others. Figure 7-5 offers an example: Compare the left image, featuring the formal pose, with the right one, which captures this brother and sister just goofing around. The formal pose is okay, but the second one tells you so much more about their personalities and relationship.

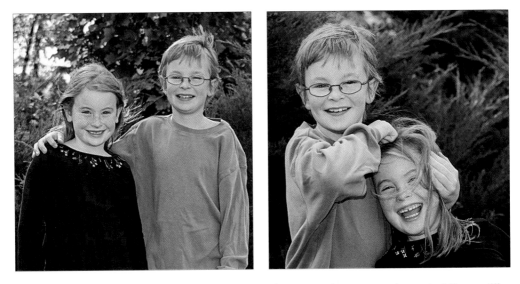

Figure 7-5: Catching a moment of brother-sister play produces a much more engaging portrait than a stiff, formal pose.

Shooting Better Action Shots

A fast shutter speed is the key to capturing a blur-free shot of any moving subject, whether it's a butterfly flitting from flower to flower, a car passing by, or a running baseball player.

What shutter speed you need depends on the speed at which your subject is moving. For the right image in Figure 7-5, a shutter speed of 1/250 second was enough to freeze the action of the children at play. But the hockey player in Figure 7-6 was moving at such a fast pace that a shutter speed twice as fast — 1/500 second — wasn't high enough. To catch this subject cleanly, I needed to amp up the shutter speed to 1/1000 second.

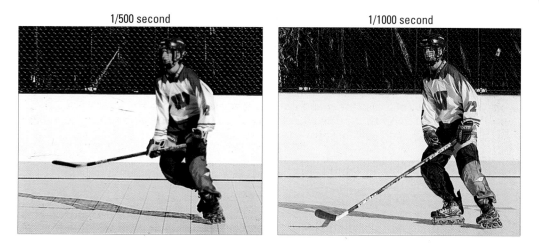

1/500 second 1/1000 second

Figure 7-6: A shutter speed of 1/500 second wasn't quite enough to stop the motion of this racing hockey player; raising the shutter speed to 1/1000 second did the trick.

Finding the right shutter speed requires some experimentation, but generally speaking, 1/500 second should be fast enough for all but the fastest subjects — my hockey player, cyclists, motorcycles, birds in flight, and so on. And for subjects moving slowly, such as a flower swaying in a gentle breeze or a child walking, you can get away with a much slower shutter speed — even 1/125 second can be enough. Of course, you should take some test shots and inspect the image on the camera monitor closely to make sure that your speed is high enough.

Whatever the speed of your subject, try setting your camera to one of the following exposure modes to capture action:

- **Shutter-priority autoexposure:** Usually abbreviated S or Tv (for exposure *time value*), this mode enables you to specify an exact shutter speed. The camera then chooses the f-stop needed to expose the image properly. Of course, you can always switch to Manual exposure and set both shutter speed and aperture yourself.

 Many cameras will tell you if you have set a speed that is too fast to get a good exposure. For example, in some cameras if the aperture value blinks after you set the shutter speed, the camera can't select an f-stop that will properly expose the photo at that shutter speed. Other cameras may prevent you from choosing a shutter speed that puts you into the exposure danger zone.

- **Sports mode:** Almost all cameras offer a Sports mode these days, although it may go by some other name (Action, for example). Whatever the name, this mode automatically dials in a fast shutter speed for you.

Here are a few other tips that pros use when capturing action:

- ✔ **Raise the ISO setting to enable a faster shutter if needed.** In dim lighting, you may not be able to get a good exposure at your chosen shutter speed or in Sports mode without taking this step. Raising the ISO does increase the possibility of noise, but a noisy shot is often better than a blurry one. (Note that some cameras automatically raise the ISO for you in dim lighting as well as when you put the camera into Sports mode.)

- ✔ **Forget about flash.** Using flash isn't usually a workable solution for action shots. First, the flash needs time to recycle between shots, so it slows your shot-to-shot time. Second, most built-in flashes have limited ranges — so don't waste your time if your subject isn't close by. And third, remember that the maximum shutter speed decreases when you use flash; the top speed is usually in the range of 1/200 to 1/320 second. That may not be fast enough to capture your subject without blur. (Some cameras can use a faster shutter speed when you use an external flash, however.)

 If you do decide to use flash, you may have to bail out of Sports mode, though; it probably doesn't permit you to use a flash.

- ✔ **Set the camera to burst mode, if available.** This mode may be called Continuous or something similar; often, the option is set through an option called *Drive mode, Release mode,* or *Shooting mode.* Whatever the name, it enables you to record a continuous series of images with a single press of the shutter button. As long as you keep the button down, the camera captures image after image at a rapid pace — two to four frames per second is common, but some high-end cameras can be faster.

- ✔ **For fastest shooting with a lens that has a manual focusing ring, consider switching to manual focusing.** You then eliminate the time the camera needs to lock focus in autofocus mode. Again, some cameras are faster than others, so you'll probably need to try it both ways.

 Note that with most point-and-shoots that offer manual focusing, you have to specify the exact camera-to-subject distance by using a menu control or some similar process that can actually slow you down. So unless you can preset the focus distance, stick with autofocus in this case.

- ✔ **In autofocus mode, try** *continuous-servo mode,* **if available.** Again, the name of the mode varies from camera to camera — on Canon models, it's usually called *AI Servo,* for example. When this feature is enabled, the camera initially sets focus when you depress the shutter button halfway but continues to adjust focus as necessary up to the time to take the picture, just in case the subject moves. All you need to do is reframe

the shot as needed to keep the subject within the area the camera's using to calculate focus.

✔ **If continuous-servo autofocus isn't available, lock in autofocus in advance.** Press the shutter button halfway to do so. Now when the action occurs, just press the shutter button the rest of the way. Your image-capture time is faster because the camera has already done the work of establishing focus.

✔ **If possible, turn off automatic image review.** Most cameras display each picture for a few seconds on the camera monitor immediately after you capture the shot. In many cases, you can't take another picture until this instant review period is over. If your camera enables you to turn off the feature, doing so is a good idea for action shooting. (Some cameras limit image review automatically in Sports mode.)

✔ **Compose the subject to allow for movement across the frame.** To make sure that your subject doesn't move out of the frame before you press the shutter button, compose the image with some extra room at the edges. You can always crop the photo later to a tighter composition (as I did for many of the photos shown in this book).

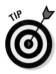

Using these techniques should give you a better chance of capturing any fast-moving subject, but action-shooting strategies also are helpful for shooting candid portraits of kids and pets. Even if they aren't currently running, leaping, or otherwise cavorting, snapping a shot before they do move or change positions is often tough. So if an interaction or scene catches your eye, set your camera into action mode and then just fire off a series of shots as fast as you can.

Finally, keep in mind that freezing action isn't the only option for moving subjects. Sometimes going the other direction, and using a shutter speed slow enough to blur the action creates a heightened sense of motion and, in scenes that feature very colorful subjects, cool abstract images as well. I took this approach for the images shown in Figure 7-7, for example. This photo features one of those centrifugal force carnival rides. Had I frozen the action, it would have been too static a shot — just a bunch of people standing around the edges of the ride. So for the left image, I set the shutter speed to 1/30 second; for the right version, I slowed things down to 1/5 second. In both cases, I used a tripod, but because nearly everything in the frame was moving, the entirety of both photos is blurry — the 1/5 second version is simply more blurry because of the slower shutter. You can see a couple more examples of using a slow shutter to intentionally blur motion in the next section.

1/30 second 1/5 second

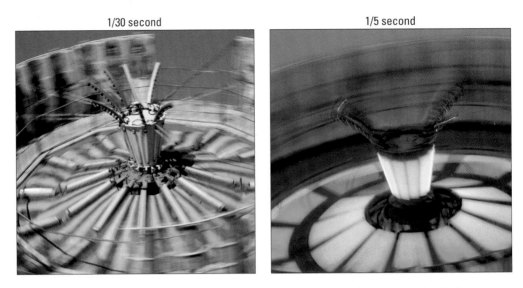

Figure 7-7: Using a shutter speed slow enough to blur moving objects can be a fun creative choice, too.

Taking in the Scenery

Providing specific camera settings for scenic photography is tricky because there's no single best approach to capturing a beautiful stretch of country-side, a city skyline, or other vast subject. Take depth of field, for example: One person's idea of a super cityscape might be to keep all buildings in the scene sharply focused, but another photographer might prefer to shoot the same scene so that a foreground building is sharply focused while the others are less so, thus drawing the eye to that first building.

That said, the following tips can help you photograph a landscape the way *you* see it:

✔ **Shoot in aperture-priority autoexposure mode, if available, so that you can control depth of field.** Again, this mode enables you to adjust the aperture, which is one factor in determining depth of field. (Chapter 6 explains depth of field fully.) The camera then handles the rest of the exposure equation for you by dialing in the right shutter speed.

For a long depth of field, dial in a high f-stop number; for a shallow depth of field, a low number. The portrait examples earlier in this chapter feature a shallow depth of field; contrast those images with the one in Figure 7-8, taken at f/22. Notice that everything from the foreground statue to the monument in the background is in sharp focus.

✓ **Try Landscape mode if aperture-priority auto-exposure isn't available.** This scene mode automatically selects a high f-stop number to produce a large depth of field, so both near and distant objects are sharply focused. Of course, if the light is dim, the camera may be forced to open the aperture, reducing depth of field, to properly expose the image. Note, too, that Landscape mode typically tweaks the image to increase contrast and produce more vivid blues and greens.

Figure 7-8: An f-stop of f/22 helped keep the background as sharp as the foreground in this city scene.

If you prefer your landscape to have a shallow depth of field, try Portrait mode instead. That mode automatically selects a lower f-stop setting. Here again, though, color and sharpness may also be manipulated slightly — this time, to produce softer edges and warmer colors.

✓ **If the exposure requires a slow shutter, use a tripod to avoid blurring.** The downside to a high f-stop is that you need a slower shutter speed to produce a good exposure. If the shutter speed drops below what you can comfortably hand-hold, use a tripod to avoid picture-blurring camera shake. No tripod handy? Look for any solid surface on which you can steady the camera (or nestle it into a camera bag or jacket). You can always increase the ISO setting to increase light sensitivity, which in turn allows a faster shutter speed, too, but that option brings with it the chances of increased image noise.

✓ **For dramatic waterfall and fountain shots, consider using a slow shutter to create that "misty" look.** The slow shutter blurs the water, giving it a soft, romantic appearance. Figure 7-9 shows this effect. I used a shutter speed of 1/5 second for this shot; the aperture was f/8. Again, use a tripod to ensure that the rest of the scene doesn't also blur due to camera shake.

- **At sunrise or sunset, base exposure on the sky.** The foreground will be dark, but you can usually brighten it in a photo editor if needed. If you base exposure on the foreground, on the other hand, the sky will become so bright that all the color will be washed out — a problem you usually can't fix after the fact.

This tip doesn't apply, of course, if your sunrise or sunset is merely serving as a gorgeous backdrop for a portrait. In that case, you should enable your flash and expose for the subject.

- **For cool nighttime pics, experiment with a slow shutter.** Assuming that cars or other vehicles are moving through the scene, the result is neon trails of light, as shown in Figure 7-10. The exposure time for this image was 10 seconds. Sometimes, if it's *really* dark, you may have to bump-up your ISO to a point that it produces a lot of digital noise — but otherwise you might not get the shot, even with a very slow shutter speed.

Figure 7-9: For misty waterfalls, use a slow shutter speed (and tripod).

Some cameras require that you use a special shutter setting known as *bulb* mode in order to take very long exposures. Typically available only in Manual exposure mode, the bulb setting records an image for as long as you hold down the shutter button.

- **For the best lighting, shoot during the "magic" or "golden" hours.** That's the term photographers use for early morning and late afternoon, when the light cast by the sun is soft and warm, at a strong angle, giving everything that beautiful, gently warmed look with nice indirect light, as shown in Figure 7-11.

Figure 7-10: A slow shutter speed (10 seconds) turns the taillights of passing cars into trails of neon light.

Figure 7-11: Late afternoon light casts a golden glow over the scene.

✐ **In tricky light, bracket shots.** *Bracketing* simply means to take the same picture at several different exposures to increase the odds that at least one of them will capture the scene the way you envision. Bracketing is especially a good idea in difficult lighting situations such as sunrise and sunset.

Getting Gorgeous Close-ups

Close-up shots can be wonderfully artistic, but they can also be challenging to take. To take good close-ups, try the following settings and techniques:

✐ **Check your owner's manual to find out the minimum close-focusing distance of your camera and/or lens.** How "up close and personal" you can get to your subject depends on your lens, not the camera body itself. Many cameras and lenses also have a Close-up or Macro focusing mode; you may have to turn this on somewhere on the camera either as a button, a preset mode, or perhaps on the LCD menu, to achieve the closest focusing distance.

✐ **Take control over depth of field by setting the camera mode to aperture-priority autoexposure mode.** Whether you want a shallow, medium, or an extreme depth of field depends on the point of your photo. In classic nature photography, for example, the artistic tradition is a very shallow depth of field, as shown in Figure 7-12, and requires an open aperture (low f-stop value). But if you want the viewer to be able to clearly see all details throughout the frame — for example, if you're shooting a product shot for your company's sales catalog — you need to go the other direction, stopping down the aperture as far as possible.

- **If aperture-priority autoexposure isn't available, try the Close-up scene mode.** In this mode, sometimes called Macro mode, the camera automatically opens the aperture to achieve a short depth of field.

 Do note that Close-up mode means and does different things depending on the camera. In some cases, it simply adjusts the close-focusing distance; in others, it affects aperture as well as some color and contrast characteristics of the image. So check your manual for details.

- **Remember that zooming in and getting close to your subject also decrease depth of field.** So back to that product shot: If you need depth of field beyond what you can achieve with the aperture setting, you may need to back away, zoom out, or both. (You can always crop your image to show just the parts of the subject that you want to feature.)

Figure 7-12: Shallow depth of field helps emphasize the part of the scene that you found most interesting.

- **When shooting flowers and other nature scenes outdoors, pay attention to shutter speed, too.** Even a slight breeze may cause your subject to move, causing blurring at slow shutter speeds.

- **Try using fill flash for better outdoor lighting.** Just as with portraits, a tiny bit of flash often improves close-ups when the sun is your primary light source. You may need to use flash exposure compensation, if available, to reduce the flash output slightly, however, because when you fire a flash very close to a subject, it may be overpowering. If you can control your flash directly, turn it down; if not, you may need to cover it with something to diffuse its light (even taping a napkin over the flash may be sufficient). And again, remember that most cameras limit the top shutter speed to around 1/200–1/320 second when you use flash, and in very bright light, that may be too slow to avoid overexposing the photo. See Chapter 5 for more tips on flash photography.

✔ **When shooting indoors, try not to use flash as your primary light source.** Because you're shooting at close range, the light from your flash may be too harsh even at a low flash exposure compensation setting. If flash is inevitable, turn on as many room lights as possible to reduce the flash power that's needed — even a hardware-store shop light can do in a pinch as a lighting source. (Remember that if you have multiple light sources, though, you may need to tweak the White Balance setting.)

✔ **To really get close to your subject, invest in a macro lens or a set of diopters.** A true macro lens, which enables you to get really, really close to your subjects, is an expensive proposition; expect to pay around $200 or more. But if you enjoy capturing the tiny details in life, it's worth the investment.

Figure 7-13: To extend your lens's close-focus capability, you can add magnifying diopters.

For a less expensive way to go, you can spend about $40 for a set of *diopters,* which are sort of like reading glasses that you screw onto your existing lens. Diopters come in several strengths — +1, +2, +4, and so on — with a higher number indicating a greater magnifying power. I took this approach to capture the extreme close-up in Figure 7-13, attaching a +2 diopter to my lens. The downfall of diopters, sadly, is that they typically produce images that are very soft around the edges, a problem that doesn't occur with a good macro lens.

Broadening Your Horizons: Shooting Panoramas

You're standing at the edge of the Grand Canyon, awestruck by the colors, light, and majestic rock formations. "If only I could capture all this in a photograph!" you think. But when you view the scene through your camera's viewfinder or LCD screen, you quickly realize that you can't possibly do justice to such a magnificent landscape with one ordinary picture.

Wait — don't put down that camera and head for the souvenir shack just yet. When you're shooting digitally, you don't have to try to squeeze the entire canyon — or whatever other subject inspires you — into one frame. You can shoot several frames, each featuring a different part of the scene, and then stitch them together just as you would sew together pieces of a patchwork quilt.

In Figure 7-14, for example, you see two images, each showing a different part of a historic farmhouse. Figure 7-15 shows the stitched panorama. Note that although most panoramas have a horizontal orientation, you also can create vertical panoramas by stitching one image atop another.

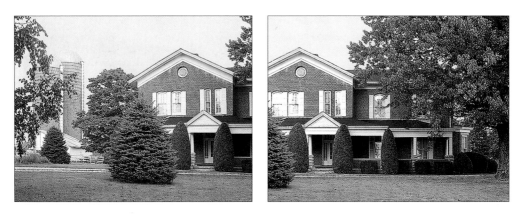

Figure 7-14: These two images served as the "material" stitched together to form the panorama shown in Figure 7-15.

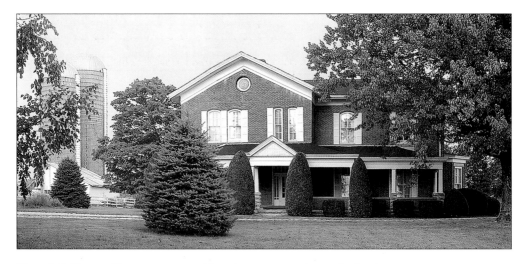

Figure 7-15: The resulting panorama provides a larger perspective on the farmhouse scene.

Although you could conceivably combine photos into a panorama using your photo-editor's regular cut-and-paste editing tools, a dedicated stitching tool makes the job easier. You simply pull up the images you want to join, and the program assists you in stitching the digital "seam." Some camera manufacturers provide proprietary stitching tools as part of the camera's software bundle. In addition, many photo-editing programs offer a stitching tool; Figure 7-16 shows the one provided in Adobe Photoshop Elements, for example.

Figure 7-16: Adobe Photoshop Elements, like many photo programs, offers a tool that automates the process of stitching panoramic images.

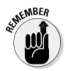

The stitching process is easy if you shoot the original images correctly. If you don't, you wind up with something that looks more like a crazy quilt than a seamless photographic panorama. Here's what you need to know:

- **Capture each picture using the same camera-to-subject distance.** If you're shooting a wide building, don't get closer to the building at one end than you do at another, for example.

- **Overlap each shot by at least 30 percent.** Say that you're shooting a line of ten cars. If image one includes the first three cars in the line, image two should include the third car as well as cars four and five. Some cameras provide a panorama mode that displays a portion of the

previous shot in the monitor so that you can see where to align the next shot in the series. If your camera doesn't offer this feature, you need to make a mental note of where each picture ends so that you know where the next picture should begin.

✔ **Maintain the right axis of rotation.** As you pan the camera to capture the different shots in the panorama, imagine that the camera is perched atop a short flagpole, with the camera's lens aligned with the pole. Be sure to use that same alignment as you take each shot. If you don't, you can't successfully join the images later.

✔ **For a horizontal panorama, keep the camera level.** For best results, use a tripod. Some tripods include little bubble levels that help you keep the camera on an even keel. If you don't have this kind of tripod, you may want to buy a little stick-on bubble level at the hardware store and put it on top of your camera.

✔ **Use a consistent focusing approach.** If you lock the focus on the foreground in one shot, don't focus on the background in the next shot.

✔ **If possible, stick with manual focusing and exposure.** This approach guarantees that the focus and exposure remain consistent across all your shots.

✔ **If autoexposure is necessary, find out whether your camera offers an autoexposure lock function.** This feature retains a consistent exposure throughout the series of panorama shots, which is important for seamless image stitching.

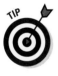

If your camera doesn't provide a way to override autoexposure, you may need to fool the camera into using a consistent exposure. Say that one-half of a scene is in the shadows and the other is in the sunlight. With autoexposure enabled, the camera increases the exposure for the shadowed area and decreases the exposure for the sunny area. That sounds like a good thing, but what it really does is create a noticeable color shift between the two halves of the picture. To prevent this problem, lock in the focus and exposure on the same point for each shot, and then reframe as you capture each segment of the scene. Choose a point of medium brightness for best results. (Whether this technique will work depends on your camera because some cameras continually adjust exposure up to the time you capture the image.)

You also need to use a consistent f-stop throughout your shots — otherwise, depth of field will vary across the stitched image. The easiest way to control f-stop is to use aperture-priority autoexposure, explained in Chapter 5. Chapter 6 talks more about depth of field.

✔ **Avoid including moving objects in the shot.** If possible, wait for bypassers to get out of the frame before you take each picture. If someone is walking across the landscape as you shoot, you may wind up with the same strolling figure appearing at several spots in the stitched panorama. Ditto for cars, bicycles, and other moving objects.

If you really enjoy creating panoramas or need to do so regularly for business purposes, you can make your life a little easier by investing in a special panoramic tripod head, which helps you make sure that each shot is perfectly set up to create a seamless panorama. Expect to pay several hundred dollars for these specialty devices.

Coping with Special Situations

A few subjects and shooting situations pose additional challenges not already covered in earlier sections. Here's a quick list of ideas for tackling a variety of common "tough-shot" photos:

- **Shooting through glass:** To capture subjects that are behind glass, such as animals at a zoo, you can try a couple of tricks. First, set your camera to manual focusing if possible — the glass barrier can give the autofocus mechanism fits. Disable your flash to avoid creating any unwanted reflections, too. Then, if you can get close enough, your best odds are to put the lens right up to the glass (be careful not to scratch your lens). If you must stand further away, try to position your lens at an angle to the glass.

- **Shooting out a car window:** Set the camera to shutter-priority autoexposure or manual mode and dial in a fast shutter speed to compensate for the movement of the car. (Sports scene mode also can produce a fast shutter speed.) Also turn on Image Stabilization, if your camera offers it. Oh, and keep a tight grip on your camera.

- **Shooting fireworks:** First off, use a tripod; fireworks require a long exposure, and trying to handhold your camera simply isn't going to work. If your camera has a zoom lens, zoom out to the shortest focal length. For cameras that offer manual focusing, switch to that mode and set focus at infinity (the farthest focus point possible on your lens). It's tough to use autofocusing with fireworks because there isn't any solid object for the autofocusing system to lock onto.

 If available, also use the Manual exposure setting. Choose a relatively high f-stop setting — say, f/16 or so — and start a shutter speed of 1 to 3 seconds. From there, it's simply a matter of experimenting with different shutter speeds. No Manual exposure mode? Try shutter-priority autoexposure mode instead. Some point-and-shoot cameras now have a Fireworks scene mode, too, in which case you can let the camera take the reins.

 A few other fireworks tips:

 - *Keep the camera steady.* Be especially gentle when you press the shutter button — with a very slow shutter, you can easily create enough camera movement to blur the image. If you purchased an accessory remote control for your camera, this is a good situation in which to use it.

- *Reduce noise.* If your camera offers a noise-reduction feature, you may want to enable it, too, because a long exposure also increases the chances of noise defects. (Keep the ISO setting low to further dampen noise.)

- *Press the shutter button at various intervals.* In addition to experimenting with shutter speed, play with the timing of the shutter release, starting some exposures at the moment the fireworks are shot up, some at the moment they burst open, and so on. For the example featured in Figure 7-17, shutter speed was about 5 seconds, and I began the exposure as the rocket was going up — that's what creates the corkscrew of light that rises up through the frame.

Figure 7-17: I used a shutter speed of 5 seconds to capture this fireworks shot.

✔ **Shooting reflective surfaces:** As mentioned in the filters section of Chapter 2, you can reduce glare from reflective surfaces such as glass and metal by using a *polarizing filter,* which you can buy for about $40. A polarizing filter can also help out when you're shooting through glass.

Another option for shooting small reflective objects is to invest in a light cube or light tent such as the ones shown in Figure 7-18, from Cloud Dome (www.clouddome.com) and Lastolite (www.lastolite.com), respectively. You place the reflective object inside the tent or cube and then position your lights around the outside. The cube or tent acts as a light diffuser, reducing reflections. Prices range from about $50 to $200, depending on size and features.

✔ **Shooting in strong backlighting:** When the light behind your subject is very strong, the result is often an underexposed subject. You can try using flash to better expose the subject, assuming that you're shooting in an exposure mode that permits flash, or you can use exposure compensation, if your camera offers it, to request a brighter exposure of your subject. (Chapter 5 talks more about this feature.)

But for another creative choice, you can purposely underexpose the subject to create a silhouette effect, as shown in Figure 7-19. Just disable flash and then experiment with using a negative exposure compensation value, which produces a darker image, until you get a look you like. Of course, if you use manual exposure, just play with your exposure settings to achieve the look you have in mind.

Cloud Dome, Inc. *Lastolite Limited*

Figure 7-18: Investing in a light cube or tent makes photographing reflective objects much easier.

Figure 7-19: Experiment with shooting backlit subjects in silhouette.

Part IV

From Camera to Computer and Beyond

The 5th Wave By Rich Tennant

Okay, enlarge the chicken bone by 900 percent and attach it to an e-mail to the museum saying, "Getting close...send more money."

One major advantage of digital photography is that you can see your results right away on the camera monitor. And when you see a keeper, you can go from camera to final output in minutes, printing your photos or sharing them via the web.

Chapters in this part address these important after-the-shot topics. Chapter 8 covers some basic in-camera playback features and then offers details about safely downloading and archiving images so they'll be around for years to come. Chapter 9 tells you what you need to know about printing your photos, and Chapter 10 shows you how to prepare your images for e-mail, web sharing, and other onscreen uses.

8

Viewing and Downloading Your Pictures

*F*or most people, the picture-taking part of digital photography isn't all that perplexing — the process is pretty much the same as shooting with a film camera, after all. Where the confusion arises is the step of getting pictures from the camera to the computer, especially for people who don't have much computer experience.

This chapter sorts out the mysteries of this part of the digital photography routine, showing you the fastest and easiest ways to transfer pictures to your computer. Look here, too, for details on some cool in-camera playback features and for information about working with pictures taken in the Camera Raw format.

If you *are* a computer novice, I encourage you to also pick up a copy of the appropriate *For Dummies* book for your Windows or Mac operating system. Although I try to provide enough information to get you started, this book doesn't have enough room to cover all the nuts and bolts of working with various operating systems. And without a good grip on computer basics, your digital photography experience will be more frustrating and less enjoyable than it should be.

Taking Advantage of Playback Options

On most digital cameras, pictures appear briefly on the monitor immediately after you press the shutter button. To take a longer look, you need to shift the camera into playback mode. Usually, you accomplish this by pressing a button labeled with a right-pointing arrowhead — the universal symbol for playback. You can get a look at a generic version of this symbol in Table 8-1.

Table 8-1	Playback Symbols
Look for This Symbol	*To Access This Feature*
▶	Playback mode
🔍⊕	Magnify image
🔍⊖	Reduce magnification
🗑	Delete image
⚿	Protect image

Once you're in playback mode, you can scroll through your pictures one by one by pressing different keys or using a scroll wheel — check your manual for specifics. But on most cameras, that's just the start of the playback functions you enjoy. Flip through that camera manual to find out whether you have access to these helpful features:

✓ **Playback zoom:** This feature enables you to magnify an image so that you can inspect the details, as shown in Figure 8-1. Usually, the zoom-in feature is represented by a magnifying glass with a plus sign, as shown in Table 8-1. A magnifying glass with a minus sign represents the zoom-out function.

✓ **Information display options:** Most cameras offer several playback display options, each of which presents different picture information with the image. Here are just a couple of common options:

 • *Shooting information:* You may be able to view symbols that represent the major settings you used to capture the picture, as shown in Figure 8-2. For example, the first row of data in Figure

8-2, captured from a Nikon playback screen, shows what exposure metering mode was in force, the exposure mode (A, for aperture priority), shutter speed, f-stop, ISO setting, and lens focal length. Along the bottom of the screen, you also can view the date and time the picture was recorded. Every manufacturer uses different symbols for this shooting data, so look for a decoder ring in your camera manual.

Figure 8-1: Most cameras enable you to magnify an image to inspect the details.

- *Brightness histogram:* Chapter 5 introduces you to brightness histograms, which are graphs that plot out the brightness values in an image. Some cameras enable you to display a histogram during playback, as shown in Figure 8-2. Checking the histogram is a great tool for making sure exposure is correct

Remember, the left side of the histogram represents shadows; the right side, highlights. And a peak in the graph represents a large collection of pixels at that brightness value. So if you see a large mass of pixels at the left end of the graph, your image may be underexposed. A clump at the right end of the graph may indicate an overexposed image.

Figure 8-2: You also may be able to view capture settings and a brightness histogram in some views.

Some advanced cameras offer a second type of histogram, an RGB histogram, which displays brightness values on a per-channel basis. For help understanding this feature, see the sidebar "Playback fun for color geeks: RGB histograms," elsewhere in this chapter.

- *Blinkies (highlight alerts):* When a picture is greatly overexposed, areas that should include a range of light tones may instead be completely white. This problem is known as *blown highlights* or *clipped highlights.* Some cameras offer a playback mode in which fully white pixels blink on and off — which is why this view mode is commonly referred to as "the blinkies."

For example, Figure 8-3 shows you an image that contains some blown highlights. I captured the screen at the moment the highlight blinkies blinked "off" — the black areas in the figure indicate the blown highlights. (I labeled a few of them in the figure.) But as this image proves, just because you see the flashing alerts doesn't mean that you should adjust exposure — the decision depends on where the alerts occur and how the rest of the image is exposed. In my candle photo, for example, it's true that there are small white areas in the flames and the glass vase. Yet exposure in the majority of the photo is fine. If I reduced exposure to darken those spots, some areas of the flowers would be underexposed. In other words, sometimes you simply can't avoid a few clipped highlights when the scene includes a broad range of brightness values.

Blown highlights

Figure 8-3: Some cameras offer a display mode that indicates blown highlights with blinking pixels.

- **Deleting photos:** Got a clunker image that you don't want to keep? Look for a button sporting a trash can, as shown in Table 8-1. After you press the button, the camera likely will ask you for confirmation that you really want to erase the photo. Answer in the affirmative, and that picture's zapped into digital oblivion.

Deleting photos one by one can be tedious, though, which is why most cameras also offer a Delete or Erase menu command. Look on the camera's Playback menu, if it has one. After selecting the option, you usually get the choice to select which photos you want to trash or to choose to erase all images on the card.

✏ **Protecting photos:** Do you see a button or switch marked with a little key symbol like the one in Table 8-1? If so, your camera enables you to protect individual pictures from being erased when you use the delete function. No button? Check the Playback menu for a Protect option. After you apply protected status, you usually see a little key symbol along with the photo, as shown in Figure 8-4. (The placement and exact design of the symbol may vary.)

Here are two important points about this feature:

Protect symbol

Figure 8-4: The little key symbol indicates that the file is locked and can't be accidentally erased.

- *Formatting the memory card erases protected photos as well as unprotected ones.* Formatting wipes the card absolutely clean, so use caution. See Chapter 3 for more about formatting memory cards.

- *Protected photos can't be edited until you unlock them.* Locked picture files remain locked even after you download them, which means that you can't edit or delete them on your computer. However, you should be able to unlock the files easily using most photo editing and browsing programs. Look for a menu command named something like Unlock Photo or Remove Protected Status — typically, the File menu holds this command. If nothing else, the software that shipped with your camera should enable you to unlock downloaded photos. You can always put the memory card back in the camera and use the camera's protect feature to remove the protected status, too.

TIP

Playback fun for color geeks: RGB histograms

Along with a brightness histogram, some cameras can display an *RGB histogram,* which reveals information about color saturation as well as exposure. The figure here, for example, shows both types of histograms: the top one is the brightness histogram; the lower three comprise the RGB histogram.

To make sense of an RGB histogram, you need to know a little about digital color theory. Chapter 6 provides an introduction, but here's a quick recap: Digital images are known as *RGB images* because they're created from red, green, and blue light. When you mix red, green, and blue light, and each component is at maximum brightness, you create white. Zero brightness in all three channels creates black. If you have maximum red and no blue or green, though, you have fully saturated red. If you mix two channels at maximum brightness, you also create full saturation. For example, maximum red and blue produce fully saturated magenta.

Back to the RGB histogram: If the histogram shows that all the pixels for one or two channels are slammed to the right end of the histogram — indicating maximum brightness values — you may be losing picture detail because of overly saturated colors. A rose petal that should contain a spectrum of shades of red may be a big blob of full-on red, for example. On the other hand, if all three channels show a heavy pixel population at the right end of the histogram, you may have blown highlights — again, because the maximum levels of red, green, and blue create white. Either way, you may want to adjust the exposure settings and try again.

A savvy RGB histogram reader can also spot color balance issues by looking at the pixel values. But frankly, color balance problems are fairly easy to notice just by looking at the image on the camera monitor, so let's leave that discussion for another lifetime, okay?

For information about manipulating color, see Chapter 6.

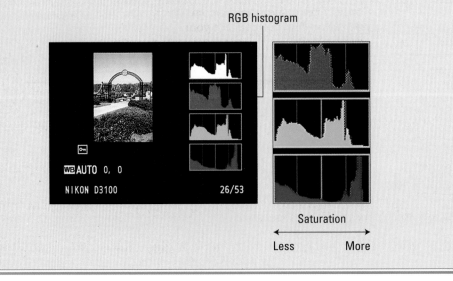

RGB histogram

Saturation

Less More

Downloading Your Images

You have a camera full of pictures. Now what? You transfer them to your computer, that's what. This step can be one of the scariest tasks for a lot of people, which is why more than a few novice photographers use their cameras for months before even considering transferring their images. Not to worry! The next few sections show you exactly how to get your images moved from camera to computer, safe and sound.

A look at your downloading options

Digital camera manufacturers have developed several ways for users to transfer pictures from camera to computer. Here's a brief overview of your choices:

- **Use a card reader.** A *card reader* is simply a little gadget that enables you to transfer files to a computer without using the camera itself. Many computers, printers, and monitors now have built-in card readers; if yours doesn't, you can buy an external one that plugs into your computer's USB port. Either way, you just pop the card out of the camera and into the card reader, and you can then transfer files just as you would when moving them from a CD, DVD, or old-fashioned floppy disk. (Remember those?) See the upcoming section "Downloading from a card reader" for more details on this transfer method.

 USB stands for *Universal Serial Bus,* which is a technology developed for connecting printers, cameras, and other devices to a computer. A USB *port* is simply a slot on the computer where you can plug in a USB cable. Figure 8-5 offers a close-up look at a USB plug and ports, which are typically marked with the symbol labeled in the figure

- **Connect the camera to the computer.** You can also connect your computer directly to your camera using the cable that came in your camera box. Normally, it connects via USB. You can then use the software that shipped with the camera to transfer images between the two devices. Or, in some cases, your camera appears on your computer as just another storage device, and you can then just drag and drop files between camera and computer as you move any data files.

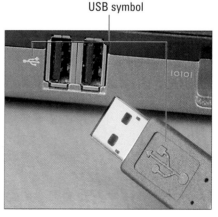

USB symbol

Figure 8-5: Most card readers and cameras connect to the computer via a USB cable.

Although this method isn't all that much more complicated than using a card reader, it does require you to keep your camera turned on during the transfer, which eats up your batteries. And you have to keep track of your camera's connection cable, which is a bother you don't have to take if you use a built-in card reader (or keep the card reader permanently connected to the computer). Read through the upcoming section "Downloading from the camera" to get a better idea of the process.

✔ **Use a camera dock.** A camera *dock,* or *docking station,* is a small base unit that you leave permanently connected to your computer. To download pictures, you place the camera into the dock. From there, the process is the same as downloading from a card reader or camera (although some docks give you a button or menu that you use to initiate the transfer). Most docks also serve as the camera's battery charger, and some offer features that simplify e-mailing and printing pictures. You can even buy docks that have a built-in snapshot printer.

A few cameras ship with a docking station; sold alone, docks usually run in the $50 to $200 range, depending on whether they incorporate a printer. Check your camera manufacturer's website to see what types of docks may be available, if any, for your camera.

✔ **Transfer wirelessly.** A few cameras now offer wireless transfer, taking advantage of the same technologies employed by wireless Internet connections, television remote controls, and other wireless devices. In order to take advantage of this feature, both your camera and computer must have the right wireless equipment. Alternatively, you can use Eye-Fi memory cards that offer built-in wireless transfer technology. (Visit the website www.eye.fi for more information about these memory cards.)

Because setting up wireless transfer varies depending on the specific technology, camera, and computer, I must refer you to your camera manual for help with that process.

✔ **Let a pro do it for you.** Not all that comfortable with computers? You may find it easier to have your local photo lab copy your files to a DVD for you. You can have a DVD made at the same time you print your pictures. Then you can put only the pictures you want to edit, e-mail, or access on your computer's hard drive — you just put the DVD in the DVD drive and copy pictures just as you may have done with music files or data files. Many places that can print digital photos offers this service.

Tips for smoother downloading

Whichever transfer option you choose, a couple of pointers can help the whole thing run more smoothly:

✔ **Transfer speed:** The speed at which your image files travel from memory card to your computer depends on the size of the picture files, the speed of the memory card, the speed of the computer, and the speed of the USB connection. For USB connections, the fastest form of that technology is USB 3.0. However, not all cameras or memory cards yet offer USB 3.0 technology, so files may still flow along at USB 2.0 speeds even if your computer does offer USB 3.0 ports. Chapter 2 talks a little more about memory card speeds; see Chapter 3 to get details about two of the factors that affect file size, resolution, and file format.

✔ **Transfer software:** When your computer detects the presence of digital images, whether they're on a CD, DVD, connected camera, or memory card, it's likely that the computer will automatically display some sort of window or program that offers to help you download your photos. In fact, multiple windows may appear. You may see a Windows utility, for example, as shown in Figure 8-6, or iPhoto on the Mac, as shown in Figure 8-7. And then a few seconds later, a download tool that's part of your photo software or camera software may pop up and beg you to let *it* do your downloading.

Figure 8-6: On a Windows-based computer, the system may display this screen full of download options.

You can use whichever of these tools you find easiest; just close the windows for the ones that you want to ignore. Better yet, consult the Help systems of those programs to find out how to disable the automatic launch. And if nothing pops up, you can start up your favorite download program as you normally launch any program.

Also note that even though you download images using one program, you don't have to stick with that program for editing your images. You can download using iPhoto, for example, and then open and edit the transferred photos in Adobe Photoshop. In some cases, you first need to *import* or *catalog* the transferred photos into the program, which simply tells the program to build thumbnails for the picture files.

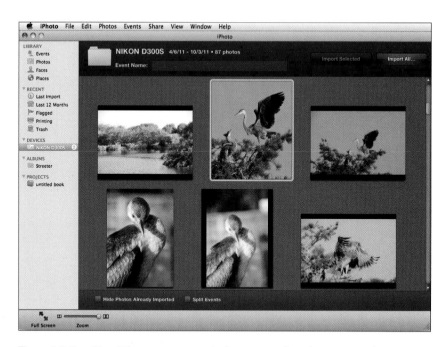

Figure 8-7: On a Mac, iPhoto may automatically start up when the computer detects a memory card or camera.

✔ **Transfer options:** Although it's impossible to provide specifics on every possible download tool, they all pretty much work the same way: You click the thumbnails of the images you want to download and then click a button (usually labeled Download or Import or something similar), and the program takes it from there.

Most downloaders provide you with lots of ways to customize the download. For example, you typically can specify the folder and drive where you want to store your photos. (In true geeky fashion, the option is usually referred to as the *destination folder.*) See the upcoming sidebar "File-organization tips" for some suggestions on the best choices to make.

Do look out for a couple of potentially dangerous options:

- *Erase originals after download.* One typical option is to automatically erase the original images on your card as you transfer them to the computer. Disable that option just in case something goes haywire. It's not a good idea to erase the images on your card until you're confident that they're safely stored on your hard drive.

- *Automatically fix red-eye.* A couple of downloaders automatically attempt to try to remove red-eye during the download process. This option can cause your downloads to take *forever* as the program tries to locate and fix areas that it thinks may be red-eye. It's better to do the job yourself after downloading.

TIP

File-organization tips

When you transfer picture files to your computer, you can store them in any folder on your hard drive that you like, but it's a good idea to stick with the default location that your computer's operating system sets aside for digital pictures. The folder is named either Pictures or My Pictures, depending on your operating system (Windows 7, Windows Vista, Mac OS X Lion, and so on). Most photo-editing programs, as well as other programs that you may use to work with your pictures, look first in the default folders when you go to transfer, edit, and save pictures. So keeping your images in those folders saves you the trouble of hunting down some custom folder every time you want to work with your photos.

After you amass a large image collection, you may want to create subfolders inside the Pictures or My Pictures folder so that you can better organize your photos. For example, you can create a Travel subfolder to hold travel photos, a Family subfolder for family images, and so on.

You might even like to rename your individual photos with filenames that let you reference them specifically. For example, suppose you took pictures in France in the year 2012. You might rename the files this way:

Original File Name: DSCN0223.jpg

Your New File Name: France 12-0223.jpg

That way, you can identify the picture subject and year by looking at the first part of the filename, yet by keeping the original file number, each image has a unique identifier. Some photo programs offer automated file renaming tools that can make this organizational step a breeze, too. Look for a menu command named something like Batch Rename.

✔ **Drag-and-drop transfer:** If you're an experienced computer user, you may prefer not to use any photo-download software. Instead, you can just use the system file-management tools — Windows Explorer or the Mac Finder — to drag and drop files from your card or camera to the hard drive. The next section, "Downloading from a card reader," demonstrates the drag-and-drop technique.

Note: Depending on your computer's operating system, you may not be able to use this method unless you use a card reader. In some versions of the Mac OS, the Finder doesn't recognize digital cameras that are connected directly via USB cable. You should still be able to use the software that shipped with your camera to download images if you want to go the direct camera-to-computer route on such systems.

Downloading from a card reader

If you own a relatively new computer or photo printer, it may be equipped with one or more memory-card slots. Assuming that one of those slots accepts the type of memory card that your camera uses, you're set: Just take

the card out of the camera and put it in the slot. (For a printer slot, be sure to turn the printer on, or your computer won't see the card.)

No built-in card slots? You can buy a card reader for very little cash at any electronics, office supply, or camera store. You can either buy a reader that accepts just one type of card or a product like the SanDisk reader shown in Figure 8-8, which works with multiple card types. Either way, to install the card reader, simply plug it in to an empty USB port on your computer. In most cases, card readers are *plug-and-play* — that is, your computer recognizes the reader without any further help from you. But some card readers ship with some software that you need to install, so be sure to check the instructions on the product box.

SanDisk

Figure 8-8: Just push the memory card into the matching slot on the card reader.

One reminder about card-reader compatibility: If you use the newer, higher-capacity SDHC or SDXC forms of Secure Digital cards, a plain old SD card reader won't do the trick. Be sure that the card reader specifically indicates compatibility with the higher-capacity cards.

Assuming that all planets are in alignment, the computer should automatically recognize the card, seeing it as just another drive, like a CD drive or DVD drive. From this point, you can either use one of the aforementioned photo downloaders, following the instructions provided by the specific program, or you can simply drag and drop the files from the card to the computer. The process is the same as you use to copy and move any type of file using Windows Explorer or the Mac Finder.

For example, Figure 8-9 shows how a card reader shows up as a drive in Windows 7 version of Windows Explorer. (This Explorer is the Windows file-management tool, not Internet Explorer, which is a web browser.) In some cases, the camera brand name appears along with or instead of a drive letter; in the figure, for example, the card contained images taken with a Nikon camera, so the Nikon label appears along with the drive letter, G. (The drive letter will vary depending on how many other drives are on your system.)

Normally, you have to open a folder or two to get to the actual image files. They're typically housed inside a main folder named DCIM (for *digital camera images*), as shown in Figure 8-9, and then within a subfolder that uses the camera manufacturer's name or folder-naming structure. After you open the folder, you may see thumbnails of the images, as in the figure, or simply the names of the files. (In Windows Explorer, you can display thumbnails by opening the View menu and choosing one of the icon options, such as Extra Large Icons.)

On a Mac, the card should appear as a drive on the desktop. Double-click the drive icon to open a Finder window and access the card contents, as shown in Figure 8-10. Again, you have to open a series of folders to get to the actual images.

Memory card

Figure 8-9: The memory card appears as a regular drive on the computer.

Figure 8-10: On a Mac, you can drag and drop files from a memory card using the Finder.

If you're shooting Camera Raw images, they may not appear as thumbnails depending on the camera model and the version of the Windows or Mac operating system you use. But you can see the filenames and still transfer them to your computer. (This applies to photo downloaders too, unless you're using software provided by the camera manufacturer, in which case the thumbnails should be visible.)

After opening the folder that contains the images, select the ones you want to transfer and then just drag them to the folder on your hard drive where you want to store them, as shown in Figure 8-11. Although it's not visible in the figure, you should see a little plus sign next to your cursor when you drag. The plus sign indicates that you're placing a *copy* of the picture files on the computer; your originals remain on the card. When you're sure that the files made it to their new home, you can put the card back into the camera and erase the originals.

To select one image file for copying, click it. To select additional files, Ctrl+click them in Windows or ⌘+click them on a Mac. Or to select all the files, press Ctrl+A (Windows) or ⌘+A (Mac).

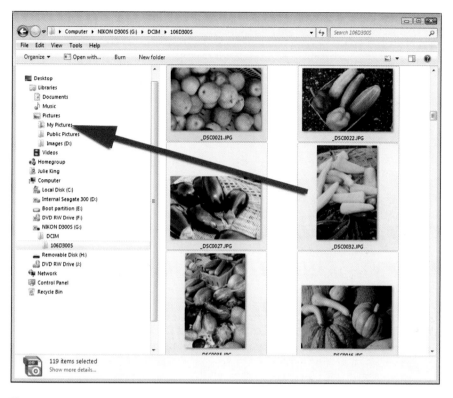

Figure 8-11: After selecting the pictures you want to transfer, just drag them to their new home.

Downloading from the camera

As an alternative to using a memory-card reader, you can attach your camera to the computer and transfer images directly. Virtually all digital cameras today connect to your computer via a USB hookup, introduced at the start of this chapter. You might have to plug the USB cable into your camera, or your camera may sit in a docking station that plugs into your USB port on your computer.

Either way, your camera manual undoubtedly provides specifics on the process of connecting to a computer. As you work through the download steps for the first time, keep the manual handy so that you can find out whether you need to follow any special procedures along the way. For example, you may need to install software that shipped with the camera before you even connect the camera to the computer.

With those caveats in mind, the following steps provide a basic look at the process:

1. **Check the camera's battery status.**

 If the battery is low, charge it before moving on. You can damage the camera, the memory card, and your picture files if the battery dies in the middle of the transfer process.

 Alternatively, if your camera came with an AC adapter, power the camera that way for downloads.

2. **Turn the computer on, but turn the camera off.**

 With some cameras, connecting to the computer while the camera is powered up can cause problems.

3. **Use the USB cable that shipped with your camera to connect the camera to an open USB port on the computer.**

 The camera's USB port is usually tucked under a little rubber flap or door; check the camera manual for help if you can't find the port.

 On the computer side, try to use a built-in USB port rather than one that's on a keyboard or an external USB hub. Sometimes the external hubs don't work as smoothly for camera connections.

4. **Turn the camera on.**

5. **Set the camera to the proper mode for image transfer.**

 For this step, you need to consult your camera manual. With some cameras, you have to choose a PC connection setting, for example, or you may need to switch to playback mode. On other cameras, no setup step is needed.

 What happens next depends on what software you have installed on your system. In Windows and on some versions of the Mac operating system, an icon representing the camera appears in Windows Explorer or on the Mac desktop. You can then drag and drop your picture files to the hard drive by using the same technique outlined in the preceding section or you can use your favorite photo-download utility. If you use a version of the Mac OS that can't see the camera as a hard drive, your best solution is to use the software that shipped with the camera to initiate the image transfer.

6. **When the download is complete, turn the camera off before disconnecting it from the computer.**

I never metadata I didn't like

Digital cameras store *metadata* along with picture data when recording an image to memory. Metadata is a fancy name for extra information that gets stored in a special area of the image file. Digital cameras record such information as the aperture, shutter speed, exposure compensation, and other camera settings as metadata.

To capture and retain metadata, cameras typically store images using a variation of the JPEG file format known as EXIF, which stands for *exchangeable image format.* This flavor of JPEG is often stated in camera literature as JPEG (EXIF). Note, though, that metadata is also stored when you shoot in the Camera Raw format instead of JPEG. (Chapter 3 explains all this file format stuff.)

The important point is that you can view metadata on some cameras during playback (refer to Figure 8-2, earlier in this chapter) as well as in many photo-editing and cataloging programs. For example, the area highlighted in red in the following figure shows a portion of the metadata panel found in Adobe Photoshop Lightroom. In most cases, the software that shipped with your camera should also be able to display image metadata; check the program's Help system to find out how.

By reviewing the metadata for each image, you can get a better grasp on how the various settings on your camera affect your images. It's like having a personal assistant trailing around after you, making a record of your photographic choices each time you press the shutter button — only you don't have to feed this assistant lunch or provide health insurance.

Metadata

Converting Raw Files

Many digital cameras can capture images in the Camera Raw file format, or just Raw, for short. As discussed in Chapter 3, this format stores raw picture data from the image sensor without applying any of the usual post-processing that occurs when you shoot using the JPEG format.

Although you can transfer Raw files to your computer using the same processes outlined in the first part of this chapter, you won't be able to see them until you use an image-editing program that can recognize the files created by your specific camera. Most camera manufacturers provide software in the camera box that enables you to view your pictures, and some third-party software can also display Raw files. (In the case of third-party programs, though, you may need to go to the software manufacturer's website and download a "Raw update" to make the program compatible with your camera.)

You usually can print your Raw files immediately from the camera maker's software. But if you want to be able to edit your photos, share them online, or use them in any other programs, such as a multimedia program, you need to *process* the Raw files and then save them in a common image format. You have a couple options for getting the job done:

- ✓ **Some cameras offer a built-in mini converter.** I say "mini" because these tools, although convenient, enable you to control just a few picture attributes. For example, Figure 8-12 offers a look at the converter available on some Nikon cameras. As you can see, you get just a handful of controls to specify exposure and color characteristics. Additionally, there's the issue of having to make judgments about those characteristics on the camera monitor — a small

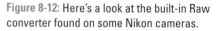

Figure 8-12: Here's a look at the built-in Raw converter found on some Nikon cameras.

canvas on which to view your work when compared with a computer monitor. And there's one more catch: Most camera converters can save the file only in the JPEG file format, which doesn't retain the image at its top-notch quality. (Chapter 3 explains JPEG and why its form of file compression lowers image quality.)

✐ **Process the files after downloading using a computer-based Raw converter.** Again, your camera software may offer a Raw converter, and many photo-editing programs also offer this tool. Figure 8-13 offers a look at the Raw converter found in Adobe Photoshop — arguably one of the most sophisticated tools of its kind.

Figure 8-13: Adobe Photoshop offers panels and panels full of image-tweaking options in its Raw converter.

As you can see from these two figures, the extent to which you can control these characteristics of your photos varies depending on the converter. Some converters are pretty sophisticated, but others, including some provided by camera manufacturers, automatically set all the image characteristics for you. These simplistic converters simply change the file format from Raw to a standard format, usually either TIFF or JPEG, applying the same picture-characteristic choices you would get if you shot them in the JPEG format instead of Raw.

Again, for details about the specific conversion settings in your Raw converter, check the program's Help system. You can also find lots of good tutorials online for popular programs such as Photoshop.

Whichever converter you use, however, here are a few general points to keep in mind:

- ✔ **Don't erase your original Raw file.** You may someday want to convert the file using different settings, and retaining the Raw file means that you always have an original image in pristine condition that you can return to if necessary.

- ✔ **The settings you use when making your Raw conversion stay with the Raw file, sort of like an invisible recipe card.** So the next time you reopen the file in the converter, you don't have to go through all the adjustments again; they're automatically applied as you did them the first time. But because your picture data still is technically "raw," you can apply a whole new set of adjustments without doing any damage to your picture.

- ✔ **Before you do any Raw conversions — or any photo editing, for that matter — you should calibrate your monitor.** Calibrating your monitor ensures that you're looking at an accurate representation of the picture brightness, color, and so on. Chapter 9 talks more about monitor calibration.

- ✔ **Raw files have different filenames depending on the camera manufacturer.** Nikon files go by the name NEF; Canon, CR2; and so on. In Windows, you see these three-letter extensions at the ends of the filenames.

- ✔ **If possible, save your converted files in the TIFF format.** This format retains all your picture data and, unlike JPEG, doesn't apply lossy compression, which degrades picture quality. Again, see Chapter 3 for more information about digital image file formats.

9

Printing Your Pictures

Getting a grip on all there is to know about digital photography can be a little overwhelming — I know; I've been there. So if you're feeling like your head is about to pop from all the new terms and techniques you've stuffed into it, I have great news for you: You need to read only the first section of this chapter to find out how to get terrific prints of your digital photos.

Those first paragraphs introduce you to retail photo-printing services that make getting digital prints easy, fast, and amazingly inexpensive. If you like, you can handle the whole thing via the Internet, without ever leaving home.

When you're ready for do-it-yourself printing — and that process, too, has been greatly simplified since the first days of digital photography — the rest of the chapter offers tips on buying a photo printer and getting the best results from it. And whether you're printing your own photos or letting someone else do the honor, this chapter also discusses ways to get your printed colors to match what you see on your monitor (or closer to that goal, anyway).

Getting Prints from a Lab

In the first years of digital photography, the only option for people who didn't want to print their own photos was to find a professional photo lab that could handle digital files. Unless you lived in a major city, you probably didn't have access to such a lab, and if you did, you paid big bucks to get your prints.

Now, any outlet that used to offer film developing, from your local drugstore to big-box retailers such as Costco or Wal-Mart, offers quick and easy digital photo processing. You just take your camera memory card to the store and specify what pictures you want to print. Depending on the service and the specific store, you can have the staff handle everything for you or upload your photos at a special kiosk and input your desired sizes, paper selections, and quantities. You can also do this online from the comfort of your own home, if you like; you simply upload the photos onto the store's photo website.

The cost of retail printing continues to get less expensive, too. Depending on the number of prints you make, you can get 4 x 6-inch prints for as little as 10 cents apiece, and buy 8 x 10-inch prints for under $3. And remember, the only prints you pay for are those you choose to upload, as opposed to how things worked in film days, when you paid to print the entire roll, including the pictures that didn't turn out so great.

You have a variety of options for getting your digital prints:

- **Request one-hour printing.** Take in your memory card, leave instructions about your print job, and go run other errands or do your shopping. Come back in an hour and pick up your prints.

 If you're worried about a lab losing your memory card, by the way, you usually have the option of copying your pictures to a CD or some other removable media, such as one of those tiny flash memory keys, and taking that to the photo lab. Just make sure that the lab can accept the type of media you want to use.

- **Use instant-print kiosks.** In a hurry? You may not even need to wait an hour for those prints. Many stores have kiosks that can print your pictures immediately. Again, you just put in your memory card, push a few buttons, and out come your prints. You can even do some retouching, such as cropping and eliminating red-eye, right at the kiosk.

- **Order online; print locally.** You can send your image files via the Internet to most retail photo printers and then specify the store where you want your prints made. Then pick up the prints at your convenience.

 This option also makes it easy to get prints to faraway friends and relatives. Instead of having the prints made at your local lab and then

mailing them off, you can simply upload your files to a lab near the people who want the prints. They can then pick up the prints at that lab. You can either prepay with a credit card or have the person getting the prints pay upon picking them up.

For help finding a lab that's conveniently located, check out www.takegreatpictures.com, which is maintained by the PhotoImaging Information Council and lists lots of locations by zip code. Look for the Resources link and then the Find a Photo Lab link. (The site also has some great photography tutorials.) Or you can go directly to the web-sites of major retailers, such as Wal-Mart or Costco, and find a list of printing services offered at each one.

✔ **Order online; get prints by mail.** Some major retailers also offer this option. In addition, you can order prints by mail from online photo-sharing sites such as Kodak Gallery (www.kodakgallery.com), Snapfish (www.snapfish.com), and Shutterfly (www.shutterfly.com). You can read more about photo-sharing sites in Chapter 10.

Buying a Photo Printer

Even if you have most of your prints made at a retail lab, adding a photo printer to your digital-photography system is still a good investment, for several reasons:

✔ When you need only a print or two, it's more convenient to do the job yourself than to send the pictures to a lab.

✔ For times when you're feeling artistic, you can print on special media, such as canvas-textured paper. With a model such as the $400 Epson Stylus Photo R2000, shown in Figure 9-1, you can even output borderless prints as wide as 13 inches.

✔ Doing your own printing gives you complete control over the output, which is important to many photo enthusiasts, especially those who exhibit or sell their work.

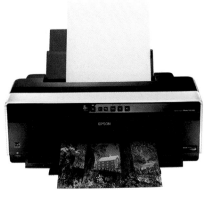

Epson America, Inc.

Figure 9-1: With this Epson printer, you can output borderless inkjet prints up to 13 inches wide.

✔ Today's photo printers can produce excellent results. In fact, most people can't tell the difference between prints made at home and those made at a lab.

When you go printer shopping, you'll encounter several types of printers. Each offers advantages and disadvantages, and the technology you choose depends on your budget, your printing needs, and your print-quality expectations. To help you make sense of things, the following sections discuss the three main types of consumer and small-office printers.

Inkjet printers

Inkjet printers work by forcing little drops of ink through nozzles onto the paper. Inkjet printers designed for the home office or small business cost anywhere from $50 to several hundred dollars.

Inkjets fall into three basic categories:

- **General-purpose models:** These printers are engineered to do a decent job on both text and pictures but are sometimes geared more to text and document printing than photos.

- **Photo printers:** Sometimes referred to as *photocentric* printers, these models are designed with the digital photographer in mind and usually produce better-quality photographic output than all-purpose printers. But they're sometimes not well suited to everyday text printing because the print speed can be slower than on a general-purpose machine. They also often require more individual ink cartridges and some output only small, snapshot-size images. However, many printers do have a foot in both the general-purpose and photo printer camps, offering good results for all printing uses.

- **Multipurpose printers:** These models combine a printer with a flatbed scanner (which can also be used as a document copier) and sometimes also a fax machine. So you can print an image file or scan a printed photo and turn it into a digital file — and then print it again! Do note that many multipurpose printers offer great photo-printing abilities, but some are more business oriented and are engineered more to document printing.

So what separates a $50 printer from a higher-priced model? Generally speaking, print quality goes up as the price goes up, although once you get past $150 or so, you may not see much difference in the look of your prints. Print quality varies even among printers of the same price range, so be sure to read reviews carefully before you buy. (See Chapter 11 for a list of some websites that offer regular equipment reviews.)

Print quality aside, what you get for more money are speedier printing and extra features such as the following:

- Ability to print on wide-format paper (larger than the usual 8½ x 11-inch letter size)

- Six or more ink colors (as opposed to the standard four colors) for better color reproduction

✔ Borderless printing

✔ Accessory that permits printing onto printable CDs and DVDs

✔ Computer-network connections

✔ Wireless network connections, either through Wi-Fi or Bluetooth technology

✔ Memory card readers and the option for printing directly from a card or camera

✔ Built-in monitors that you can use to preview your pictures

✔ Integrated fax, copier, and scanner

Most inkjet printers enable you to print on plain paper or thicker (and more expensive) photographic stock, either with a glossy or matte finish. That flexibility is great because you can print rough drafts and everyday work on plain paper and save the more costly photographic stock for final prints and important projects.

The downside? Well, you've no doubt discovered this for yourself: Although most inkjet printers themselves are inexpensive, *printing* is not necessarily cheap because the inks they use can be pretty pricey. And inkjet printer manufacturers will almost always tell you that you need to use their own brand of ink instead of less-costly third-party inks for best results.

Another option is to have your inkjet cartridges professionally refilled at a local store; this service is becoming common, especially in large metropolitan areas. The vendors guarantee the quality of the ink, and if you don't like the results, you have a place you can go to with your prints to get help.

Either way, using a third-party, aftermarket brand of ink, while less expensive and sometimes perfectly adequate, can *potentially* produce unsatisfactory results and, worse yet, can invalidate your warranty. So beware before buying a bunch of cheap inkjet cartridges; do your homework by researching the topic to see what other users of your printer have experienced. And do stop to consider that printer manufacturers spend lots of research time and money developing ink formulas that best mesh with their printers' ink delivery systems and with various papers, including those they manufacture and sell themselves. So it makes sense that the media offered by the manufacturer — both inks and papers — would stand the best chance of producing optimum results.

All that said, inkjets are the best option for most digital photographers. The exception is if you have high-volume printing needs or care as much about regular document printing as photo printing. If that describes you, check out laser printers, too, described next. And if you're interested only in printing snapshot photos — perhaps you already have a printer for outputting letters and other documents — the upcoming section about dye-sub printers may also be of interest.

Laser printers

Laser printers use a technology similar to that used in photocopiers. You probably don't care to know the details, so here's the general idea: The process involves a laser beam, which produces electric charges on a drum, which rolls toner — the ink, if you will — onto the paper. Heat is applied to the page to permanently affix the toner to the page.

The upsides to laser printers include:

- Color lasers can produce near-photographic quality images as well as excellent text.
- They're faster than inkjets.
- You can use plain paper or special photo paper, just as with an inkjet (although you get better results if you use a high-grade laser paper as opposed to cheap copier paper).
- Although you may pay more up front for a laser printer than for an inkjet, you should save money over time because the price of toner is usually lower than for inkjet ink.
- Many color lasers are designed for high-volume, networked printing, making them attractive to offices where several people share the same printer.

The downsides?

- Although they've become much more affordable over the past two years, color lasers still run $100 and up, with a higher average price than inkjet printers (although prices are still going down).
- These printers tend to be big in stature as well as price — this typically isn't a machine that you want to use in a small home office that's tucked into a corner of your kitchen.
- Because they're geared primarily toward office use, some laser printers don't have the digital-photography niceties found in many inkjets: memory-card slots, monitors for viewing photos on your cards, and the like.

As for photo quality, it varies from machine to machine, so as with inkjet printers, be sure to read reviews carefully. Some laser-printed photos aren't quite as impressive as those from the best inkjets, but some new models come very close.

Dye-sub (thermal dye) printers

A third type of printer you may encounter, although it's not nearly as common as inkjets and laser printers, is called a *dye-sub* printer.

TIP

Protecting your prints

No matter what the type of print, you can help keep its colors bright and true by adhering to the following storage and display guidelines:

✔ If you're framing the photo, mount it behind a matte to prevent the print from touching the glass. Be sure to use acid-free, archival matte board and UV-protective glass.

✔ Display the picture in a location where it isn't exposed to strong sunlight or fluorescent light for long periods of time.

✔ In photo albums, slip pictures inside acid-free, archival sleeves.

✔ Don't adhere prints to a matte board or other surface using masking tape, scotch tape, or other household products. Instead, use acid-free mounting materials, sold in art-supply stores and some craft stores. And don't write on the back of the print with anything but a pen made for printing on photographs.

✔ Limit exposure to humidity, wide temperature swings, cigarette smoke, and other airborne pollutants, as these can also contribute to image degradation. You can do this by having a framer seal the photo into a frame.

✔ Although the refrigerator door is a popular spot to hang favorite photos, it's probably the worst location in terms of print longevity. Unless protected by a frame, the photo paper soaks up all the grease and dirt from your kitchen, not to mention jelly-smudged fingerprints and other telltale signs left when people open and close the door.

✔ For the ultimate protection, always keep a copy of the image file on a CD-R, DVD-R, or other storage medium so that you can output a new print if the original one deteriorates.

Dye-sub is short for *dye-sublimation,* which is worth remembering only for the purpose of one-upping the science-fair winner who lives down the street. Dye-sub printers transfer images to paper using a plastic film or ribbon that's coated with colored dyes. During the printing process, heating elements move across the film, causing the dye to fuse to the paper.

Dye-sub printers are also called *thermal-dye* printers — heated (thermal) dye . . . get it?

At present, only a few consumer photo printers offer this technology. Dye-sub printers fall within the same price range as quality inkjets, and most produce good-looking prints.

However, dye-sub machines present a few disadvantages that may make them less appropriate as your primary home or office printer:

✔ Most dye-sub printers can output only snapshot-size prints.

✔ You have to use special stock designed to work expressly with dye-sub printers. (Typically, you buy a printing pack that includes both the

requisite paper and the dye film or ribbon.) That means that dye-sub printers aren't appropriate for general-purpose documents; these machines are purely photographic tools.

✔ Printing can be slower than with an inkjet or laser because the paper has to pass through the printer's innards several times, once for each color of dye and, usually, a final pass for the application of a clear overcoat.

More printer-shopping tips

After narrowing down what type and size of printer you need, a few additional shopping tips can help you pick the right product off the store shelves:

✔ **Don't spend on extras you won't use.** Decide whether you really need all the bells and whistles found on some new printers. For example, some will print directly onto a CD or DVD (although you need special but commonly available printable CDs or DVDs), print from a wireless connection, or let you print directly from a memory card. These features may be handy for you, but if you don't need them, they will also make a printer more expensive than a similar-quality model without the extra features.

✔ **Don't worry too much about the specification known as *dpi*.** This abbreviation stands for *dots per inch* and refers to the number of dots of color the printer can create per linear inch. A higher dpi means a smaller printer dot, and the smaller the dot, the harder it is for the human eye to notice that the image is made up of dots. So in theory, a higher dpi should mean better-looking images, but because different types of printers create images differently, an image output at 300 dpi on one printer may look considerably better than an image output at the same or even higher dpi on another printer. And frankly, any new printer you buy today is probably going to offer enough resolution to produce print quality that's plenty good. So although printer manufacturers make a big deal about their printers' resolutions, dpi isn't always a reliable measure of print quality.

✔ **For inkjets, look for a model that uses four or more colors.** Most inkjets print using four colors: cyan, magenta, yellow, and black. This ink combination is known as CMYK (see the sidebar "The separate world of CMYK," later in this chapter). But some lower-end inkjets eliminate the black ink and just combine cyan, magenta, and yellow to approximate black. "Approximate" is the key word — you don't get good, solid blacks without that black ink, so for best color quality, avoid three-color printers.

Some high-end photo inkjets feature six or more ink colors, adding lighter shades of the primary colors or several shades of gray to the standard CMYK mix. The extra inks expand the range of colors that the printer can manufacture, resulting in more accurate color rendition, but add to the print cost.

TIP

If you enjoy making black-and-white prints — *grayscale* prints, in official digital-imaging lingo — look for a printer that adds the extra gray cartridges. Some printers that use only one black cartridge have a difficult time outputting truly neutral grays — prints often have a slight color tint. Browse magazines that cover black-and-white photography for leads on the best machines for this type of printing.

✔ **Inkjets that use separate cartridges for each color save you money.** On models that have just one cartridge for all inks, you usually end up throwing away some ink because one color often becomes depleted before the others. With multiple ink cartridges, you just replace the ones that are running out.

✔ **Compare print speeds if you're a frequent printer.** If you use your printer for business purposes and you print a lot of images, be sure that the printer you pick can output images at a decent speed. And be sure to find out the per-page print speed for printing at the printer's *highest-quality* setting. Most manufacturers list print speeds for the lowest-quality or draft-mode printing. When you see claims like "Prints at speeds *up to . . . ,*" you know you're seeing the speed for the lowest-quality print setting.

✔ **Computer-free printing options give you extra flexibility.** Some printers can print directly from camera memory cards — no computer required. Several technologies enable this feature:

- *Built-in memory card slots:* You insert your memory card, use the printer's control panel to set up the print job, and press the Print button. Be sure that the printer offers card slots that are compatible with the type of memory card you use, though.

- *PictBridge:* This feature enables you to hook up your camera to your printer via USB cable for direct printing. (Both the camera and the printer must offer PictBridge capabilities.)

- *DPOF (dee-poff):* This acronym stands for *digital print order format* and enables you to select the images you want to print through your camera's user interface. The camera records your instructions on the memory card. Then, if you use a printer that has memory card slots, you put the card into a slot, and the printer reads and outputs your "print order." Again, both the camera and the printer must offer DPOF technology.

- *Wireless connections:* Manufacturers are offering a number of Wi-Fi and Bluetooth-enabled printers, too. If you use a camera or memory card that offers wireless connectivity, you can send your pictures from the camera to the printer wirelessly.

- *Google Cloud printing:* Some new printers are compatible with Google's Cloud Print service, which enables you to wirelessly access photos you've stored with Google Cloud. (*Cloud* is a geeky way of referring to online data storage services.) For more about this option, visit `www.google.com/cloudprint/learn`.

The separate world of CMYK

As you know if you read Chapter 6, onscreen images are *RGB* images, which are created by combining red, green, and blue light. Your digital camera and scanner also produce RGB images. Professional printing presses and most, but not all, consumer printers, on the other hand, create images by mixing four colors of ink — cyan, magenta, yellow, and black. Pictures created using these four colors are called *CMYK* images. (The *K* is used instead of *B* because black is called the *key* color in CMYK printing.)

You may be wondering why four primary colors are needed to produce colors in a printed image, while only three are needed for RGB images. (Okay, you're probably not wondering that at all, but go with it, will you?) The answer is that unlike light, inks are impure. Black is needed to help ensure that black portions of an image are truly black, not some muddy gray, as well as to account for slight color variations between inks produced by different vendors.

What does all this CMYK stuff mean to you? First, if you're shopping for an inkjet printer, be aware that some models print using only three inks, leaving out the black. Color rendition is usually worse on models that omit the black ink.

Second, if you're sending your image to a service bureau for printing, you may need to convert your image to the CMYK color mode and create *color separations*. CMYK images comprise four color channels (digital vats of color data) — one each for the cyan, magenta, yellow, and black image information. Color separations are nothing more than grayscale printouts of each color channel. During the printing process, your printer combines the separations to create the full-color image. If you're not comfortable doing the CMYK conversion and color separations yourself or your image-editing software doesn't offer this capability, your service bureau or printer can do the job for you. (Be sure to ask the service rep whether you should provide RGB or CMYK images, because some printers require RGB.)

Don't convert your images to CMYK for printing on your own printer, however, because consumer printers are engineered to work with RGB image data. And no matter whether you're printing your own images or having them commercially reproduced, remember that CMYK has a smaller *gamut* than RGB, which is a fancy way of saying that you can't reproduce with inks all the colors you can create with RGB. CMYK can't handle the really vibrant, neon colors you see on your computer monitor, for example, which is why images tend to look a little duller after conversion to CMYK and why your printed images don't always match your onscreen images.

One more note about CMYK: If you're shopping for a new inkjet printer, you may see a few models described as CcMmYK or CcMmYKk printers. Those lowercase letters indicate that the printer offers a light cyan, magenta, or black ink, respectively, in addition to the traditional cyan, magenta, and black cartridges. As mentioned earlier, the added inksets are provided to expand the range of colors that the printer can produce.

Of course, direct printing takes away your chance to edit your pictures; you may be able to use camera or printer settings to make minor changes, such as rotating the image, making the picture brighter, or

applying a prefab frame design, but that's all. Direct printing is great on occasions where print immediacy is more important than image perfection, however. For example, a real-estate agent taking a client for a site visit can shoot pictures of the house and output prints in a flash so that the client can take pictures home that day.

✓ **Research independent sources for cost-per-printer information.** Consumer magazines and computer publications often publish articles that compare current printer models based on cost per print. Some printers use more expensive media than others, so if you're having trouble deciding between several similar models, this information could help you make the call. Note that some printer ads and brochures also state a cost per print, but the numbers you see are approximations at best and are calculated in a fashion designed to make the use costs appear as low as possible. As they say in the car ads, your mileage may vary.

✓ **Read reviews and blog comments for other input, too.** Once again, it pays to check out reviews in magazines and online sites to find detailed reviews about print quality and other printer features. You also can get lots of good real-world information by searching out blogs and user forums where people discuss their experiences with models that you're considering.

Avoiding Printing Pitfalls

After years of helping friends and family sort out their photo-printing problems, I've learned that most printing woes can be traced to just a handful of issues. The next three sections provide the information you need to avoid them, whether you're printing your own photos or having the job done at a retail lab.

Checking resolution: Do you have enough pixels?

For good quality prints, you need an adequate pixel population. Chapter 3 explains the role of pixel count, or resolution, in detail, but the short story is that you should aim for the neighborhood of 200 to 300 pixels per linear inch of your print. That means that if you want to print, say, an 11 x 14-inch photo, your image needs to contain at least 2200 x 2800 pixels, or roughly 6 megapixels. Don't have enough pixels? Expect prints that exhibit stairstepping along curved and diagonal lines and other visual defects. (Chapter 3 has some examples.)

If you're printing photos at a retail or online site, the printer's order form usually indicates how large a print you can make given the image's pixel count. If you're doing your own printing, you can find out how many pixels

you have by looking at the image file properties in Windows Live Photo Gallery or, on a Mac, by using iPhoto, as follows:

✔ **Windows:** In Windows Live Photo Gallery, click the image thumbnail and then click the View tab at the top of the window. Then click the Image Size icon, as shown in Figure 9-2, to display the image's pixel dimensions beneath the thumbnail. (These instructions refer to the version of Windows Live Photo Gallery found in Windows 7; the process may be slightly different in older versions of Windows.)

✔ **Mac:** After launching iPhoto, track down the image thumbnail and then choose View⤳Info. A box showing an assortment of picture settings appears, with the resolution listed in the area highlighted in Figure 9-3.

Remember that even though some photo programs enable you to add pixels to an existing image, doing so never improves picture quality. Again, see Chapter 3 for proof of this disappointing fact of photo life.

Image Size Pixel dimensions

Figure 9-2: You can check the pixel count in the Windows Live Photo Gallery.

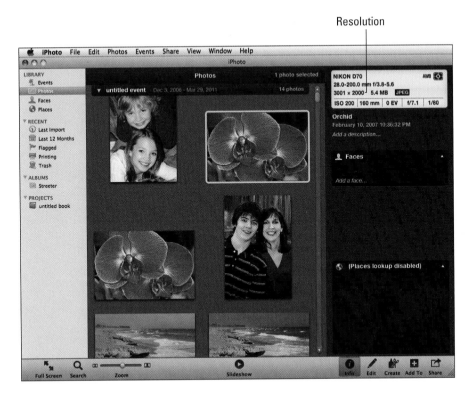

Resolution

Figure 9-3: On a Mac, choose the Info command from the View menu to inspect the resolution information.

Getting print and monitor colors in sync

Aside from poor picture quality, the number one printing complaint is that colors on the computer monitor don't match what shows up in print. When this problem occurs, most people assume that the printer is to blame, but in fact, the most likely culprit is actually the monitor. If the monitor isn't accurately calibrated, the colors it displays aren't a true reflection of your image colors.

To ensure that your monitor is displaying photos on a neutral canvas, you can start with a software-based calibration utility, which is just a small program that guides you through the process of adjusting your monitor. The program displays various color swatches and other graphics and then asks you to provide feedback about what you see on the screen.

If you use a Mac, the operating system offers a built-in calibration utility, called the Display Calibrator Assistant. (Access it by opening the System Preferences dialog, clicking the Displays icon, clicking the Color button, and then clicking the Calibrate button.) The latest incarnation of the Windows operating system, Windows 7, has a similar tool called Display Color Calibration. You also can find free calibration software for both Mac and Windows systems online; just enter the term *free monitor calibration software* into your favorite search engine.

Software-based calibration isn't ideal, however, because our eyes aren't that reliable in judging color accuracy. For a more accurate calibration, you may want to invest in a device known as a *colorimeter,* which you attach to or hang on your monitor, to accurately measure and calibrate your display. Companies such as Datacolor (www.datacolor.com) and X-Rite (www.xritephoto.com) sell this type of product along with other tools for ensuring better color matching. Figure 9-4 shows the X-Rite ColorMunki Display, for example, which retails for about $190.

X-Rite

Figure 9-4: For precise monitor calibration, invest in a colorimeter such as the ColorMunki Display from X-Rite.

Whichever route you go, the calibration process produces a monitor *profile,* which is simply a data file that tells your computer how to adjust the display to compensate for any monitor color casts. Your Windows or Mac operating system loads this file automatically when you start your computer. Your only responsibility is to perform the calibration every month or so, because monitor colors drift over time.

If your monitor *is* calibrated, color-matching problems may be caused by any of these other secondary issues:

- ✐ **One of your print nozzles or heads is empty or clogged.** Check your manual to find out how to perform the necessary maintenance to keep the nozzles or print heads in good shape.

- ✐ **You chose the wrong paper setting in your printer software.** When you set up your print job, be sure to select the right setting from the paper-type option — glossy, matte, and so on. This setting affects how the printer lays down ink on the paper.

- ✐ **Your printer and photo software are fighting over color-management duties.** Some photo programs offer features that enable the user to control

how colors are handled as an image passes from camera to monitor to printer. Most printer software also offers color-management features. The problem is, if you enable color-management controls both in your photo software and your printer software, you can create conflicts that lead to wacky colors. So check your photo software and printer manuals to find out what color-management options are available to you and how to turn them on and off.

Even if all the aforementioned issues are resolved, however, don't expect perfect color matching between printer and monitor. Printers simply can't reproduce the entire spectrum of colors that a monitor can display. In addition, monitor colors always appear brighter because they are, after all, generated with light.

Finally, be sure to evaluate your print colors and monitor colors in the same ambient light — daylight, office light, whatever — because that light source has its own influence on the colors you see.

Choosing good quality paper

With photo paper, as with most things in life, you get what you pay for. The better the paper, the more your images will look like traditional print photographs. In fact, if you want to upgrade the quality of your images, simply changing the paper stock can do wonders.

If your printer can accept different stocks, print drafts of your images on the cheaper stocks, and reserve the good stuff for final output. "Good stuff," by the way, means photographic paper from a well-known manufacturer, not the cheap store brands. Start with paper from the manufacturer of your printer because that paper is specifically engineered to work with your printer's inks. The prints you make with that paper can give you a baseline from which you can compare results on other brands.

Don't limit yourself to printing images on standard photo paper, though. You can buy special paper kits that enable you to put images on calendars, stickers, greeting cards, window decals, transparencies (for use in overhead projectors), and all sorts of other stuff. It's also fun to try out some of the new textured papers, which have surfaces that mimic traditional watercolor paper, canvas, and the like.

Printing Your Own Photos

After you check your image's pixel count and decide upon a good print size, actually sending your photo to the printer is as easy as opening the picture in your photo software and choosing the Print command, typically found on the File menu.

In many programs, though, you don't even need to open the photo — you just click the image thumbnail and then use a printing wizard to ship the picture to your printer. The next two sections show you how to get the job done in Windows Live Photo Gallery and Apple iPhoto, for example. If you use other software, the process should be similar, but check the program's Help system for details if you get stuck.

Printing from Windows Live Photo Gallery

To print from the version of Windows Live Photo Gallery found in Windows 7, take these steps:

1. **Click the image thumbnail.**

2. **Click to open the File menu, labeled in Figure 9-5.**

 The menu isn't labeled, but if you pause your mouse over the little triangle labeled in the figure, the word *File* appears (you must have Windows tooltips enabled). At any rate, clicking that triangle opens the File menu.

Click to open File menu

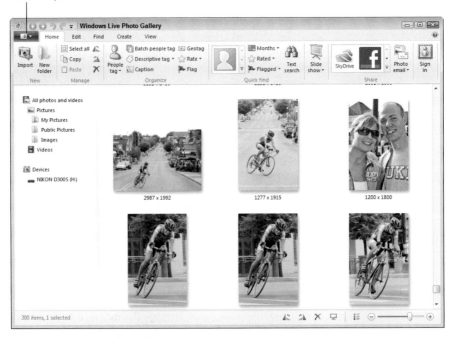

Figure 9-5: Click this triangle to open the File menu and access the Print command.

3. **Click the Print icon to open a submenu containing two options, Print and Order Prints.**

4. **Click the Print icon on the submenu.**

 A box of printing options appears, as shown in Figure 9-6.

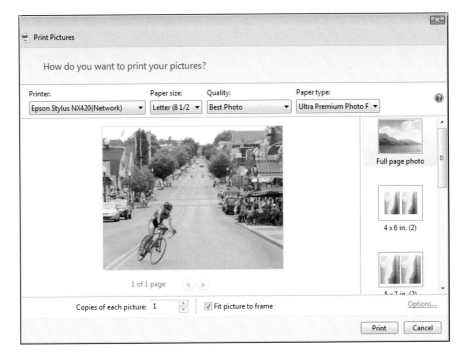

Figure 9-6: Specify your paper size, print orientation, and other print options here.

5. **Choose your printing options and click Print.**

 The file heads off to the printer for output.

Printing from Apple iPhoto

Here's how to send your pictures to the printer from the free photo software found on Mac computers, Apple iPhoto:

1. **Launch iPhoto and click your image thumbnail.**

2. **Choose File⇨Print to display the Print Settings dialog, shown in Figure 9-7.**

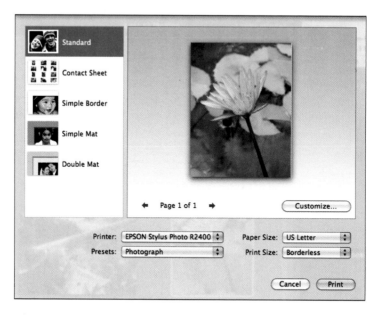

Figure 9-7: Choose the Print command from the File menu to access these print options.

3. **Click one of the icons on the left side of the dialog to specify the print type.**

For a plain old print, click the Standard option; to add framing effects, click Simple Border, Simple Mat, or Double Mat. You can customize these effects later.

4. **Select your desired print options (printer, paper size, and so on).**

5. **To customize the border or mat, click the Customize button.**

A second window of options appears in which you can adjust the colors and designs of the effects.

6. **Click the Print button in the lower-right corner of the dialog box.**

If you took Step 5, click the Print button in the customization window; otherwise, click the one in the original printing options dialog box.

You can use the Contact Sheet option in the Print Settings dialog box to print a page of small thumbnails for a batch of images. In Step 1, click the first image you want to include and then ⌘+click the others. Or to select all images, press ⌘+A. After clicking the Contact Sheet icon in Step 3, click the Customize button to specify the number of columns of thumbnails you want on the contact sheet. Click the Print button to finish the job.

Seeing Things in Black and White

While most of the pictures people take today are in color, you can easily change them to black and white using an image-editing program. Photoshop Elements, for example, has an easy-to-use tool for just this task, shown in Figure 9-8. And with many images, you may discover that you like the black-and-white version of some pictures better than the color original.

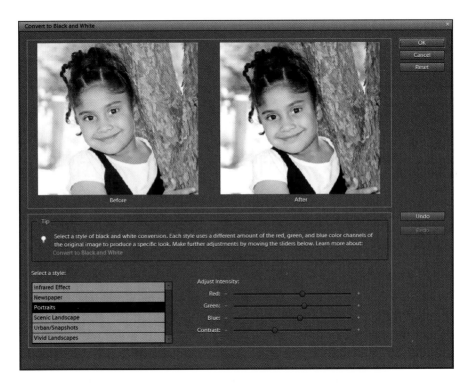

Figure 9-8: Photoshop Elements makes converting color images to black-and-white easy.

After you do your conversion, save your image with a different filename using the Save As option (usually found under the File menu on your editing program). This ensures that you will have your original image *and* your new black-and-white version.

Printing your black-and-white images can be a challenge, though, because most photo printers are designed more for color printing. So follow these tips to get the best reproduction:

✔ **A printer that uses two or more shades of black ink as well as the usual color inks produces the best results.** Epson, Canon, and HP all offer a number of dedicated photo printers that use either two or three

shades of black ink and are capable of printing great-looking black-and-white prints. These printers are more expensive, however, than standard printers.

✔ **Paper matters, too.** There are a number of inkjet papers with a variety of coatings and textures made specifically for monochrome (black-and-white) images, and using these products can make a big difference.

✔ **If you can't get good results from your own printer, the easiest solution is to look for a lab that offers black-and-white printing.** Labs that work with professional photographers, especially, offer various options, so check around — especially if you're printing an important photo that you are going to frame or have around for a long time.

Publishing Your Own Coffee-Table Book

Ever seen a coffee-table–style book of photographs from a wedding? It used to be that you had to print copies of the best photos from a wedding or other event and then insert them into a leather- or linen-bound fancy book to keep as a high-quality showpiece.

Today, you can do the same thing online by uploading your favorite photos from virtually any event or collection and have them printed in a beautiful book. You can have anywhere from a few photos to several hundred in a single book and, as an added bonus, you can even create "virtual" copies of the book for sharing online, complete with music.

Many companies offer photo printing into books of all sizes and styles, including the following:

✔ **Shutterfly** (www.shutterfly.com)

✔ **Snapfish** (www.snapfish.com)

✔ **Blurb** (www.blurb.com)

✔ **MyPublisher** (www.mypublisher.com)

✔ **Kodak Gallery** (www.kodakgallery.com)

You simply create an online account, decide on a design, upload your photos, and then use the various templates and layouts provided to create your book. Many photo-editing programs also have book-building templates and links to connect you with various book printers.

10

Onscreen, Mr. Sulu!

*W*hen you print pictures, you need lots of pixels — a high-resolution photo, that is — to get good results. But when you display your pictures onscreen, you need very few pixels. Even the most inexpensive, low-megapixel, entry-level cameras can deliver more than enough pixels to create acceptable images for web pages, online photo albums, multimedia presentations, and other onscreen uses. The process of preparing your pictures for the screen can be a little confusing, however — in part because so many people don't understand the correct approach and keep passing along bad advice to newcomers.

This chapter shows you how to do things the right way, explaining how to use free tools provided in Windows and on a Mac to create appropriately sized pictures for online use. You also get some tips on adding pictures to a web page, find out how to create a custom screen saver featuring your photos, and get help turning your favorite image into desktop wallpaper for your computer.

In this chapter, as with other chapters, I show you how to accomplish certain tasks using the tools provided in Windows 7 and, on a Mac, using the Snow Leopard version of the Mac operating software. If you use other versions of Windows or the Mac OS, steps should be very similar, however.

Step into the Screening Room

With a printed picture, your display options are fairly limited. You can pop the thing into a frame or photo album. You can stick it to a refrigerator with one of those annoyingly cute refrigerator magnets. Or you can slip it into your wallet so that you're prepared when an acquaintance inquires after you and yours.

In their digital state, however, photos can be displayed in all sorts of new and creative ways, including the following:

- ✔ **On a web page:** If your company has a website, add interest by posting product pictures, employee photos, and images of your corporate head-quarters. Many folks these days even have personal web pages devoted not to selling products but to sharing information about themselves. (Your Internet provider may provide you with a free page just for this purpose.) See "Nothing but Net: Photos on the Web," later in this chapter, for some advice about using photos on a web page.

- ✔ **Via e-mail:** E-mail a picture to friends, clients, or relatives, who then can view the image on their computer screens, save the image file, and even edit and print the photo if they like.

- ✔ **On a photo-sharing site:** When you have more than a few pictures to share, forego e-mail and instead take advantage of photo-sharing sites such as

 - • Kodak Gallery (www.kodakgallery.com)

 - • Snapfish (www.snapfish.com)

 - • Shutterfly (www.shutterfly.com)

 - • SmugMug (www.smugmug.com)

After uploading pictures, you can invite people to view your album and buy prints of their favorite photos. Figure 10-1 shows an album I created at SmugMug, for example.

Some sites enable you to create and share albums at no charge as long as you purchase a certain number of prints or other photo products. Others, such as SmugMug, charge a small annual subscription fee that gives you the right to upload, store, and share full-size photos without having to buy any other photo services. The other advantage of a paid sharing site is that the interface is typically devoid of the advertising that the free sites display, giving your albums a more professional look.

Do *not* rely on photo-sharing sites as your only archival picture stor-age. Most free sites delete your pictures if you don't buy prints within a certain amount of time, and even a subscription site may not retain your images if the business goes under, as has happened in the past. Always back up your most important images to DVD or CD.

Figure 10-1: Photo-sharing sites such as SmugMug offer a great way to share lots of pictures with friends, family, and clients.

✔ **On social networking sites:** If you're one of the zillions of folks with a page on Facebook or some other social networking site, you can post your pictures for all your friends to see. (***Warning:*** Unless you lock down your privacy settings, all your not-friends can see your photos, too . . .)

Many photo programs have tools to make it easy to ship your pictures directly to social networking sites, in fact. In Windows Live Photo Gallery, for example, just click the Facebook icon, labeled in Figure 10-2, to access such a tool and share your latest masterpieces. In iPhoto, click the Share button at the bottom of the window and then click the Facebook icon in the menu that pops up. (In both cases, you need to take a few setup steps after you click the icon to help Facebook and the photo program shake hands.)

✔ **In a multimedia presentation:** Import the picture into a multimedia presentation program such as Microsoft PowerPoint. The right images, displayed at the right time, can add excitement and emotional impact to your presentations and also clarify your ideas. Check your presentation program's manual for specifics on how to add a digital photo to your next show.

✔ **As a screen saver:** Create a personalized screen saver featuring your favorite images or pick a single image to use as your desktop wallpaper. The upcoming sections "Creating a Slide-Show Screen Saver" and "Hanging Photo Wallpaper" show you how to do this in Windows and on a Mac.

Click to connect to Facebook

Figure 10-2: Many programs now have tools to make it easy to ship photos directly to Facebook and other social media sites.

✔ **As a slide show:** Many photo-editing and cataloging programs also offer a tool for making digital slide shows. In iPhoto, for example, click the Create button at the bottom-right corner of the window to display a pop-up menu, as shown in Figure 10-3, and then click Slide Show to access the slide-show creation tool. In Windows Live Photo Gallery, click the Home tab at the top of the window and then click the Slide Show icon to access the slide-show options.

For another fun slide-show option, check out Animoto, a website where you can create a slide show complete with music and text and then share it online with friends (www.animoto.com). You can create and share 30-second videos for free; if you purchase an annual subscription, starting at $30, you can produce videos of any length and even obtain high-definition copies of your shows to burn to DVD (the cost varies depending on your subscription level).

✔ **On TV:** Many digital cameras have video-out ports that enable you to view your photos on a TV so that you can show your pictures to a living room full of guests. For more about this option, see the section "Viewing Photos on a TV," later in this chapter.

✔ **On a digital photo frame:** Wouldn't it be nice if you could have all your best photos displayed in your living room or office, but without having to print and frame all of them? A digital photo frame allows you to do just that, by providing a framed LCD screen that displays photos without needing to be connected to a computer. You just insert your camera memory card into a slot on the frame.

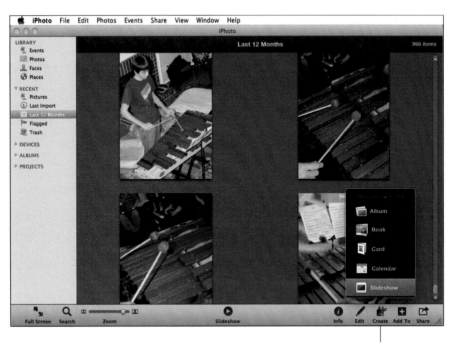

Click to open Create menu

Figure 10-3: Along with many photo programs, Apple iPhoto has a tool that makes creating slide shows easy.

Digital photo frames come in a variety of sizes and styles, ranging from 6-inch screens to 15 inches and larger. And just like regular photo frames, they come with various frame styles, as well, such as wood finishes, white, black, and so on. Many frames even have speakers and can play digital movies and MP3 files, so you can have music or dialogue accompanying your show.

Preparing Pictures for Screen Display

How many times have you received an e-mail message that looks like the one in Figure 10-4? Some well-meaning friend or relative sent you a digital photo that's so large you can't view the whole thing on your monitor.

The problem is that computer monitors can display only a limited number of pixels. Chapter 3 explains this issue in detail, but the short story is that the average photo from one of today's digital cameras has a pixel count in excess of what the monitor can handle.

Figure 10-4: The attached image has too many pixels to be viewed without scrolling.

Fortunately, the latest e-mail programs have tools that automatically adjust the display of large images to make them viewable. For example, in Windows Live Mail, photos that are attached to e-mail messages appear as thumbnails that you can click to display a viewer window. But even so, that doesn't change the fact that sending someone a mega-resolution picture means that you're sending them a very large file, and large files mean longer downloading times and, if recipients choose to hold onto the picture, a big storage hit on their hard drives.

Sending a high-resolution photo *is* the thing to do if you want the recipient to be able to generate a good print. But it's polite practice to ask people if they *want* to print 11 x 14 glossies of your new puppy before you send them a dozen 14-megapixel shots.

For simple e-mail sharing, I suggest limiting photos to about 800 pixels across and 600 pixels down. That ensures that people who use an e-mail program that doesn't offer the latest photo-viewing tools can see your entire picture without scrolling, as in Figure 10-5.

Figure 10-5: At 720 x 480 pixels, the entire photo is visible even when the e-mail window consumes some of the screen real estate.

A couple of pertinent facts on the issue of online images:

- You also need to shrink the size of pictures that will become part of a regular web page. The web designer should be able to give you the maximum pixel dimensions to use. See "Nothing but Net: Photos on the Web," later in this chapter for more details.

- Some photo programs offer e-mail tools that can create and share a resized image for you automatically. If you use iPhoto's e-mail tool, for example, you can specify how large a photo you want to share. Ditto for the e-mail tool in Windows Live Photo Gallery.

- In addition to resizing high-resolution images, also check their file type; if the photos are in the Raw or TIFF format, you need to create a JPEG copy for online use. Web browsers and e-mail programs can't display Raw or TIFF files.

✔ Finally, remember that although you want your online photos to be small, recording your originals at a tiny size isn't a good idea because, if you want to print the photo, you won't have enough pixels to produce a good result. Instead, shoot your originals at a resolution appropriate for print and then create a low-res copy of the picture for e-mail sharing or for other online uses. The next two sections provide the scoop on making a low-res copy using free tools included with Windows 7 and with the Mac operating software. If you use different software, check the program's Help system for information about resizing your photos and saving a copy of the resized photo.

Creating web-friendly copies in Windows Live Photo Gallery

Windows 7 includes Windows Live Photo Gallery, featured in Figure 10-6. To create a low-resolution copy of your original image using the program, follow these steps:

Click to open Resize tool

Figure 10-6: In Windows Live Photo Gallery, the Resize option is found on the Edit tab.

1. **Launch Windows Live Photo Gallery.**

2. **Track down your image and click its thumbnail.**

 Check the image file type — if you captured it in the Raw format, you must convert it to JPEG or TIFF before you can go any further. Chapter 8 talks more about converting Raw images to a standard file format.

3. **Click the Edit tab to display the tools shown in the figure.**

4. **Click Resize, labeled in the figure.**

5. **You see the dialog box shown in Figure 10-7.**

6. **Click the Select a Size drop-down list and select a photo size.**

 Again, I recommend the Small setting, which sets the longest edge of the photo to 800 pixels.

 Windows Live Photo Gallery

 Resize

 Select a size:

 Small: 800

 Maximum dimensions:

 800

 Save to:

 C:\Users\Julie King\Pictures\Nikon Transfer 2\001 Browse...

 Resize and Save Cancel

 Figure 10-7: Stick with the Small size option to ensure that recipients can view your pictures easily.

7. **Choose the folder where you want to store the resized image.**

 The current folder appears below the Select a Size drop-down list; if you want to put the picture somewhere else, click the Browse button and select the new destination folder.

8. **Click the Resize and Save button.**

 To avoid overwriting your original, the resized copy uses the same name as the original but with the actual photo size tagged onto the end of the name. For example, if the original is named DSC0001.jpg and you choose the Small size option, the resized copy has the filename DSC0001 (800 x 600).jpg. This naming structure makes it easy to see which photo is the one you've created for online sharing, but if you want to rename it, you can use the Rename option, which is found directly above the Resize option on the Edit tab of the Windows Live Gallery window (refer to Figure 10-6). When you click the button, the filename area in the lower-right corner of the window becomes active, and you can type in a new name.

Prepping photos using Apple iPhoto

On a Mac, you can use iPhoto to resize your photos for screen use. Follow these steps:

1. **Open iPhoto and find the photo you want to resize.**

2. **Click the picture.**

3. **Choose File⇨Export.**

 You see the Export dialog box, as shown in Figure 10-8.

Export
File Export Web Page QuickTime™ Slideshow

Kind: JPEG

JPEG Quality: High

Include: ☐ Title and keywords
☐ Location information

Size: Custom

Max dimension

of 800 px

File Name: Use filename

Prefix for sequential:

966 items Cancel Export

Figure 10-8: In iPhoto, use the Export command to resize photos for the web.

4. **Choose JPEG from the Kind drop-down list.**

5. **Set the JPEG Quality level.**

This option determines how much JPEG file compression is applied and, in turn, how much quality loss occurs. The greater the amount of compression, the smaller the resulting file, but the lower the picture quality. I suggest choosing High — the picture will still look great, and the file will be a little smaller than if you use the Maximum quality setting.

6. **Open the Size drop-down list and select Custom.**

 The dialog box now presents a box where you can enter the new size for the photo, as shown in Figure 10-8.

7. **Choose Dimension from the Max drop-down list.**

8. **Enter the size, in pixels, of the longest edge of the photo.**

 I suggest using 800 as the longest dimension.

9. **Select Use Filename from the File Name box.**

 Don't worry — you'll have a chance to give the resized copy a unique name in the next step.

10. **Click the Export button.**

 Now you see the standard Mac file-saving dialog box. In the Save As box, enter a new name for the photo (so that you don't overwrite the original). Then specify the folder where you want to put the resized image and click OK.

 I always give my web-sized copies the suffix "Web" so that I can easily see that I'm looking at a resized image. For example, if the original image has the filename P2280031.jpg, I name the small copy P2280031Web.jpg.

Sizing screen images in inches

Newcomers to digital photography often have trouble sizing images in terms of pixels and prefer to rely on inches as the unit of measurement, and some photo-editing programs don't offer pixels as a unit of measurement in their image-size dialog boxes. If you can't resize your picture using pixels as the unit of measurement or you prefer to work in inches, look for an option that enables you to set the image output resolution, and set that value to 72 or 96 ppi.

Where do these 72 and 96 ppi figures come from? They're based on default monitor resolution settings historically used on Macintosh and PC monitors. Mac monitors usually leave the factory with a monitor resolution that results in about 72 screen pixels per linear inch of the viewable area of the screen. PC monitors are set to a resolution that results in about 96 pixels for each linear inch of screen. So if you have a 1 x 1-inch picture and set the output resolution to 72 ppi, for example, you wind up with enough pixels to fill an area that's 1-inch square on a Macintosh monitor.

Note that this approach is pretty unreliable, however. First, not all monitors use default resolution settings that result in 72 or 96 ppi. And even monitors that do follow that default standard typically enable the user to choose from a variety of other resolution settings, which also blows the 72/96 ppi guideline out of the water. For more precise onscreen sizing, sizing your images in terms of pixels is the way to go.

You can use this same tool to convert a Camera Raw image to JPEG — just choose JPEG from the Kind drop-down list after you open the Export dialog box. However, the Export tool has no options for processing the Raw file — you can't adjust color, exposure, sharpness, and so on. So it's best to tackle this task in a normal Raw converter. Chapter 8 talks more about converting Raw files.

Nothing but Net: Photos on the Web

If your company operates a website or you maintain a personal website, you can easily place pictures from your digital camera onto your web pages.

Without knowing what web-page creation program you're using, providing specifics on the commands and tools you use to add photos to your pages isn't possible, but here are a few general guidelines to set you on the right path:

- **Don't go overboard.** If you want your website to be one that people love to visit, take care when adding photos (and other graphics, for that matter). Too many images or images that are too big quickly turn off viewers, especially viewers with slow dialup connections. Remember that every pixel adds to file size and download time, and every second that people have to wait for a picture to download brings them a second closer to giving up and moving on from your site.

- **For business websites, make sure that every image you add is *necessary*.** Don't junk up your page with lots of pretty pictures that do nothing to convey the message of your web page — in other words, images that are pure decoration. These kinds of images waste the viewer's time and cause people to click away from your site in frustration.

- **If you use a picture as a hyperlink, also provide a text-based link.** (A *hyperlink*, in case you're new to the Internet, is a graphic or bit of text that you click to travel to another web page.) This suggestion applies whether you use a single image as a link or combine several images into a multi-link graphic, or *image map*. Why the need for both image and text links? Because many people with slow Internet connections set their browsers so that images do not automatically download. Images appear as tiny icons that the viewer can click to display the entire image. This setup reduces the time required for a web page to load. But without those text links, people can't navigate your site unless they take the time to load each image.

- **Save web-bound photos in the JPEG file format.** This format produces the best-looking onscreen pictures, and all web browsers can display JPEG files. PNG (pronounced *ping*) is a less-common image standard on the web, and JPEG 2000 is a newer version of JPEG that has yet to be adopted and put into use.

✔ **Don't save photos in the GIF or TIFF format.** If you're familiar with web design, you may be wondering about using the GIF format for your online photos. GIF, which stands for Graphics Interchange Format, is a great format for small graphics, such as logos. But it's not good for photos because a GIF image can contain only 256 colors. As a result, photos can turn splotchy when saved to this format, as illustrated by Figure 10-9. And the TIFF format, although great for printing, produces files that are too large for web use and can't be displayed in web browsers.

People argue about whether to say *jiff*, as in *jiffy*, or *gif*, with a hard *g*. I go with *jiff* because our research turned up evidence that the creators of the format intended that pronunciation, but it doesn't matter how you say GIF as long as you remember not to use it for your web photos.

Figure 10-9: For better-looking web photos, use the JPEG file format (top). GIF images can contain only 256 colors, which can leave photos looking splotchy (bottom).

✔ **Understand how pixel count affects display size.** Chapter 3 fills you in on this topic; the earlier section "Preparing Pictures for Screen Display" offers additional guidelines. Since you can't know what size monitors your pages will be viewed on, it's best to take a lowest-common denominator approach and size your images with respect to a screen resolution of 800 x 600 pixels. Don't forget that the web browser will eat up part of the available screen space, too.

✔ **If you want to control the use of your photos, think twice about posting them online.** Remember, anyone who visits your page can download, save, edit, print, and distribute your image — without your knowledge or approval unless you have a way of protecting your images online (provided by some professional photo gallery services, such as Printroom.com). Yes, a savvy web designer can take steps to disable picture downloading, but a savvy hacker can get around those safeguards.

To prevent unauthorized use of your pictures, you may want to investigate digital watermarking and copyright protection services. To start learning about such products, visit the website of one of the leading providers, Digimarc (`www.digimarc.com`). The website operated by the organization Professional Photographers of America (`www.ppa.com`) provides good background information on copyright issues in general. Many image-editing programs also let you add a watermark to your photos (such as your name or a logo) to protect them.

Would you like that picture all at once, or bit by bit?

When you save a picture in the JPEG format inside a photo editor, you usually encounter an option that enables you to specify whether you want to create a *progressive* image. This feature determines how the picture loads on a web page.

With a progressive JPEG, a faint representation of your image appears as soon as the initial image data makes its way through the viewer's modem. As more and more image data is received, the picture details are filled in bit by bit. With *nonprogressive* images, no part of your image appears until all image data is received.

Progressive images create the *perception* that the image is being loaded faster because the viewer has something to look at sooner. This type of photo also enables website visitors to

decide more quickly whether the image is of interest to them and, if not, to move on before the image download is complete.

However, progressive images take longer to download fully, and some web browsers don't handle them well. In addition, progressive JPEGs require more RAM (system memory) to view. For these reasons, most web design experts recommend that you don't use progressive images on your web pages.

If you decide to go with the GIF format instead of JPEG, by the way, you encounter an option called *interlacing*, which has the same result as a progressive JPEG. For reasons illustrated in this chapter (refer to Figure 10-9), you shouldn't really use GIF for photos but, if you do, don't create interlaced files.

Viewing Photos on a TV

Want to share your photos with a group of people? You may be able to display those photos on your TV, which is a great alternative to passing around your camera or having everyone huddle around your computer monitor.

Displaying your photos on a television also can help you get a better look at your pictures than you can on your camera monitor or even your computer monitor, especially if your computer sports a smallish monitor. Small defects that may not be noticeable on a small screen become readily apparent when viewed on a 27-inch television screen.

You can get those photos up on the big screen in a number of ways:

- **Memory card slots:** Some TVs and DVD players offer memory card slots that accept the most popular types of camera memory cards. You can then just pop the card out of the camera and into the slot. Some DVR (digital video recorder) and VCR units also offer card slots. If your equipment doesn't have such slots, you can buy stand-alone card readers made especially for this purpose.

 Most television devices can't display Raw images, however; your photos must be in the standard JPEG format to work. Some stand-alone reader units can display Raw files, however. (See Chapter 3 for a description of Raw and JPEG.)

- **Video-in/video-out ports:** If your camera has a video-out port, you can connect it with a video cable to the video-in port on your TV (or DVD or whatever), as shown in Figure 10-10. Then you turn on the camera and navigate through your pictures using the camera's own playback controls.

 Although the hookup shown in Figure 10-10 features a standard definition audio/video (A/V) connection, cameras that record HD (high-definition) video typically can connect via an HDMI cable to an HDTV for high-def playback as well. You may even be able to use your HDTV remote control to activate certain playback features. (Check your camera manual for how-to's.)

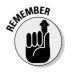

 Most digital cameras sold in North America output video in NTSC format, which is the video format used by televisions in North America. You can't display NTSC images on televisions in Europe and other countries that use the PAL format instead of NTSC. So if you're an international business mogul needing to display your images abroad, you may not be able to do it using your camera's video-out feature. Some newer cameras do provide you with the choice of NTSC or PAL formats.

✔ **USB connection:** A few new TV and video devices even have a USB port. This enables you to connect your camera for picture playback or hook the TV to your computer and access pictures stored on your hard drive (or other computer storage device).

✔ **DVD playback:** If you can't get your pictures onto the TV via any of the above routes, you can always create a video DVD of your pictures; many photo programs and slide-show programs offer tools to help you do this. Then you can just pop the DVD into your DVD player for playback. (Check your DVD player's manual to find out what format of DVD recordings it accepts, and make sure that you burn the DVD using that specification.)

Figure 10-10: You can connect some cameras to a TV for picture playback.

For all these viewing options, you need to track down the manual for your television, DVD player, or whatever device you're using to get the pictures to

the screen to find specifics on how to proceed from here. You may need to set the device's input signal to a special auxiliary input mode or use certain buttons on your remote controls to initiate and control picture playback.

Creating a Slide-Show Screen Saver

When your computer is turned on but not in use, the monitor probably displays a *screen saver,* a series of graphics or images that move across the screen. You can replace the prefab system screen saver with one that features your favorite images. The next two sections show you how to do it in Windows and on a Mac.

Creating a Windows screen saver

In Windows 7, follow these steps to create a custom screen saver:

1. **Put the images that you want to include in the screen saver in a separate folder.**

 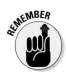

 Make sure that the images are in the JPEG format; you can't use Raw files for this purpose. See Chapter 8 for information about processing Raw files; see Chapter 3 if the terms JPEG and Raw are new to you.

 If you don't want to move the files out of their current folder for organizational purpose, follow the steps outlined earlier in this chapter, in the section "Preparing Pictures for Screen Display," to make low-resolution copies and store them in a new folder. You can then keep the originals at their full size and in their original folder.

2. **Right-click an empty area of the Windows desktop and click Personalize at the bottom of the pop-up menu that appears.**

 The Windows Control Panel window opens with the desktop personalization options at the forefront, as shown in Figure 10-11.

3. **Click the Screen Saver icon, labeled in the figure.**

 Now you see the Screen Saver Settings dialog box, shown in Figure 10-12.

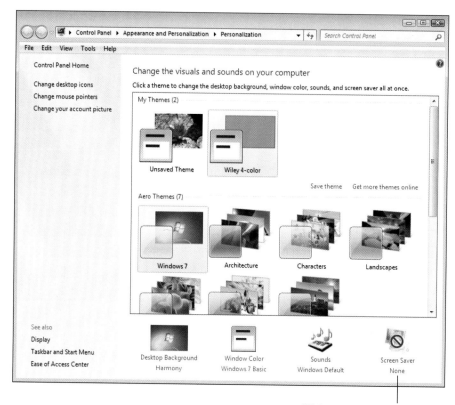

Click to create screen saver

Figure 10-11: Personalize your screen saver through the Windows Control Panel.

4. **Choose Photos from the Screen Saver drop-down list.**

 Some of your photos should then appear in the display preview area.

5. **Click the Settings button to open the dialog box shown in Figure 10-13.**

6. **Click the Browse button.**

7. **In the resulting dialog box, select the folder that contains the photos you want to include in the screen saver. Then click OK.**

 You're returned to the dialog box shown in Figure 10-13.

8. **Select an option from the Slide Show Speed drop-down list.**

Figure 10-12: Choose Photos from the Screen Saver drop-down list.

Figure 10-13: Click the Browse button to select the folder that contains the images that you want to use in the screen saver.

9. **To have photos displayed in random order, select the Shuffle Pictures check box.**

 If the box is deselected, photos play in the order they appear in the folder.

10. **Click the Save button to return to the Screen Saver Settings dialog box (shown earlier in Figure 10-12).**

11. **Specify the Wait time.**

 This setting determines how long a period of inactivity should pass before the screen saver kicks in.

 You can click the Preview button to get a look at how the screen saver will run at the currently selected speed.

12. **Specify whether you want Windows to display the user logon screen when you wake the computer.**

 In other words, when you press a key on the keyboard or move the mouse, do you want to stop the screen saver and immediately return to what you were doing before it started? If so, leave the check box deselected. If you instead want to have the person who wakes the system log onto the computer, select the check box.

13. **Click OK.**

 Your screen saver should start running after the period of inactivity you specified in the Wait option box. To interrupt the screen saver, just press a key or move your mouse.

Creating a Mac screen saver

If you use a Mac, follow these steps to create a custom screen saver featuring your favorite photos:

1. **Move the pictures that you want to include in the screen saver into a single folder.**

 You can make low-resolution copies of your originals, following the steps laid out in the earlier section "Preparing Pictures for Screen Display," and then put all the copies into a new folder. That way, you can keep the originals at their full size and at their original location.

2. **Choose System Preferences from the Apple menu to open the System Preferences dialog, shown in Figure 10-14.**

Click to create a screen saver

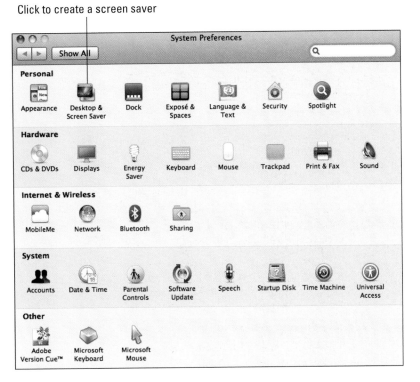

Figure 10-14: Create a custom screen saver on a Mac via the System Preferences dialog.

3. **Click the Desktop & Screen Saver icon.**

 I labeled the icon in the figure. After you click the icon, you see the Desktop & Screen Saver dialog.

4. **Click the Screen Saver tab at the top of the dialog to display the options shown in Figure 10-15.**

5. **In the scrolling list on the left side of the dialog, choose the folder that contains your images.**

 If the folder isn't visible, click the plus sign under the scrolling list and then choose Add Folder of Pictures from the pop-up menu that appears. Track down your folder and click Choose. The folder should then appear in the scrolling list.

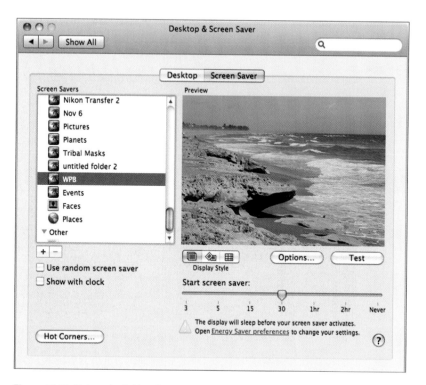

Figure 10-15: Select the folder that contains your images and set other screen saver preferences here.

6. Use the other dialog options to set your preferences for the screen saver.

You can specify how long the computer should wait after a period of inactivity to start the screen saver and choose from a couple *transition effects* (how pictures fade from one to another). Click the Options button to access additional preferences settings.

7. Click the Test button to preview the screen saver.

8. When you're happy with the results, close the dialog.

Just click the red button in the upper-left corner of the dialog.

Hanging Photo Wallpaper

Wallpaper is the official name of the image that appears on your computer *desktop* — the main computer screen. Instead of sticking with the standard

Windows or Mac wallpaper, you can plaster one of your favorite photos on the desktop, as I did for the Windows 7 desktop shown in Figure 10-16.

Figure 10-16: Select a favorite photo to use as your desktop wallpaper.

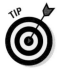

If you captured the photo in the Raw format, you must convert it to JPEG for this use. Chapter 8 tells you more about processing Raw files, and Chapter 3 introduces the whole concept of JPEG, Raw, and file formats.

With that preamble out of the way, the next two sections provide specifics for Windows and Mac wallpaper hanging.

Creating wallpaper in Windows 7

To choose a desktop background in Windows 7, follow these steps:

1. **Right-click an empty area of the desktop and choose Personalize from the menu that appears.**

 You see the Windows Control Panel dialog box with the desktop customization options displayed.

2. **At the bottom of the dialog box, click the Desktop Background icon.**

 Now you see the dialog box shown in Figure 10-17.

3. **Click the Browse button to display a folder selection dialog box.**

4. **Select the folder that contains your image and click OK.**

 Thumbnails of all images in the folder should appear, as shown in Figure 10-17.

Figure 10-17: Click the Browse button to select the folder that contains your image.

5. **Click the thumbnail of the image you want to use as your wallpaper.**

6. **Select an option from the Picture Position drop-down list to specify how you want the image displayed.**

 If you want the image to appear at its original proportions, choose Center. Other options manipulate the picture to fit the dimensions of the screen.

7. **Click Save Changes to exit the dialog box.**

8. **Close the Control Panel dialog box.**

 Your new wallpaper should appear on the desktop.

Hanging wallpaper on a Mac

On a Mac computer, follow these steps to change your desktop wallpaper:

1. **Choose System Preferences from the Apple menu.**

 The System Preferences dialog appears.

2. **Click the Desktop & Screen Saver icon.**

 Now you see the Desktop & Screen Saver dialog.

3. **Click the Desktop tab inside the dialog.**

 The options shown in Figure 10-18 appear.

4. **Choose the folder that contains your image from the list on the left side of the dialog.**

 Don't see your folder? Click the plus sign under the list. A dialog then opens, and you can select your folder. Click Choose to add it to the Desktop & Screen Saver dialog's list of folders.

 After you choose your folder, thumbnails of all images in the folder appear in the dialog.

5. **Click the image thumbnail.**

 Your photo appears in the preview area at the top of the dialog.

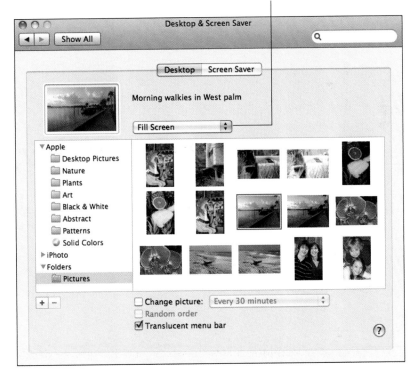

Picture Position drop-down list

Figure 10-18: Select your wallpaper image via the Desktop & Screen Saver panel of the System Preferences dialog.

6. **Choose an option from the drop-down list labeled Picture Position in Figure 10-18.**

 You can choose to fill the screen with the picture, center the picture, and so on. As you choose each option, the preview updates to show you the results.

7. **Use the other dialog options to customize the wallpaper further:**

 • *Change Picture and Random Order:* If you select the Change Picture check box, the system will automatically display a different wallpaper picture after the period of time you specify. You can choose to have them displayed in random order or in the same order they appear in the folder.

 • *Translucent menu bar:* Select this option to make the background of the menu bar disappear. The menu text then appears over your picture.

8. **Close the dialog when you're happy with your wallpaper.**

Part V
The Part of Tens

The 5th Wave By Rich Tennant

"I've got some new image editing software, so I took the liberty of erasing some of the smudges that kept showing up around the clouds. No need to thank me."

*S*ome people say that instant gratification is wrong. I say, phooey. Why put off until tomorrow what you can enjoy this minute? Heck, if you listen to some scientists, we could all get flattened by a plunging comet or some other astral body any day now, and then what will you have for all your waiting? A big fat nothing, that's what.

In the spirit of instant gratification, this part of the book is designed for those folks who want information right away. The chapters herein present useful tips and ideas in small snippets that you can rush in and snag in seconds. Without further delay. Now, darn it.

Chapter 11 lists ten great Internet resources for digital photographers, from sites that offer equipment reviews to forums where you can chat with other photographers. Chapter 12 offers ten tips to help you maintain your gear, prevent catastrophes, and deal with emergency digital camera situations.

Ten Great Online Resources

In This Chapter

▶ Exploring camera review sites

▶ Chatting with other photographers

▶ Viewing online tutorials and discovering other helpful hints

▶ Getting troubleshooting and technical support help

▶ Finding pages of photographic inspiration

*I*t's 2 a.m. You're aching for inspiration. You're yearning for answers. Where do you turn? No, not to the refrigerator. Well, okay, maybe just to get a little snack — some cold pizza or leftover chicken wings would be good — but then it's off to the computer for you. Whether you need solutions to difficult problems or just want to share experiences with like-minded people around the world, the Internet is the place to turn. At least, it is for issues related to digital photography. For anything else, talk to your spiritual leader, psychic hotline, Magic 8-Ball, or whatever source you usually consult.

This chapter points you toward ten great online digital photography resources to get you started. New sites are springing up every day, so you can no doubt uncover more great pages to explore by doing a web search on the words *digital photography* or *digital cameras.*

The site descriptions provided in this chapter are current as of press time. Because websites are always evolving, some of the specific features mentioned may be updated or replaced by the time you visit a particular site.

Digital Photography Review

www.dpreview.com

Click here for a broad range of digital photography information, from news about recently released products and promotional offers to discussion groups where people debate the pros and cons of different camera models. An educational section of the site is provided for photographers interested in delving into advanced picture-taking techniques.

The Imaging Resource

www.imaging-resource.com

Point your web browser here for reliable equipment-buying advice and digital photography news. An especially helpful tutorials section offers hints and advice about everything from choosing a camera to taking better pictures. In-depth product reviews and discussion forums related to digital photography round out this well-designed site.

ePHOTOZINE

www.ephotozine.com

This site offers product reviews as well as articles covering all aspects of digital photography, video tutorials, discussion forums, and an excellent glossary of photographic terms. You also can show off your best work, get feedback from other photographers, and enter photo contests here.

Digital Photo Magazine

www.dpmag.com

This site makes articles from past issues of *Digital Photo* magazine and more available at its website. Along with equipment reviews, you can find tutorials on photography and photo editing, as well as interviews with noted photographers.

Outdoor Photographer

www.outdoorphotographer.com

Outdoor Photographer magazine has long been a great resource for nature and wildlife photographers. Its online site offers tips, articles from past issues, buying guides, discussion forums, and even a photo gallery where you can show off your best work.

Shutterbug

www.shutterbug.com

At this site, you can explore the online version of the respected magazine *Shutterbug,* which offers how-to articles and equipment reviews related to both film and digital photography. Comprehensive reviews in addition to forum, gallery, and technique sections provide extensive information about digital cameras and other imaging tools. If you're looking for some fame, the site's contest section is a good place to enter your best photos.

Strobist.com

www.strobist.com

Strobe is another word for *flash,* and this site is a great place to learn all about the art and science of flash photography. You can find tutorials for beginners, discussion forums, equipment reviews, and articles in which pros explain exactly how they tackled lighting on various assignments.

Photo.net

www.photo.net

This large online photography community website offers galleries for inspiration, a wealth of how-to articles, discussion forums, and much more. You can even upload photos and get critiques from other members.

PhotoWorkshop

www.photoworkshop.com

This interactive, online photography community website is for everyone interested in digital photography, amateur to professional. You can find scads of tutorials, read articles featuring the work of leading photographers, enter photo contests, and get in-depth help with a variety of hardware and software issues.

Manufacturer Websites

Most camera manufacturers maintain websites that offer technical support as well as updates to camera *firmware* (the software inside your camera). You can find similar assistance and updates at sites run by printer and software vendors.

But don't stick just with the sites related to your specific equipment. Although most manufacturer websites are geared to marketing the company's products, many also offer terrific generic tutorials and other learning resources for newcomers to digital photography. Here are just a few to get you started:

- **Adobe** (www.adobe.com): Travel via the Learning link to the Adobe TV section, where you can watch free movies demonstrating various photo-editing techniques.

- **Canon** (www.canon.com): Review the Learning Station section of the site for a variety of digital photography tips.

- **Kodak** (www.kodak.com): In the Consumer Products section, explore the Tips and Projects link.

- **Nikon USA** (www.nikonusa.com): Click the Learn and Explore link to check out a variety of educational resources.

- **Olympus America** (www.olympusamerica.com): From the home page, click the Cameras and Audio link and then look for the Learn link.

Again, links get changed as sites get updated, which seems to happen virtually overnight these days. But if you have trouble locating these areas of the websites, try entering *tutorials* or the name of the link I mention in the site's search box.

Top Ten Maintenance and Emergency Care Tips

In This Chapter

▶ Protecting your memory card

▶ Safeguarding your camera from heat, cold, and water

▶ Backing up regularly

▶ Recovering accidentally deleted photos

▶ Taking care of your computer's hard drive

The old Boy Scout motto, "Be prepared," applies in spades when it comes to digital photography. Although you can't foresee all potential incidents that might snag your photo shoot, you can keep your camera in tip-top condition and practice some basic preventative measures to ensure that your equipment stays safe and in good working order. This chapter provides strategies to help you do just that and, for times when your best efforts aren't enough, some tips for dealing with unexpected emergencies.

Keep Spare Batteries on Hand

Digital cameras are hungry for power, which means you will have to replace or recharge the batteries from time to time. To avoid missing important photographic opportunities, always keep a spare set of batteries or an extra rechargeable on hand. That way you don't waste precious time running to the store or waiting for your battery

to recharge when you could be taking pictures. The same holds true for an external flash, if your camera supports one.

The amount of time and number of photos that you can shoot before replacing your batteries vary depending on how you use your camera. If you start to run low on battery power, try these energy-conservation tips:

- **Limit the use of the monitor.** The monitor is one of the biggest power drains, so wait to review your pictures until you have fresh batteries. When you're not using the monitor to take pictures, turn it off, even if you leave the camera itself powered up.

- **Turn on your camera's auto-off function.** Most cameras offer a feature that automatically shuts the camera off after a period of inactivity to save power. You may even be able to reduce the wait time that must pass before the shutdown occurs.

- **Go flash-free.** The internal flash also consumes lots of battery juice. When the flash recycle time starts to slow down, that's a clue that your batteries are fading.

- **Turn off image stabilization.** On some cameras, turning off this feature saves battery power (but check your manual because this tip doesn't apply to all models of cameras and lenses).

- **Avoid using continuous autofocus, if your camera offers it.** In this mode, the camera continuously adjusts focus from the time you press the shutter button halfway until the time you actually take the picture. And because the autofocus motor consumes power, you can preserve some battery life by sticking with regular autofocus or, on an interchangeable lens model, shifting to manual focus.

- **Keep spare batteries warm.** Batteries deplete faster when they get cold, so tuck your extra batteries in a shirt pocket or find some other way to keep the chill off.

Always do whatever you can to protect spare, loose batteries from short-circuiting as well. That means protecting the metal electrical contacts from connecting (both touching the same piece of aluminum foil, for example). Most batteries come with little caps that cover the contacts, and it's a good idea to use them; otherwise, cover them with tape or keep them in separate containers.

Use the Strap!

Almost every camera ships with a neck or wrist strap — which is why it baffles me to see so many people carrying cameras around without one. Should you stumble while shooting, that strap could prevent the camera from hitting the pavement, so take the time to dig it out of your camera box and attach it.

Once you have the strap attached, though, you still have to pay attention. I see too many photographers with bulky dSLRs slung over their shoulders instead of around their neck, strolling casually down the street, the camera swaying this way and that, perilously close to walls, doors, and other objects that could damage the lens with one sharp bump.

One other word of caution: When you set your camera on a table, desk, or whatever, don't leave the strap hanging down off the side. It's too easy for someone passing by to inadvertently brush against the strap and send the whole camera crashing to the ground. Sadly, I learned this very expensive lesson the hard way — in my case, that "someone" was my four-footed furry friend.

Safeguard Your Memory Cards

If any dirt gets onto the copper strips or holes in your memory card, you may not be able to transfer images, or your images may become corrupt during transfer. The key to preventing this from happening is to keep cards as clean as possible. You can store them in your camera, the little plastic cases they shipped in, or a memory card case.

While memory cards are remarkably durable, they're still somewhat fragile and very easily lost. CompactFlash pinholes are especially susceptible to things like lint in your pocket.

Lastly, try not to expose memory cards to extreme cold or heat. Setting one on your dashboard on a sunny day, for example, is asking for trouble.

Clean the Lens and LCD with Care

Is there anything more annoying than a dirty lens? Let's face it: Fingerprints, raindrops, and dust happen, and they all get in the way of the perfect image. And LCD monitors also can get gunked up pretty easily.

To clean your lens and LCD, stick with these tools:

- A **microfiber cloth** (like the ones used for cleaning eyeglasses). It works either with or without lens-cleaning fluid. And yes, you can go ahead and breathe onto the glass or plastic LCD to fog it up with some moisture first.

- Any **cotton product,** such as a t-shirt or dishtowel, is usually okay as long as it's clean and lint-free.

✔ A **manually operated bulb blower** commonly available in any camera store. Some come with a little natural-fiber brush, which is also okay. It's a good idea to use this type of tool before wiping your lens if it's especially dirty to ensure that bigger particles of dirt aren't rubbed into the lens.

Do not use any of the following to clean a lens or LCD:

✔ **The same microfiber cloth you use for your glasses.** It may have oily residue from your face.

✔ **Facial tissue, newspaper, napkins, or toilet paper.** These are made from wood products and can scratch glass and plastic and can harm a lens coating.

✔ **Household cleaning products** (window cleaner, detergent, toothpaste, and the like).

✔ **Compressed air.** These cans contain a chemical propellant that can coat your lens or LCD with a permanent residue. Even more scary, compressed air can actually crack the monitor.

✔ **Synthetic materials** (like polyester). They usually don't clean well, anyway.

✔ **Any cloth that's dirty** or that's been washed with a fabric softener.

Of course, you should always carry and store your camera in a quality case or bag; see Chapter 2 for a look at some options.

Update Your Firmware

Just when you thought software and hardware were confusing enough, along comes another techno-term to deal with: *firmware*. This special software lives permanently on your camera, telling it how to operate and function — in essence, it's your camera's gray matter.

Every now and then, camera manufacturers update firmware to fix problems and bugs, enhance features, and generally do housekeeping that makes your camera operate better. Sometimes these changes are minor, but occasionally they fix pretty serious problems and errors.

To benefit from these updates, you have to download the new firmware files from your camera manufacturer's website and install them on your camera. If you signed up for manufacturer e-mail updates when you registered your camera (you *did* do that, right?), the company should inform you of updates when they occur. But it's a good idea to also simply check the manufacturer's camera support page every three months or so to make sure that you don't miss an important firmware update.

Depending on the camera brand and model, you typically can update your camera one of two ways:

- **Download and install the files from a memory card.** Put a memory card in a card reader connected to your computer and then download the firmware files from the website to the card. After the files are on the card, put it in your camera and follow the directions in your camera manual (or on the website) to install the firmware.

- **Download and install directly to your camera.** You also may be able to download directly to your camera by connecting the camera to your computer using a USB cable. Again, check your camera manual for specifics on this process.

Don't push any buttons or disconnect the camera until the update is finished. Cameras don't like being interrupted during brain surgery. (Be sure your camera batteries are fully charged before you begin, too.)

Protect Your Camera from the Elements

Remember that a digital camera is pretty much a computer with a lens, and like any electronic device, you camera isn't designed to cope with weather extremes. So take these safety steps:

- **Don't let your camera catch a cold.** Extreme cold can cause various mechanical functions in your camera to freeze; it can stop your lens from zooming or your shutter release button from operating. Your LCD may stop functioning as well, and your battery power may drop so much that your camera won't even turn on. If you must take your camera into the cold, keep it in a camera case under your jacket until you're ready to use it.

- **Don't let it get heat stroke, either.** Extreme heat can damage your camera as well and can be especially hard on your LCD screen, which can "go dark" if it gets too hot. If this happens, simply get your camera to a cooler place. Typically, it will return to a normal viewing state. Although heat generally doesn't cause as many problems as cold, leaving your camera in direct sunlight (such as in a car) isn't a good idea. If you can at least cover it with a towel or t-shirt, your camera will be happier.

- **Avoid rapid changes in temperature.** Changing temperature extremes, such as going from a warm room into sub-freezing weather, are especially bad for your camera. Condensation forms on the camera parts and lens elements, which can (at best) obstruct your ability to take good photos and (at worst) cause permanent moisture damage. To avoid problems, store your camera in a sealed Ziploc-type bag until it adjusts to the new temperature.

✔ **Keep it dry.** Digital cameras, like most other electronic devices, don't do well if they get wet. Water — especially salt water — can short important camera circuitry and corrode metal parts. A few raindrops probably won't cause any big problems, but exposure to enough water, even momentarily, can result in a death sentence for a camera.

If you do accidentally leave your camera on the picnic table during a downpour or drop it in the swimming pool, all may not be lost, however. Remove the batteries and memory card, wipe the camera with a clean, dry cloth — try not to push any camera buttons in the process — and set it in a warm place where it can dry out as much and as quickly as possible. You can even try sealing it in a plastic bag along with some uncooked rice — the rice grains will absorb some of the moisture. With luck, the camera will come back to life after it's had time to dry out. If not, it's off to the repair shop to see whether anything more can be done.

By the way, if you want to try underwater photography on *purpose*, you can buy waterproof housings that are designed to let you operate all the camera's buttons and such but still keep the innards safe and dry. Some companies also make a variety of products that protect your gear when you shoot in the rain. See Chapter 2 for an introduction to just some protection options.

Clean the Image Sensor

The *image sensor* is the part of your camera that absorbs light and converts it into a digital image. If dust, hair, or dirt gets on the sensor, it can show up as small spots on your photos. Image-sensor spots are often most visible in the sky or in bright, clear areas of your image, but can be seen just about anywhere.

Many new cameras have an internal cleaning system designed to remove any stray flotsam and jetsam from the sensor. Usually, the camera is set up at the factory to go through a cleaning cycle each time you turn the camera on, off, or both. You may also be able to initiate a cleaning cycle at other times through a menu option.

If the camera's internal cleaning mechanisms don't do the trick, you need to take your camera to a repair shop to have the sensor cleaned manually. Although you can find products designed to help you do this job yourself, you do so at your own peril. This job is a delicate one, and really should be done only by a trained technician. Call your local camera store to find out the best place in town to have the cleaning done. (Some camera stores offer free cleaning for cameras purchased from them.)

You can help limit the amount of dust and dirt that finds its way to your image sensor by keeping the camera stored in a case or camera bag when not in use and being cautious when shooting in dicey environmental situations — windy days on the beach, for example. If you own an interchangeable lens camera, be especially careful when changing lenses, because that's a prime occasion for dirt to sneak into the camera. Also try to point the camera slightly downward when you attach the lens; doing so can help prevent dust from being sucked into the camera by gravity.

Back Up Your Images Regularly

When disasters such as fires or floods occur, photos are one of the first things people try to save. Photographs are precious memories and often can't be replaced.

Digital images can be destroyed not only by fire or flood, but also by a computer hard-drive failure if that's the only place you have them stored. While not extremely common, hard drives have been known, on occasion, to simply stop working. It's difficult and expensive — and occasionally impossible — to retrieve files from one that's gone bad.

The key to preventing a disaster such as this is simple: Back up your images on a CD or DVD. Store the disks in a location separate from your originals. Some people keep backups in safe-deposit boxes at banks, in other family members' homes, or in their offices, for example. As another option, you can pay to store extra copies of your images at online storage sites such as Carbonite (www.carbonite.com) or Mozy (www.mozy.com).

For more information on storage devices designed to hold your favorite photos, see Chapter 2.

Use Image Recovery Software to Rescue Lost Photos

It happens to everyone sooner or later: You accidentally erase an important picture — or worse, an entire folder full of images. Don't panic yet — you may be able to get those pictures back.

The first step: *Stop shooting.* If you take another picture, you may not be able to rescue the deleted files. If you must keep shooting, and you have another memory card, replace the one with the accidental erasure with the other card. You can work with the problem card later.

For pictures that you erased using the camera's delete function, go online or to your local computer store to buy a file-recovery program such as Lexar Image Rescue ($34; www.lexar.com) or SanDisk RescuePro ($39 for one-year subscription; www.sandisk.com). For these programs to work, your computer must be able to access the camera's memory card as if the card were a regular drive on the system. So if your camera doesn't show up as a drive when you connect it to the computer, you need to buy a card reader.

If you erased pictures on the computer, you may not need any special software. In Windows, deleted files go to the Recycle Bin and stay there until you empty the Bin. Assuming that you haven't taken that step, just use Windows Explorer to open the Bin, click an erased file, and then choose File⇨Restore to "un-erase" the picture. On a Mac, deleted files linger in the Trash folder until you choose the Empty Trash command. Until you do, you can open the Trash folder and move the deleted file to another folder on your hard drive.

Already emptied the Recycle Bin or Trash? You also can buy programs to recover files that were dumped in the process; start your software search at the two aforementioned websites.

Clean Out Your Computer's Hard Drive

You probably know that computers need lots of RAM (*random-access memory*) in order to run smoothly and quickly. But you may not know that a computer also needs a significant amount of empty space on its hard drive — that's the component that holds all your files and programs — to perform well. The computer uses that free space, sometimes called *scratch disk space,* to temporarily store data as it's processing your files. Without enough free space, the computer slows down and may not be able to perform some photo-editing tasks at all, especially on large image files.

Generally speaking, you should keep at least 10GB (gigabytes) of free space on your hard drive, although some photo programs may request even more. Keeping that free space available may mean moving data files onto external hard drives, CDs, or DVDs for storage; it may also mean uninstalling unused applications.

Chapter 2 gives you a look at some of your storage options and talks more about building a computer system that's robust enough for digital photography.

Appendix

Glossary of Digital Photography Terms

. .

C an't remember the difference between a pixel and a bit? Resolution and resampling? Turn here for a quick refresher on that digital photography term that's stuck somewhere in the dark recesses of your brain and refuses to come out and play.

24-bit image: An image containing approximately 16.7 million colors.

AE lock: A way to prevent the camera's autoexposure (AE) system from changing the current exposure settings if you reframe the picture or the lighting changes before the image is recorded.

aperture: One of three critical exposure controls; an opening made by an adjustable diaphragm, which permits light to enter through the camera lens and reach the image sensor. The size of the opening is measured in f-stops (f/2.8, f/8, and so on). Aperture also affects depth of field, or the distance over which sharp focus is maintained.

aperture-priority autoexposure: A semiautomatic exposure mode; the photographer sets the aperture, and the camera selects the appropriate shutter speed to produce a good exposure at the current ISO (light sensitivity) setting.

artifact: A defect created by too much JPEG compression.

aspect ratio: The proportions of an image. A 35mm-film photo has an aspect ratio of 3:2; the standard digital camera image has an aspect ratio of either 3:2 or 4:3.

autoexposure: A feature that puts the camera in control of choosing the proper exposure settings. *See also* aperture-priority autoexposure and shutter-priority autoexposure.

backlight: Bright light coming from behind your subject, which can cause your subject to be underexposed in autoexposure shooting modes.

bit: Stands for *binary digit;* the basic unit of digital information. Eight bits equals one *byte.*

bit depth: Refers to the number of bits available to store color information. A standard digital camera image has a bit depth of 24 bits. Images with more than 24 bits are called *high-bit images.*

burst mode: A special capture setting, offered on some digital cameras, that records several images in rapid succession with one press of the shutter button. Also called *continuous capture* mode.

byte: Eight bits. ***See also*** bit.

Camera Raw: A file format offered by some digital cameras; records the photo without applying any of the in-camera processing or file compression that is usually done automatically when saving photos in the other standard format, JPEG. Also known as *Raw.*

card reader: A device used to transfer images from your CompactFlash, Secure Digital (SD), or other type of memory card to your computer.

catchlight: The bright, small reflective spots seen in a subject's eyes in a photo that can come from a flash or natural light.

CCD: Short for *charge-coupled device.* One of two types of imaging sensors used in digital cameras.

CIE Lab: A color model developed by the Commission Internationale de l'Eclairage. Used mostly by digital-imaging professionals.

CMOS: Pronounced *see-moss.* A much easier way to say *complementary metal-oxide semiconductor.* A type of imaging sensor used in some digital cameras.

CMYK: The print color model, in which cyan, magenta, yellow, and black inks are mixed to produce colors.

color correction: The process of adjusting the amount of different colors in an image (for example, reducing red or increasing green).

color model: A way of defining colors. In the RGB color model, for example, all colors are created by blending red, green, and blue light. In the CMYK model, colors are produced by mixing cyan, magenta, yellow, and black ink. (Black is the *key* color, thus the K in CMYK.)

color temperature: Refers to the color cast emitted by a light source; measured on the Kelvin scale.

CompactFlash: A type of removable memory card used in many digital cameras; about the size and thickness of a matchbook.

compositing: Combining two or more images in a photo-editing program.

compression: A process that reduces the size of the image file by eliminating some image data.

continuous autofocus: An autofocus feature on some digital cameras, in which the camera continuously adjusts focus as needed to keep a moving subject in focus.

contrast: The amount of difference between the brightest and darkest values in an image. High-contrast images contain both very dark and very bright areas.

crop: To trim away unwanted areas around the perimeter of a photo, typically done in a photo-editing program.

depth of field: The zone of sharp focus in a photograph. With shallow depth of field, the subject is sharp but distant objects are not; with large depth of field, both the subject and distant objects are in focus. Manipulated by adjusting the aperture, focal length, or camera-to-subject distance.

digital zoom: A feature offered on most digital cameras; crops the perimeter of the image and then enlarges the area at the center. Results in reduced image quality.

diopter: An adjustment on a camera viewfinder to accommodate your eyesight.

downloading: Transferring data from your camera to a computer or from one computer device to another.

downsampling: Eliminating excess pixels from a digital photo. Often done to create a web-friendly version of a high-resolution image.

dpi: Short for *dots per inch.* A measurement of how many dots of color a printer can create per linear inch. Higher dpi means better print quality on some types of printers, but on other printers, dpi is not as crucial.

DPOF: Stands for *digital print order format.* A feature offered by some digital cameras that enables you to add print instructions to the image file; some photo printers can read that information when printing your pictures directly from a memory card.

driver: Software that enables a computer to interact with a digital camera, printer, or other device. Usually, this installs automatically when you plug your device into your computer, but sometimes you have to use a CD to install it.

dSLR: Stands for *digital single-lens reflex;* one type of digital camera that accepts interchangeable lenses.

dye-sub: Short for *dye-sublimation.* A type of photo printer.

dynamic range: The overall range of brightness values in a photo, from black to white. Also refers to the range of brightness values that a camera, scanner, or other digital device can record or reproduce.

edges: Areas where neighboring image pixels are significantly different in color; in other words, areas of high contrast.

EV compensation: A control that slightly increases or decreases the exposure chosen by the camera's autoexposure mechanism. EV stands for *exposure value;* EV settings typically appear as EV 1.0, EV 0.0, EV –1.0, and so on.

EVF: An electronic viewfinder, which delivers an electronic pixel version of what the camera lens actually captures through a small viewfinder display. Different from an optical viewfinder, which employs lenses to approximate the camera lens view or looks directly through the lens.

EXIF metadata: *See* metadata.

exposure: The overall brightness and contrast of a photograph, determined mainly by three settings: aperture, shutter speed, and ISO.

exposure compensation: Another name for EV compensation.

file format: A way of storing image data in a digital file. Popular digital-camera formats include Camera Raw, JPEG, and TIFF.

fill flash: Using a flash to fill in darker areas of an image, such as shadows cast on subjects' faces by bright overhead sunlight or backlighting.

flash exposure (EV) compensation: A feature that enables the photographer to adjust the strength of the camera flash.

f-number, f-stop: Refers to the size of the camera aperture. A higher number indicates a smaller aperture. Written as f/2, f/8, and so on. Affects both exposure and depth of field.

gamut: Say it *gamm-ut.* The range of colors that a monitor, printer, or other device can produce. Colors that a device can't create are said to be *out of gamut.*

GIF: Short for *Graphics Interchange Format.* A file format often used for web graphics; not suitable for photos because it can't handle more than 256 colors.

gigabyte: Approximately 1,000 megabytes, or 1 billion bytes. In other words, a really big collection of bytes. Abbreviated as GB.

grayscale: An image consisting solely of shades of gray, from white to black. Often referred to generically as a *black-and-white image* (although in the truest sense, a black and white image contains only black and white, with no grays).

HDR: Stands for *high dynamic range* and refers to a picture that's created by merging multiple exposures of the subject into one image using special computer software. The resulting picture contains a greater range of brightness values — a greater dynamic range — than can be captured in a single shot.

histogram: A graph that maps out shadow, midtone, and highlight brightness values in a digital image; an exposure-monitoring tool that can be displayed on some cameras. Also found inside some of the exposure-correction filter dialog boxes displayed in some photo-editing programs.

HSB: A color model based on hue (color), saturation (purity or intensity of color), and brightness.

HSL: A variation of HSB, this color model is based on hue, saturation, and lightness.

image sensor: The array of light-sensitive computer chips in your camera that senses light and converts it into digital information.

ISO: Traditionally, a measure of film speed; the higher the number, the faster the film. On a digital camera, it means how sensitive the image sensor is to light. Raising the ISO allows faster shutter speed, smaller aperture, or both, but also can result in a noisy (grainy) image. Stands for *International Organization for Standardization.*

jaggies: Refers to the jagged, stairstepped appearance of curved and diagonal lines in low-resolution photos that are printed at large sizes.

JPEG: Pronounced *jay-peg.* The primary file format used by digital cameras; also the leading format for online and web pictures. Uses *lossy compression,* which eliminates some data in order to produce smaller files. A small amount of compression does little discernible damage, but a high amount destroys picture quality. Stands for *Joint Photographic Experts Group,* the group that developed the format.

JPEG 2000: An updated version of the JPEG format; not yet fully supported by all web browsers or other computer programs.

Kelvin: A scale for measuring the color temperature of light. Sometimes abbreviated as *K,* as in 5000K. (But in computerland, the initial *K* more often refers to kilobytes, as described next.)

kilobyte: One thousand bytes. Abbreviated as *K,* as in 64K.

LCD: Stands for *liquid crystal display.* Often used to refer to the display screen included on most digital cameras.

lossless compression: A file-compression scheme that doesn't sacrifice any vital image data in the compression process, used by file formats such as TIFF. Lossless compression tosses only redundant data, so image quality is unaffected.

lossy compression: A compression scheme that eliminates important image data in the name of achieving smaller file sizes, used by file formats such as JPEG. High amounts of lossy compression reduce image quality.

manual exposure: An exposure mode that enables you to control aperture, shutter speed, and ISO. Usually represented by the letter M on the camera's exposure mode dial or menu option.

manual focus: A setting that turns off autofocus and instead enables you to set focus by twisting a ring on the lens barrel or by specifying a specific focusing distance through camera menus.

megabyte: One million bytes. Abbreviated as MB. *See also* bit.

megapixel: One million pixels; used to describe the resolution offered by a digital camera.

Memory Stick: A memory card used by some Sony digital cameras and peripheral devices. About the size of a stick of chewing gum.

metadata: Extra data that gets stored along with the primary image data in an image file. Metadata often includes information such as aperture, shutter speed, and EV compensation setting used to capture the picture, and can be viewed using special software. It can also include information you add in a photo-editing program, such as a copyright, your name, keywords, or a photo caption. Often referred to as *EXIF metadata;* EXIF stands for *Exchangeable Image File Format.*

metering mode: Refers to the way a camera's autoexposure mechanism reads the light in a scene. Common modes include *spot metering,* which bases exposure on light in the center of the frame only*; center-weighted metering,* which reads the entire scene but gives more emphasis to the subject in the center of the frame; and *matrix, evaluative, pattern,* or *multizone metering,* which calculates exposure based on the entire frame.

monopod: A telescoping, single-legged pole onto which you can mount a camera and lens in order to hold it more stably while shooting. It will not stand on its own, unlike a tripod.

noise: Graininess in an image, caused by a very long exposure, a too-high ISO setting, or a defect in the electrical signal generated during the image-capture process.

NTSC: A video format used by televisions, DVD players, and VCRs in North America and some parts of Asia (such as Japan, Taiwan, South Korea, and the Philippines). Many digital cameras can send picture signals to a TV, DVD player, or VCR in this format.

optical zoom: A traditional zoom lens; has the effect of bringing the subject closer and shortening depth of field.

output resolution: The number of pixels per linear inch (ppi) in a printed photo; the user sets this value inside a photo-editing program.

PAL: The video format common in Europe, China, Australia, Brazil, and several other countries in Asia, South America, and Africa. Some digital cameras sold in North America can output pictures in this video format. *See also* NTSC.

PictBridge: A universal standard that allows digital cameras and photo printers to connect directly by USB cable, without the computer serving as a middleman. Any PictBridge camera can connect to any PictBridge printer, regardless of whether both are made by the same manufacturer.

pixel: Short for *picture element.* The basic building block of every image.

pixelation: A defect that occurs when an image has too few pixels for the size at which it is printed; pixels become so large that the image takes on a mosaic-like or stairstepped appearance.

platform: A fancy way of saying "type of computer operating system." Most folks work either on the Windows platform or the Macintosh platform.

plug-in: A small program or utility that runs within another, larger program. Many special-effects filters operate as plug-ins to major photo-editing programs such as Adobe Photoshop Elements.

ppi: Stands for *pixels per inch.* Used to state image output (print) resolution. Measured in terms of the number of pixels per linear inch. A higher ppi usually translates to better-looking printed images.

Raw: *See* Camera Raw.

Raw converter: A software utility that translates Camera Raw files into a standard image format such as JPEG or TIFF.

red-eye: Light from a flash being reflected from a subject's retina, causing the pupil to appear red in photographs. Can sometimes be prevented by using a red-eye reduction flash setting; can also be removed later in most image-editing programs.

resampling: Adding or deleting image pixels. Adding a large amount of pixels degrades images.

resolution: A term used to describe the number of pixels in a digital image. Also a specification describing the rendering capabilities of scanners, printers, and monitors; means different things depending on the device.

RGB: The standard color model for digital images; all colors are created by mixing red, green, and blue light.

rule of thirds: A philosophy for composing images where various parts of your image are separated and flow among nine squares, aligned tic-tac-toe style. Normally you center elements of your subject onto cross-points of the vertical and horizontal lines.

SD card: A type of memory card used in many digital cameras; stands for *Secure Digital.*

SDHC card: A high-capacity form of the SD card; requires a camera and card reader that specifically supports the format. Stands for *Secure Digital High Capacity* and refers to cards with capacities ranging from 4MB to 32MB.

SDXC card: *Secure Digital Extended Capacity;* used to indicate an SD memory card with a capacity greater than 32MB.

sharpening: Applying an image-correction filter inside a photo editor to create the appearance of sharper focus.

shutter: An exposure control that determines the length of the image exposure.

shutter-priority autoexposure: A semiautomatic exposure mode in which the photographer sets the shutter speed and the camera selects the appropriate aperture.

shutter speed: The duration of the image exposure. Typically measured in fractions of a second, as in 1/60 or 1/250 second.

slow-sync flash: A special flash setting that allows (or forces) a slower shutter speed than is typical for the normal flash setting. Results in a brighter background than normal flash.

SmartMedia: A thin, matchbook-sized, removable memory card used in some older digital cameras.

TIFF: Pronounced *tiff,* as in a little quarrel. Stands for *tagged image file format.* A popular image format supported by most Macintosh and Windows programs. It is *lossless,* meaning that it retains image data in a way that maintains maximum image quality. Often used to save Raw files after processing and all pictures after editing.

tripod: Used to mount and stabilize a camera, preventing camera shake that can blur an image; characterized by three telescoping legs.

UHS: A classification assigned to some SD memory cards; stands for *Ultra High Speed.*

unsharp masking: The process of using the Unsharp Mask filter, found in many image-editing programs, to create the appearance of a more focused image. The same thing as *sharpening* an image, only more impressive sounding.

uploading: The same as downloading; the process of transferring data between two computer devices.

upsampling: Adding pixels to a digital photo in a photo-editing program. Usually degrades picture quality.

USB: Stands for *Universal Serial Bus.* A type of port now included on all computers. Digital cameras come with a USB cable for connecting the camera to this port.

white balance: Adjusting the camera to compensate for the color temperature of the lighting. Ensures accurate rendition of colors in digital photographs.

xD-Picture Card: A type of memory card used in digital cameras.

Index

• *T* •

• *U* •

• *V* •

Apple & Mac

iPad 2 For Dummies,
3rd Edition
978-1-118-17679-5

iPhone 4S For Dummies,
4th Edition
978-1-118-03671-6

iPod touch For Dummies,
3rd Edition
978-1-118-12960-9

Mac OS X Lion
For Dummies
978-1-118-02205-4

Blogging & Social Media

CityVille For Dummies
978-1-118-08337-6

Facebook For Dummies,
4th Edition
978-1-118-09562-1

Mom Blogging
For Dummies
978-1-118-03843-7

Twitter For Dummies,
2nd Edition
978-0-470-76879-2

WordPress For Dummies,
4th Edition
978-1-118-07342-1

Business

Cash Flow For Dummies
978-1-118-01850-7

Investing For Dummies,
6th Edition
978-0-470-90545-6

Job Searching with Social
Media For Dummies
978-0-470-93072-4

QuickBooks 2012
For Dummies
978-1-118-09120-3

Resumes For Dummies,
6th Edition
978-0-470-87361-8

Starting an Etsy Business
For Dummies
978-0-470-93067-0

Cooking & Entertaining

Cooking Basics
For Dummies, 4th Edition
978-0-470-91388-8

Wine For Dummies,
4th Edition
978-0-470-04579-4

Diet & Nutrition

Kettlebells For Dummies
978-0-470-59929-7

Nutrition For Dummies,
5th Edition
978-0-470-93231-5

Restaurant Calorie Counter
For Dummies,
2nd Edition
978-0-470-64405-8

Digital Photography

Digital SLR Cameras &
Photography For Dummies,
4th Edition
978-1-118-14489-3

Digital SLR Settings
& Shortcuts
For Dummies
978-0-470-91763-3

Photoshop Elements 10
For Dummies
978-1-118-10742-3

Gardening

Gardening Basics
For Dummies
978-0-470-03749-2

Vegetable Gardening
For Dummies,
2nd Edition
978-0-470-49870-5

Green/Sustainable

Raising Chickens
For Dummies
978-0-470-46544-8

Green Cleaning
For Dummies
978-0-470-39106-8

Health

Diabetes For Dummies,
3rd Edition
978-0-470-27086-8

Food Allergies
For Dummies
978-0-470-09584-3

Living Gluten-Free
For Dummies,
2nd Edition
978-0-470-58589-4

Hobbies

Beekeeping
For Dummies,
2nd Edition
978-0-470-43065-1

Chess For Dummies,
3rd Edition
978-1-118-01695-4

Drawing For Dummies,
2nd Edition
978-0-470-61842-4

eBay For Dummies,
7th Edition
978-1-118-09806-6

Knitting For Dummies,
2nd Edition
978-0-470-28747-7

Language &
Foreign Language

English Grammar
For Dummies,
2nd Edition
978-0-470-54664-2

French For Dummies,
2nd Edition
978-1-118-00464-7

German For Dummies,
2nd Edition
978-0-470-90101-4

Spanish Essentials
For Dummies
978-0-470-63751-7

Spanish For Dummies,
2nd Edition
978-0-470-87855-2

Math & Science

Algebra I For Dummies,
2nd Edition
978-0-470-55964-2

Biology For Dummies,
2nd Edition
978-0-470-59875-7

Chemistry For Dummies,
2nd Edition
978-1-1180-0730-3

Geometry For Dummies,
2nd Edition
978-0-470-08946-0

Pre-Algebra Essentials
For Dummies
978-0-470-61838-7

Microsoft Office

Excel 2010 For Dummies
978-0-470-48953-6

Office 2010 All-in-One
For Dummies
978-0-470-49748-7

Office 2011 for Mac
For Dummies
978-0-470-87869-9

Word 2010
For Dummies
978-0-470-48772-3

Music

Guitar For Dummies,
2nd Edition
978-0-7645-9904-0

Clarinet For Dummies
978-0-470-58477-4

iPod & iTunes
For Dummies,
9th Edition
978-1-118-13060-5

Pets

Cats For Dummies,
2nd Edition
978-0-7645-5275-5

Dogs All-in One
For Dummies
978-0470-52978-2

Saltwater Aquariums
For Dummies
978-0-470-06805-2

Religion & Inspiration

The Bible For Dummies
978-0-7645-5296-0

Catholicism For Dummies,
2nd Edition
978-1-118-07778-8

Spirituality For Dummies,
2nd Edition
978-0-470-19142-2

Self-Help & Relationships

Happiness For Dummies
978-0-470-28171-0

Overcoming Anxiety
For Dummies,
2nd Edition
978-0-470-57441-6

Seniors

Crosswords For Seniors
For Dummies
978-0-470-49157-7

iPad 2 For Seniors
For Dummies, 3rd Edition
978-1-118-17678-8

Laptops & Tablets
For Seniors For Dummies,
2nd Edition
978-1-118-09596-6

Smartphones & Tablets

BlackBerry For Dummies,
5th Edition
978-1-118-10035-6

Droid X2 For Dummies
978-1-118-14864-8

HTC ThunderBolt
For Dummies
978-1-118-07601-9

MOTOROLA XOOM
For Dummies
978-1-118-08835-7

Sports

Basketball For Dummies,
3rd Edition
978-1-118-07374-2

Football For Dummies,
2nd Edition
978-1-118-01261-1

Golf For Dummies,
4th Edition
978-0-470-88279-5

Test Prep

ACT For Dummies,
5th Edition
978-1-118-01259-8

ASVAB For Dummies,
3rd Edition
978-0-470-63760-9

The GRE Test For
Dummies, 7th Edition
978-0-470-00919-2

Police Officer Exam
For Dummies
978-0-470-88724-0

Series 7 Exam
For Dummies
978-0-470-09932-2

Web Development

HTML, CSS, & XHTML
For Dummies, 7th Edition
978-0-470-91659-9

Drupal For Dummies,
2nd Edition
978-1-118-08348-2

Windows 7

Windows 7
For Dummies
978-0-470-49743-2

Windows 7
For Dummies,
Book + DVD Bundle
978-0-470-52398-8

Windows 7 All-in-One
For Dummies
978-0-470-48763-1